STITCHING

LOVE

AND LOSS

STITCHING LOVE AND LOSS

×

A Gee's Bend Quilt

×

LISA GAIL COLLINS

University of Washington Press
Seattle

A V ETHEL WILLIS WHITE BOOK

Stitching Love and Loss was made possible in part by a grant
from the V Ethel Willis White Endowment, which supports the
publication of books on African American history and culture.

Design by Mindy Basinger Hill / Composed in Adobe Caslon Pro

27　26　25　24　23　　5　4　3　2　1

Printed and bound in the United States of America

UNIVERSITY OF WASHINGTON PRESS *uwapress.uw.edu*

LIBRARY OF CONGRESS CATALOGING-IN-PUBLICATION DATA

Names: Collins, Lisa Gail, author.

Title: Stitching love and loss : a Gee's Bend quilt / Lisa Gail Collins.

Description: Seattle : University of Washington Press, [2023] |
Includes bibliographical references and index.

Identifiers: LCCN 2022056039 | ISBN 9780295751603 (hardback) |
ISBN 9780295751610 (paperback) | ISBN 9780295751627 (ebook)

Subjects: LCSH: Gee's Bend (Ala.)—Social conditions. | Pettway, Arlonzia,
1923–2008—Family. | African Americans—Alabama—Boykin
(Wilcox County)—Social conditions. | African American quiltmakers—
Alabama—Boykin (Wilcox County)—Social conditions. |
Quilting—Psychological aspects.

Classification: LCC F332.W5 C65 2023 |
DDC 976.1/3800496073—dc23/eng/20221207

LC record available at https://lccn.loc.gov/2022056039

FOR ARLONZIA PETTWAY (1923–2008),
whom I did not have the honor of meeting, for sharing
so many gifts—born of vision, determination, faith, and hope—
with the world. And for her mother, Missouri Pettway (1900–1981),
whose extraordinary, exemplary quilt made in mourning
offers lessons essential to us all.

FOR MARY ANN PETTWAY,
manager of the Gee's Bend Quilters' Collective,
for opening her home to my family and for the magnificent
gift of introducing my youngest son to quilt making.

FOR MY FATHER, WILLIAM EDWARD COLLINS (1934–2008),
whom I miss beyond measure, whose warm and loving spirit
is now most palpable when I am in the presence of his exuberant
grandchildren or lying still with my face turned toward the sun.

AND FOR HIS MOTHER, WILLIE LEE COLLINS (1916–34),
who took her last precious breath while giving life to him.

NOW, TOO, FOR MY MOTHER, JOYCE MARILYN COLLINS
(1936–2016), a lifelong teacher who pieced together an enduring
community of friends and neighbors that remains wonderfully
healthy for children and other living things.

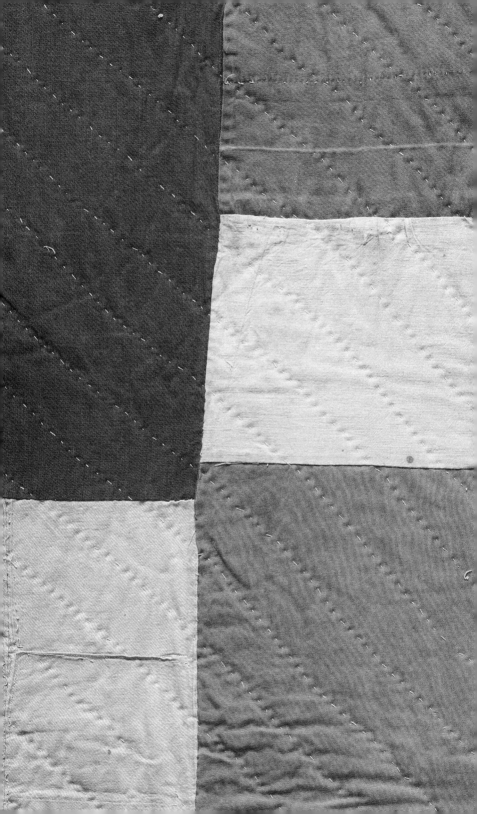

CONTENTS

ACKNOWLEDGMENTS

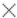

A New York Public Library's Schomburg Center for Research in Black Culture Scholars-in-Residence Fellowship, funded by the National Endowment for the Humanities, launched this book project. A decade later, a residency as an Ailsa Mellon Bruce Visiting Senior Fellow at the Center for Advanced Study in the Visual Arts (CASVA) at the National Gallery of Art in Washington, DC, enabled me to bring it to completion. I am grateful both to the scholars who gathered around the seminar table in Central Harlem and those who, amid overlapping pandemics, gathered hybrid style in DC for their advice, encouragement, and the model of their own rich projects. Studying quilts firsthand in the brilliant and magical presence of Julia Burke, senior conservator of textiles at the National Gallery, was an experience I will cherish forever. While in DC, Lowery Stokes Sims graciously introduced me to Linda Day Clark, whose glorious portraits grace this book. I am also grateful for the wonderful students who creatively and courageously shared in my interdisciplinary seminar on intimacy and quilts, allowing me to learn and grow alongside them. Over the years, Naomi Bland, Charlacia Dent, Sophie Asakura, Anya Bernstein, Sasha Ekman, and David and Kathryn Bruno all provided extraordinary research assistance. Larin McLaughlin believed in this book, and Anitra Grisales helped me see it whole—my thanks for both these editors is wide. For two decades now, my heart and brain have increased their capacities from the openhearted friendship and

wise and gentle counsel of my friends and colleagues Lisa Brawley, Light Carruyo, Lydia Murdoch, and Judith Weisenfeld. Further proof of my great fortune is sharing a home with Lee Bernstein. For all he does every day to make our busy household a creative hub of interdisciplinary inquiry, laughter, and good food, I am full of love and gratitude. And of course, it is our lit-from-within children, now nearly grown—Memphis, my research assistant at the Birmingham Public Library and frequent travel companion throughout the Black Belt, and Sasha, my creative consultant and sewing partner at Gee's Bend Quilting Workshops at the Alabama Folk School—who never fail to ask the truly important questions with sheer wonder and pure joy.

Missouri Pettway's Quilt Made in Mourning

The Memory of Its Making

Nearly six decades after her father's dying and death, Arlonzia Pettway remembered vividly how in late 1941 or 1942 her mother, Missouri Pettway, newly suffering the loss of her husband and the father of their children, pieced together a quilt out of his old, worn work clothes. Approaching eighty at the time and a seasoned quilt maker herself, Arlonzia Pettway readily recalled this quilt made by her grieving mother—and involving her own bereaved assistance—within the small African American farming community of Gee's Bend, Alabama. Her telling testimony, in 2000 or so, went like this: "It was when Daddy died. I was about seventeen, eighteen. He stayed sick about eight months and passed on. Mama say, 'I going to take his work clothes, shape them into a quilt to remember him, and cover up under it for love.' She take his old pants legs and shirttails, take all the clothes he had, just enough to make that quilt, and I helped her tore them up. Bottom of the pants is narrow, top is wide, and she had me to cutting the top part out and to shape them up in even strips."[1]

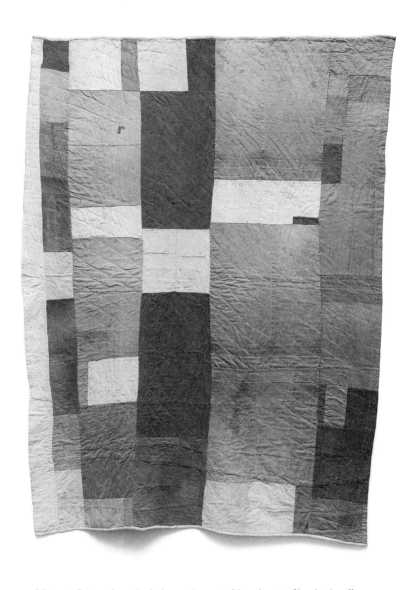

Missouri Pettway's work clothes quilt, created largely out of her husband's worn clothing while she was newly experiencing his loss. Missouri Pettway, *Blocks and Strips Work-Clothes Quilt*, 1942, cotton, corduroy, and cotton sacking, 90 × 69 in. National Gallery of Art, Patrons' Permanent Fund and Gift of the Souls Grown Deep Foundation. Courtesy of Hazel Marks.

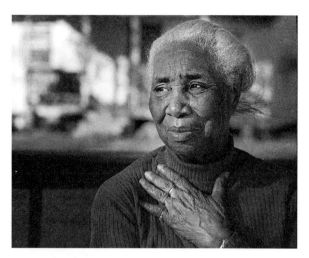

Arlonzia Pettway sitting on her porch in Gee's Bend, 2003.
Photograph by Linda Day Clark.

The way Arlonzia Pettway remembered this delicate time and this decisive act at the turn of the twenty-first century, the living, moving force behind her mother's creation of this pieced-together quilt, was the early death of her husband, Nathaniel Pettway (1898–1941), at the age of forty-three, following months of sickness and suffering. Within her lasting remembrance of the anguished impetus and inner resolve prompting the quilt's initial conception, Nathaniel and Missouri Pettway's firstborn daughter recalled her mother's expressed aims and intentions in making her pieced, or patchwork, quilt—including her choice of quilting materials and design and her desire for the covering's creation and use—had been deeply laden with love, loss, and longing. Her mother's hands, the daughter remembered, had worked to express and tend her aching heart.

This tender textile and the powerful memory of its making provide a path to dwell in some of the lifeways and lifeworlds of Missouri and Nathaniel Pettway's homeplace of Gee's Bend, Alabama, a community well accustomed to living with and through quilts. This handmade cotton quilt and the way it was remembered by an eldest daughter of

a recently widowed mother call us to contemplate vital life stories as well as core aspects of the staggering history and striking creativity of this rural Black Belt community located on former cotton plantation land and intimately familiar with grief. At the same time, Missouri Pettway's quilt and her daughter Arlonzia Pettway's remembrance of it shine light on critical dimensions of living, dying, and grieving. Considered together, the textile and the testimony bring attention to human suffering, resilience, creativity, and grace both within and beyond Gee's Bend. The pieced-together quilt's inspiration, construction, and desired use touch on enduring questions, simultaneously singular and shared, such as: How do we tend the loss of a loved one? What are things people in mourning need and feel moved to do? What supports people during this extraordinarily difficult time? What are the roles for creativity in grief—this fundamental human emotion and experience of profound distress propelled by loss? And more specifically, how might a closely crafted material object—a handmade pieced cotton quilt—in its conception, making, and use serve the excruciating work of grieving a loved one? At once a story of grief, a quilt, and a community, *Stitching Love and Loss* thinks intently, imaginatively, and expansively about Missouri Pettway's cotton covering in relation to the history of a place, its residents, and the necessary work of mourning.

Missouri Pettway's Handmade Quilt

Composed largely out of her husband's worn clothing while she was newly experiencing his loss, Missouri Pettway's handmade quilt is intimately bound with these central concerns by way of both its implicit and explicit links between practices of quilt making and processes of grieving. Measuring about seven and a half feet by five and three-quarters feet—ample covering for one—and made of over fifty blocks and strips of cloth cut and torn mainly from her farming husband's former field clothes, Missouri Pettway's improvised quilt was done by design using a model in her mind.[2] Created deliberately

and decisively while in the strong grasp of grief, her quilt, as her firstborn daughter remembered, served as a textile elegy—a pieced cotton dirge—that she made to support her grieving self and assist in holding and carrying the memory of her husband. Softly responsive and tending to inner needs, hers was a creative purposeful act born of wisdom, hardship, and hope.

Informed possibly by community precedent, probably by a personal quilt making practice she had developed throughout four decades of living, and certainly by skill and inner instruction, Missouri Pettway composed her elegiac covering with profound eloquence by bringing together bold rectilinear shapes of varying sizes and sheens with a cool utilitarian palette of gray, blue, red, and cream. Now, with the passing of eight decades, her quilt's washed-with-bleach and dried-by-sun cotton colors are even further faded and more quietly in conversation with each other. Thick strips and big blocks of gray and blue fabric predominate within Missouri's pieced quilt's gently geometric composition. Evoking a world of farmwork, the stately strips and blocks of hefty gray fabric are likely the flayed legs of a pair of Nathaniel's homemade field pants, as threads of evidence—seams, hems, and hurriedly stitched repairs—are in plain view. Reddish brown stains are also clearly visible on the gray cotton fabric. Concerning the presence and nature of these deep caramel-colored stains, Arlonzia—a key keeper of her family's and her community's history—linked them to her late father's work pants, their family's livelihood in Gee's Bend, and the soil of Alabama's rural Black Belt when she explained: "It got mud on the knee. Why, he used to crawl around and dig sweet potatoes."[3]

Contrasting with the neutral gray pant legs, with their ripe reddish brown stains, the blue strips and blocks of cloth, with their slight variations in tone, are quite possibly made from the typically tucked-in tails of a work shirt worn by Nathaniel and a second pair of his hard-wearing pants. Tiny and stitched into the pieced quilt top near the edge of one of its shorter sides is a sole square of material made of sturdy and faded blue denim. The red fabric pieces, made

of pinwale corduroy, are likely from another pair of the late farmer's trousers or a long-sleeved shirt, as a lengthy seam is visible. The cream cloth appears to be plain weave cotton. Bordered unevenly by cream cloth on three of its four sides, this pale cloth appears to be the quilt's sacking-like backing brought around front to form and finish all but one of the quilt's outer edges.

Quilts are made of two or three layers of material connected by string or thread. Missouri Pettway's quilt looks to be made of two layers; its pieced top and plain backing are bound, or "quilted," together with hand sewing and all-purpose stitching. On close examination, these long and likely rapid stitches of strong cream thread look to be moving diagonally across her quilt top—like they are dancing with speed and grace across her pieced and plaintive poem.

In conceiving of her cotton covering, Missouri Pettway drew on her skilled knowledge and intimate awareness of quilts and their making as practical and sustaining resources and created a wholly precious utility quilt. The quilt maker put her art and her craft—what she made by the work of her head, heart, and hands—to exceedingly good use, creating a covering both infinitely expressive and eminently useful. Based on her daughter's testimony, this quilt Missouri pieced together out of her late husband's work clothes was intentionally designed to tend her grief—to provide comfort, solace, meaning, and purpose for her grieving self during this extraordinarily difficult time of transition and change. Achingly eloquent and thoroughly of use, Missouri Pettway's quilt made in mourning lies at this exceptionally dire and delicate state of being, for the dying as well as for the living, of striving for serenity and arriving at what is next.

A Story of Grief, a Quilt, and a Community

Stitching Love and Loss tells a story of the small African American farming community centered around Gee's Bend, Alabama (officially known since 1949 as Boykin), by way of this quilt made by Missouri Pettway.[4] Woven within this broad story is close consideration of

how the art and act of quilt making may have supported the needs of grief and the work of grieving for this newly widowed woman at midlife: Missouri Pettway was forty-one and the mother of ten children living at home when her husband died.[5] At once a story of grief, a quilt, and a community, *Stitching Love and Loss* is a decidedly interdisciplinary study. It strives to provide a portrait of this rural Black Belt community located in a deep bend of the winding Alabama River by engaging what has been made, collected, stored, and written down as well as what has been recalled, recounted, and passed down and around. Immersed in a thoroughly human story, *Stitching Love and Loss* takes a holistic approach—a stance aligned with living and life—by considering connections between a closely crafted material object, a pieced-together quilt, and the history of a community, a family, and the essential work of mourning. Interpreting various sources of history and memory—oral testimony, quilts, Farm Security Administration photographs, Works Progress Administration narratives, government documents, travel accounts, songs, and stories—and drawing on quilting practice; labor, cultural, and social history; studies of region and religion; and the literature on grief and loss, *Stitching Love and Loss* offers a layered understanding of this renowned quilt making community in southern Alabama—between Selma and Mobile—by way of Missouri Pettway's handmade cotton covering.

Like Missouri Pettway's extraordinary, exemplary quilt, this book is a willed creation. It is an intentionally pieced-together work that builds on existing primary and secondary materials, on sources available in the here and now, to create something purposeful and new—a work that I hope first does no harm and, also, rings true. Like the clear construction of Missouri's quilt with its pieces and layers joined visibly together by way of a needle pulling thread, this is a written work—patterned by the pieces—that readily shows its stitching and shares how it is bound. Loosely structured by the steps the quilt maker likely took to create her pieced cotton quilt in late 1941 or 1942, each chapter draws on a quilt making step as a touchstone

Officially known since 1949 as Boykin, Gee's Bend is surrounded by the Alabama River on three sides, with one main road leading in and out. The map below shows where Gee's Bend is located in Wilcox County, and the map to the left shows Gee's Bend in relation to larger cities and towns in the region. Maps produced by Melissa Meyer at the Cartographic Research Lab, College of Arts and Sciences, University of Alabama.

to explore integral elements of the history, life, and legacy of the community centered around Gee's Bend. By nature and structure, this study of Missouri Pettway's quilt made in mourning and the powerful memory of its making is also, in good part, a story of the extended families and surrounding Black Belt farming communities that helped conceive, shape, and complete her cotton covering as well as tell its extraordinary tale.

Missouri Pettway's decision to make a quilt out of her husband's

old worn clothes while newly experiencing his loss is the point of departure for chapter 1, "Woven within the Land." Following some of the stories of the past, I think broadly about this place where she created her quilt and its residents—including long before it became known as Gee's Bend and before Alabama became a state—trying to bring into focus some of the staggering histories of grief and loss, as well as creativity and persistence, that reside within this land. The early preparatory work of gathering, assembling, and preparing the quilting materials that followed Missouri's decision to create her quilt informs chapter 2, "Carrying History and Memory." Drawing on Arlonzia Pettway's lasting memory of closely assisting her mother with this formative work, I explore how Arlonzia also served ably as a historian for her family and community—gathering, carrying, and forwarding the stories that formed their history and legacy. Missouri appears to have taken on the next step, the piecing of her quilt top, by herself. This seemingly solitary process of gathering onto her lap the strips and blocks of worn and remembered cloth, arranging and rearranging the familiar fabric into a design of her own creation, and then stitching the pieces together by hand forms chapter 3, "Seeking Sanctuary." Here I consider the quilt maker's piecing as an opportunity to dwell inwardly in her sorrow and seek solace. Completed in 1942, Missouri Pettway's quilt is made entirely of cotton, the all-powerful entity that fueled the institution of slavery within Alabama's Black Belt and the very commodity that defined labor in Gee's Bend for over a century. In chapter 4, "Lined with Labor," I examine some of the histories and struggles lining the quilt maker's African American farming community with this historically life-claiming fiber, this catastrophic cash crop, never too far from view. When Missouri Pettway created her quilt, it was common local practice for female kin and other neighborly women to visit a quilt maker's home and assist in the final step of sewing together, or quilting, the layers of her quilt. Chapter 5, "Shared Care and Prayer," centers this supportive and collaborative effort and looks at some of the forms of work this task-oriented gathering may have performed within this active faith community

and rich quilt culture. Grounded by an understanding of grief as at once a profound experience of distress and a profound expression of love, I think briefly and imaginatively in the book's conclusion, "Sacred Utility," on some of the ways Missouri Pettway's utilitarian quilt made of her late husband's work clothes may have been of vital use. Finally, in the coda, "Pulled to This Place," I consider some of the forces and factors that have drawn a steady succession of visitors, myself included, to this African American farming community in the heart of Alabama's Black Belt for nearly a century.

The Quilts of Gee's Bend

Gee's Bend, Alabama, as a place and the bold and compelling quilts created by its residents first captured my imagination in 2003, when I witnessed, along with over two hundred thousand others, *The Quilts of Gee's Bend* exhibition at the Whitney Museum of American Art.[6] Manhattan was the second venue for this stunning show of quilts and photographs, which opened at the Museum of Fine Arts, Houston, in 2002 and then traveled with much anticipation and acclaim to a dozen other museums across the country, before closing in 2008.[7] Curated by Alvia Wardlaw, William Arnett, John Beardsley, and Jane Livingston, this widely popular and highly celebrated exhibition showcased some seventy quilts, dating from the 1930s to 2000, created by both living and deceased quilt makers from this small Wilcox County community.[8] An ambitious large-scale exhibition, *The Quilts of Gee's Bend* shared with a broad museum-going public, the art, artists, and history of this predominantly African American community located in the heart of Alabama's Black Belt, this storied region historically tied to a cotton economy and originally named for its dark fertile soil.

Organized thematically, the scores of striking quilts that made up the exhibition were grouped on the gallery walls by topics such as key forms, frequently used materials, local patterns, and personal

approaches to design. Missouri Pettway's pieced cotton quilt made in mourning was prominently displayed. Based on the source and prior use of its principal materials—the strips and blocks of Nathaniel's well-worn clothing—her quilt was hung in the "work clothes quilts" section of the show. Flanked by other gently geometric quilts created from readied and repurposed pieces of old field clothes—overalls, pants, shirts, skirts, and socks—this then sixty-plus-year-old cotton covering was accompanied by her daughter Arlonzia Pettway's testimony, in which Arlonzia recalled the circumstances surrounding its creation.

It was early in 2003 when I saw *The Quilts of Gee's Bend*. I remember being in the company of a favorite museum companion—a social historian friend who magically seems to share my desired but unstated rhythm for talk and silence, movement and stillness, while in the presence of art. Sheer delight is the feeling I recall as we experienced this stunning show of quilts within arm's reach of each other on that winter day. As I was newly pregnant with my first child, I also remember brimming with anticipation at the prospect of soon sharing my rapidly growing secret with my good friend. And in this way, I was flush with the prospect of birth when I first experienced this quilt—with its implicit love story at its core—made by a woman in the thick grip of grief.

On that day, Missouri Pettway's quilt captivated me for its quiet power and the raw anguish of its creation. Imagining mother and daughter, together, tearing up the worn clothes of their loved one so the newly widowed mother could create a covering out of the familiar fabric gave me pause nearly twenty years ago, when I was quietly drawn in close to her quilt and its story. This familial image of shared sorrow, intimate yearning, creative sustenance, and healing love remained with me. Fully drenched and drowning in my own excruciating loss five years after first beholding her quilt, Missouri Pettway's quilt drew me in, once again, close and still.

Call to Home

While recovering from the birth of my second child in 2007, I was called home. My father was dying, and he wanted me at his side. His call did not come as a surprise. The last time he had visited, we had napped. Seeking comfort and protection for a weak and weary body riddled with cancer, he had finally found a somewhat possible position stretched out on my long brown couch. I lay a soft blanket on him and made tea. As he slept—so hopefully finding some ease and escape from the sheer physical and emotional pain of dying of a quickly spreading cancer—I stretched out on the couch opposite him and lay awake and prayed. Hearing rain and lying still on my side with my head turned toward him, I knew then and there that I needed to begin holding my beloved father in my memory. For while he was wholly striving to live, his body had borne just about all it could bear. He was suffering and seeking a path to peace, relief, and release. He was seeking a way home.

My father's clear and courageous call a few months later did not come as a surprise; I had been living in fear of the phone. Responding to his call, I returned home to Cleveland, Ohio, where I accompanied my Birmingham, Alabama–born and raised father, William Edward Collins (1934–2008), on his final journey from this earth by holding his impossibly thin and startlingly soft hand while his newborn grandson lay at my chest. My second son just coming to be while my father was passing away.

"You were gifted," a renowned sociologist later said to me, referring to how my father had sought and secured my presence at his bedside as he made his difficult transition from life on earth. But of course, it did not feel anything like a gift at the time. Someone entirely precious to me had just taken their final breath, and it felt like the absolute end of all light, warmth, and air. In the thick grip of my own grief exactly five years after first encountering Missouri Pettway's handmade quilt made in mourning, her tender quiet quilt once again captured my

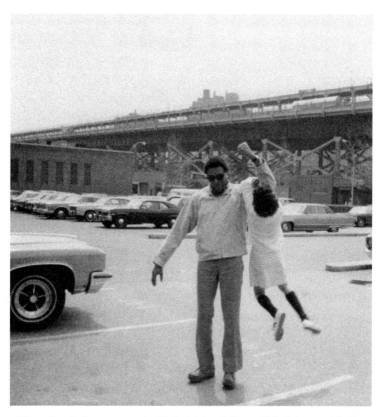

The author (in her mom-made skirt) with her dad, 1975. (My father would offer me his arm as a jungle gym when there was no playground nearby.)

imagination. Compelled this time by raw inner necessity and driven by both desire and despair, I sought to learn some of the lessons of her faded cotton covering, her lovingly stitched lament, and the histories and memories surrounding it. *Stitching Love and Loss*, in a sense, is a chronicle of my seeking. Here is what I have been learning. Here is what I know now.

Now, having dwelled on Missouri Pettway's quilt for over a decade and having lived intimately with loss for most of this time, I am increasingly aware that my near daily, nearly devotional, practice of

holding her cotton covering in my head and heart, coupled by the healing grace of time, has served to soothe my soul and soften my sorrow. It is clear to me now that in piecing this book together, in making it whole, I also met and tended my own grief. Her extraordinary, exemplary quilt continues to guide me on.

STITCHING

LOVE

AND LOSS

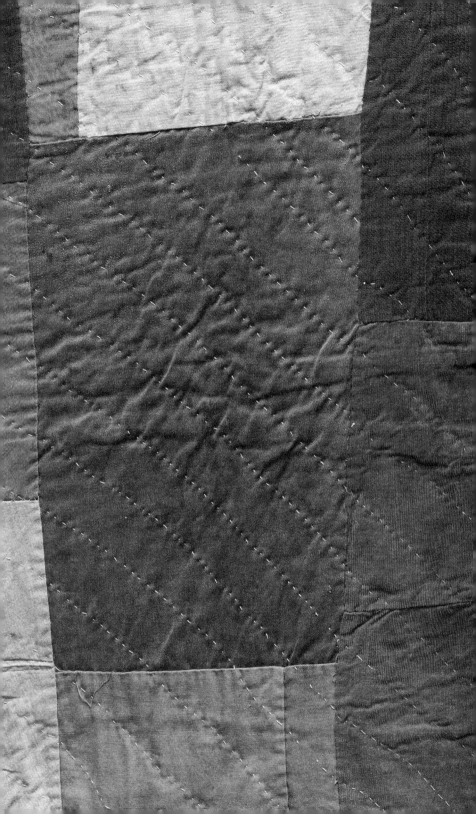

CHAPTER ONE

×

Woven within the Land

Heart of the Black Belt

Missouri Pettway was the fourth-born, or perhaps the fourth-surviv-
ing, child of Esau and Sally (Miller) Pettway; the birth date inscribed
on her loving headstone in the cemetery behind the Pleasant Grove
Baptist Church is December 3, 1900. This child of Gee's Bend was
raised at the dawn of the twentieth century on this land in a near
loop of the Alabama River. At the time Missouri Pettway was born,
Gee's Bend was a rural community long oriented around what had
been "the quarters," the place where enslaved individuals and families
on the old Pettway cotton plantation, likely including some of her
own ancestors, had lived—and where, two generations later, their
descendants, comprising many of the quilt maker's kin and kinfolks,
lived among a gathering of log houses within this small Black Belt
farming community set atop rich bottomland.

Born and raised in the same house her mother had grown up in,
Missouri Pettway's eldest daughter, Arlonzia, distinctly recalled the
condition of their house and the homes of their neighbors—while also
tacitly signaling the importance of quilts—with this memory: "Be-
cause the houses wasn't good where we were living in, 'cause you could

right Missouri Pettway's headstone in the cemetery behind Pleasant Grove Baptist Church. Photograph by David Bruno.

below The view just beyond the cemetery at Pleasant Grove Baptist Church. Photograph by David Bruno.

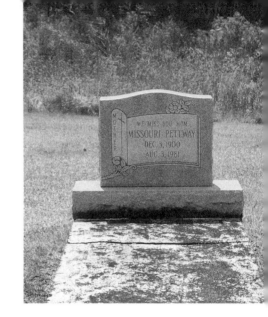

look and see the stars and the moon and anything. Look this way you could see the sun, you look that way you could see the stars, you look up and see the moon, because the house was so raggedy."[1] Missouri and Nathaniel Pettway's firstborn daughter also remembered the floors of the log and plank houses were as drafty as their spare roofs and walls. The way she remembered it, her great-grandmother Dinah Miller had worked to cover the gaps by spreading a quilt on the floor, over its wide cracks, for the children of the household to eat on and to keep the rising dust—from hogs running and fighting under the house—from finding a way to their food.[2]

During Missouri Pettway's childhood, about one thousand people lived and worked in and around Gee's Bend, and nearly all of them—and at times every one of them—were African American.[3] Many of these individuals were direct descendants of the enslaved

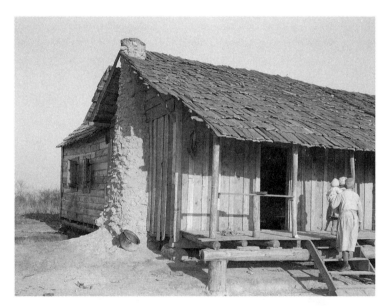

Residents climbing the steps to a log and plank house. Arthur Rothstein, *Cabin with Mud Chimney. Gee's Bend, Alabama*, 1937. Library of Congress, Prints & Photographs Division, FSA/OWI Collection, reproduction number LC-DIG-fsa-8b35932.

men, women, and children whom the area's largest cotton planter, Mark H. Pettway, and his family had claimed to own in the decades before the Civil War. Some of these residents, two generations later, continued to carry the planter family's last name, it now being thoroughly their own.

By Arlonzia Pettway's account, her mother had started working the farms and fields of Gee's Bend with her parents, doing what needed doing, when she was twelve.[4] By all accounts, gripping hunger and grinding poverty were perpetually present within this largely sharecropping and tenant farming community during the first decades of the twentieth century. Extreme hunger was experienced recurrently due to both forces of nature and forces of man. Highlighting the community's vulnerability during the early twentieth century is the enduring memory of a devastating raid during the fall of 1932 of over

Residents outside some of the remaining cabins and outbuildings on the former Pettway plantation in 1937. Arthur Rothstein, *Cabins on the Old Pettway Plantation. Gee's Bend, Alabama*, 1937. Library of Congress, Prints & Photographs Division, FSA/OWI Collection, reproduction number LC-DIG-fsa-8b35845.

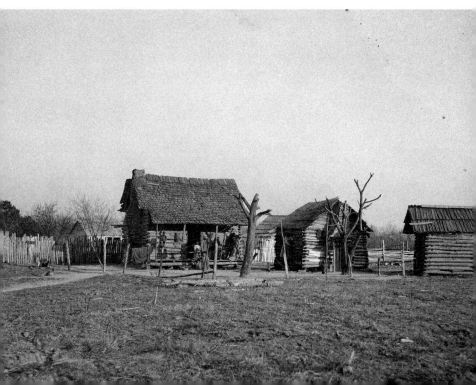

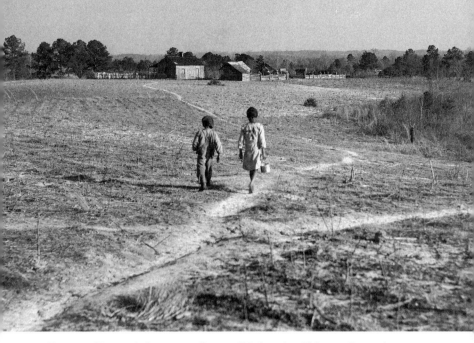

Lovett and Loucastle (carrying pail), two of Nathaniel and Missouri Pettway's children, walking together toward the cabins in 1937. This gathering of log and plank structures was previously the site of "the quarters," the place where enslaved individuals and their families had lived on the former cotton plantation. Arthur Rothstein, *Footpaths across the Field Connect the Cabins. Gee's Bend, Alabama*, 1937. Library of Congress, Prints & Photographs Division, FSA/OWI Collection, reproduction number LC-DIG-fsa-8b38853.

sixty local families for their plows, tools, wagons, work animals, livestock, and crops. Seemingly set in motion by surviving heirs of an advancing agent from the county seat of Camden, the raid was ostensibly waged to settle the impoverished families' debts to the late furnishing merchant's coffers. Occurring at a time—an epic time—of boll weevil infestation, exhaustion of the soil, and depressed cotton prices across the Black Belt, this catastrophic raid took place, not unrelatedly, at a

time when Nathaniel and Missouri Pettway, who are remembered to have married in 1916, were struggling mightily to make a living from farming and fully responsible for a household full of family.[5]

Born in 1923, the couple's third child, Arlonzia, was nine years old at the time of this Great Depression era raid, and she bore its memory like a river remembers its way. When interviewed extensively in her eighth decade of life—as part of the wide coverage of *The Quilts of Gee's Bend* traveling exhibition—Arlonzia repeatedly recounted the story of this grave and punishing act that had terrorized her family and neighbors by threatening and upending their already precarious lives. In one account, she recalled her mother had been piecing together a quilt top out of old clothes when she heard the desperate cries of her neighbors. Upon hearing these sounds of sorrow and panic, Missouri Pettway realized the dreaded raiders and their wagon train were near. Knowing then what was heading her way, the quilt maker quickly made use of what she held in her hands—needle, cloth, and thread—to sew together a sack out of four wide shirttails to hide some of her family's material assets: some sweet potatoes and corn.[6] Missouri Pettway decisively acting and deliberately making and making do while in harm's way—this is the image her eldest daughter carried forward and publicly shared of this devastating raid. Notably, with its emphasis on the anguished impetus, inner resolve, and purposeful handiwork of her mother's intentional act during this extraordinarily difficult time, Arlonzia's memory reverberates both with the quilt her mother made in mourning a decade later and the way its story was told.

In sharing the story of this Depression era crisis that further forced the farming community of Gee's Bend into dire poverty, Arlonzia Pettway also recalled her mother's heroic use of a hoe. For in another account of this merciless nighttime raid—a raid that, as one resident voiced, "broke us up"—Arlonzia shared how her mother, after hearing the screams, cries, pleads, and prayers of her neighbors, and after witnessing the robbing of her family's corn, sweet potatoes, and only hog, successfully threatened a looter with a hoe, enabling her family to

keep their last remaining farm animals.[7] Roundly recounting Missouri Pettway's brandishing of this iconic implement of grinding labor as a fierce and formidable weapon, her firstborn daughter brought forward another commanding memory—a portrait of her mother as resourceful, resistant, and resolute in fighting off starvation:

> And after about eight o'clock, here come this man with this buggy. He coming on in there, and he went in there and he got the little corn out of the barn. He got the few sweet potatoes, and we didn't have but one hog. He got the one hog. He got the hog, and Mama had three or four hens, a hens and a rooster . . . and she had got to the place she couldn't take it no more. And he just started to the hen house to get the hens and the rooster out there. When he started there, she picked up this long crooked handle hoe and told that man, "If you go in my hen house and get my last hen, I'm going to cut your neck off with this hoe." And at that time that man jumped in this buggy and down that road he went. And that's how brave she was.[8]

Late in life, Arlonzia Pettway looked back on this desperate and disastrous night when corn was snatched from cribs and hogs were prodded from pens—when the hard-earned livelihoods of her family and neighbors were thrown into wagons and hauled off by "help" hired by the advancing agent's heirs—and she shared with palpable pride: "He didn't get to my mama that day."[9]

During the four decades of Nathaniel Pettway's short life on earth and the eight decades of Missouri Pettway's life course, Gee's Bend was—and it remains—an economically poor, Black majority community within a poor and sparsely populated Black Belt county. Consistently characterized by the US Department of Agriculture as a rural area of "persistent poverty," Wilcox County, Alabama, is a place where, for many, basic human needs—for food, adequate housing, access to education, medical care, and fairly compensated work—have gone, and continue to go, unmet.[10] Given this hard reality, it comes as no surprise that in bearing this heavy burden and carrying its immense weight, making and making do have been essential skills. Born of necessity,

they have been part and parcel of life. Both making and making do have been integral to the social fabric and the community's strength and survival.

"Quilts Had to Be a Part of the Culture"

While Missouri and Nathaniel Pettway were raising their family in Gee's Bend during the 1920s and 1930s, and for generations of families who came before them, the creation of warm quilts was a response to necessity. Homes were cold and damp in the winter, and most of the households, full of family, struggled to secure sufficient food, clothing, and shelter. At the time, many resident and area families lived in simple structures furnished with a mix of handcrafted and recycled furniture and without running water, gas, or electricity. These struggling farm families had little access to cash and store-bought goods such as factory-made blankets. Most of what they had, they either grew or made. Recalling with unflinching honesty and clear distress her own 1920s upbringing near Gee's Bend, quilt maker Nettie Young, a neighbor and contemporary of Arlonzia Pettway, remembered: "When I was growing up, you didn't have nothing to throw away. You used everything—no waste food, no waste clothes, no waste nothing. . . . Everybody was in the same shape. We didn't buy nothing, because we didn't have nothing to buy nothing with. I just can't hardly tell you how life was back then, because you wouldn't believe it no-how. But we lived the hard life. We lived about a starvation life."[11] Extending her neighbor and peer's memories of hunger and hardship, Arlonzia shared why quilts within this context of scarcity and poverty were so needed for cover. Recalling family life and why quilts were fundamental to the Gee's Bend community of her 1920s and 1930s childhood, she explained:

> Well, the quilts had to be a part of the culture because at that time the people weren't able to buy blankets and most of the women had a lot of children. Every woman you see most was married had nine or ten

children, and they had to have cover. If you didn't have any—houses were so pieces, you look through the cracks and see the hogs under the house, and you had to have cover to keep those children warm. . . . You had to spread a quilt on the floor to keep the air from coming to your baby when he start sitting alone. So quilting was very important in Gee's Bend at that time because we were depending on that to keep us warm.[12]

Nathaniel Pettway fell ill in 1941, and as his eldest daughter remembered, "he stayed sick about eight months," before dying at the age of forty-three. Following nearly a year of sickness and sorrow and then while newly suffering the loss of her husband of over two decades, Missouri Pettway made a personal decision to piece together a quilt out of his worn work clothes. In making her decision, in choosing to create her quilt, Missouri drew from and deepened an activity, a chore, a skill, an art form, and a vital community resource women in Gee's Bend had practiced and shared for generations. Missouri had likely pieced together many useful quilts long before she decided to make this one, and she created this quilt—her quilt—in a way that was available to her, in a manner that supported her, and as she knew how.

In *The Quilts of Gee's Bend* exhibition at the Whitney Museum of American Art, Missouri Pettway's handmade cotton quilt was flanked by other pieced together quilts created from readied and repurposed field clothes. With its worn materials, pieced construction, and improvised design, her quilt visibly resembles some of the extant utilitarian quilts made in early- and mid-twentieth-century Gee's Bend for the oft-expressed purpose of keeping family members warm. Yet in contrast to these quilts made by her predecessors and peers, as well as other quilts she made, Missouri's quilt made in mourning was not created with this specific intention. It instead was created with another noble aim. As remembered by her daughter, Missouri expressly designed this quilt to meet the needs of her grief—to support her grieving self and assist in holding and carrying the memory

of her late husband. Recalling her mother's stated desire in making her cotton covering, Arlonzia Pettway recounted: "Mama say, 'I going to take his work clothes, shape them into a quilt to remember him, and cover up under it for love.'"[13]

With intention and desire, Missouri Pettway deliberately drew from a textile tradition she had inherited and sustained—the making of "work clothes quilts" to keep family members warm—and put it to another purpose, transforming tradition to tend to her loss.

Ancient Land and Early Inhabitants

Woven within the story of Missouri Pettway's quilt and its making is the staggering history of the place where she lived—before it became known as Gee's Bend, before Alabama became a state, before exploration and colonization of Native lands. Following some of the stories of the past also makes it clear that grief and loss have long been present on this ancient land and experienced closely by those who have resided here. Long looking makes plain that a striking creativity, along with a staggering history, is firmly threaded within this land and the lives of those who have known it as home.

Indigenous peoples of the Mississippi Valley, creators and sustainers of ancient Mississippian cultures and societies, were early inhabitants in what is now the southeastern United States, including on the land now known as the Black Belt region of Alabama. About eighty miles north of Gee's Bend—at the northwestern edge of the Black Belt—stands a stunning and telling testament to ancient America and the continent's original inhabitants. Fourteen miles south of the west-central Alabama city of Tuscaloosa—a city named in the Chahta (Choctaw) language for a formidable sixteenth-century Mississippian leader—twenty or so earthen mounds stand still. Soundlessly and monumentally, they grace the land at a 320-acre site in Moundville, Alabama—where present-day Hale and Tuscaloosa counties meet—on the resource-rich and strategic banks of the Black Warrior River. Organized around what appears to be a central plaza and at

one time protectively enclosed by a palisade or log stockade, these majestic manmade mounds, built of the earth, are surviving remains of a once densely populated city. They are the earthen remains of a vital social, political, and spiritual center that archaeologists believe was inhabited from around 1200 to 1450 CE—about six hundred to eight hundred years ago—and likely surrounded by other smaller related Mississippian towns and corn-based farming communities of the Black Warrior Valley.[14] Recent site studies suggest this planned community was highly populated for about a century, and then for the next century or so—from somewhere around 1300–1450 CE, before the arrival of the first Europeans—the city's population declined and the principal function of the immediate area changed. For some reason or reasons currently unknown or beyond clear grasp, the site seems to have shifted from a well-inhabited settlement to a depopulated burial ground and ceremonial center. Current research suggests burial sites largely replaced residential sites, and the area directly organized around the majestic earthen mounds and central plaza was transformed into a special place for burying the dead.[15]

At present, experts at Moundville Archaeological Park, a National Historic Landmark and a division of the University of Alabama, are uncertain why this marked shift took place and why this large and powerful urban settlement seems to have been mostly abandoned, with its historic population largely dispersed, by the late fifteenth century. As contact with European explorers, and contact with the disease pandemics they brought with them, first began in what is now west-central Alabama in 1540–41, with Spanish conquistador Hernando de Soto's torturous and terrorizing horseback expedition throughout the Southeast (whose forces killed the formidable Mississippian leader Tuskaloosa [Tascalusa]), other life-threatening and life-ending forces—of man, nature, or both—likely led to the city's decline. Researchers are also uncertain exactly how resident survivors of this once populous place, as well as survivors of neighboring farming communities, recovered and regrouped and persisted to form prominent modern southeastern Native nations, such as the Chahta,

Chikasha (Chickasaw), and Muscogee (Creek)—all of whom had members living near the uninhabited Moundville settlement during the colonial era.[16] Accompanying the dispersal of the area's population in the fourteenth and fifteenth centuries, it seems there was a related coalescing of groups of survivors and an adaptive reforming of Indigenous communities and societies.

Today study of this striking sacred site and the physical evidence that has been unearthed here continues. Like the presence of the earthen mounds, the unearthed material things—the stone tools, carved bowls, pipes, stone discs, palettes, pendants, ornaments of copper and shell, and ceramic vessels—are telling.[17] The image of an open eye embedded in the palm of a human hand, a recurrent motif on the unearthed objects created during the fourteenth and fifteenth centuries (when Moundville served as a site where the dead were brought for burial), perhaps symbolically alludes to the journey after death and/or an opening or portal to another world or realm.[18] Telling also are the less tangible forms of expressing and documenting the past, specifically origin stories and other forms of oral testimony and tradition. These sources and subjects of cultural history and memory—passed down and around and carried forth within and beyond Native American and Indigenous communities—richly attest to a lineage, a cherished ancestry, connected to the creators and inhabitants of these made-by-man mounds mysteriously abandoned over five hundred years ago. One powerful example: when asked in 2002 about her familial and communal connection to the ancient Mississippian sites, Joyce Bear, then a historic preservation officer for the Muscogee Nation, explained:

> When our people were forcibly removed into Indian Territory (Oklahoma) in the 1830s on what we call the infamous "Trails of Tears," we brought the culture and traditions of the old Mississippian world with us. We never forgot our ancient homelands in the southeastern part of the United States. I remember as a child my mother used to talk about

huge mounds that were in Georgia and Alabama, which were referred to as the "Old Homelands," and she would say, those are our ancestors—the "old folks" or the "old people." My mother was born in 1910 and only had about a tenth-grade formal education, but yet she knew about them because she was taught through oral tradition.[19]

For over two decades now, descendants of Mississippian peoples, members of Indigenous communities with close ties to the Southeast—including families who trace their ancestry directly to this sacred site—gather, alongside thousands of other visitors, to honor and celebrate their ancestors and their historic homelands at the Moundville Native American Festival, held annually on this hallowed ground located in the heart of the Black Warrior River Valley. Dwelling in this staggering history makes clear that creativity and persistence, along with grief and loss, have been inscribed on this ancient land for at least a millennium—from a time at the edge of memory yet held within the earth.

Settling and Slavery

Another, and perhaps a closer, context for the establishment of this place now known as Gee's Bend, Alabama, was the institution of slavery in the United States as well as both the transatlantic and domestic slave trades that fueled and enabled it. Joseph Gee, a planter and enslaver from Halifax County, North Carolina, came to this fertile bottomland in 1816, two years after the Muscogee Nation had been forced to cede it and three years before Alabama officially became a state. Arriving on this land as a single man in his early fifties to establish a cotton plantation, Gee appears to have been the first white settler—or at least the first in written record—to reside within this rounded riverbend that spanned, at its base, about ten thousand acres.[20] At the time of his arrival, this land—a parcel of the nearly twenty-three million acres the United States had seized from the

Muscogee Nation in 1814—was part of the Mississippi Territory, as the Alabama Territory formed the following year, in 1817, and Alabama gained statehood two years after that.

A story often told is that Joseph Gee arrived on this land with eighteen enslaved persons, whom he had forced to migrate on foot—by walking over seven hundred miles—from his northeastern North Carolina plantation.[21] Although other available sources are unable to narrate the details of this specific horror, the public record echoes these oft-remembered numbers. State census data for 1820—the first official account of the brand-new state of Alabama—lists Gee as a head of household in Wilcox County, with no relations, and as owning eighteen enslaved persons.[22] But census data, by design, stands silent on how exactly these captive individuals had arrived. Also, this initial 1820 enumeration took place four years after Gee's arrival on the land, and many life-altering events—including birth, death, purchase, sale, and escape—could have affected the size of the enslaved population on his plantation during the intervening years.

Still, what this persistent story might well mean is that eighteen enslaved and captive persons may indeed have made this agonizing march from northeastern North Carolina to what is now southwestern Alabama, possibly as part of an extensive caravan of wagons, carts, horses, tools, and livestock that Joseph Gee commanded—perhaps by the torture and terror of the whip—for his brutal, ambitious move. Conceivably including some individuals who rode in wagons and others on horseback, in addition to those who made the overland trek by foot, these migrants likely traveled southwestward through the Carolinas to the state of Georgia. Once in Georgia, they probably caught up with the Federal Road, the postal horse path—which followed, in part, Muscogee trading paths—that just a few years earlier, during the War of 1812, had further expanded to accommodate wheeled traffic.[23]

While on this increasingly major and mightily contested, by the majority of Muscogee people, southern thoroughfare, these migrants—both the forced and the free—passed directly through what

remained of the existing Muscogee Nation and onto homelands its members had recently been forced to surrender after losing the so-called Creek Wars of 1813–14 and signing the resultant Treaty of Fort Jackson.[24] In this way, what had just recently happened at Horseshoe Bend directly impacted the establishment of Gee's Bend. Consequently, a major catastrophe and cause of loss and grief of this 1816 southwestward march to the lower Mississippi Territory commanded by Joseph Gee—along with the many contemporaneous ones like it— was the further undermining of Muscogee territory and sovereignty. These early treks by settlers, squatters, and speculators on the newly widened Federal Road began what is generally known as "westward expansion" and what is often referred to locally as "Alabama fever." Pivotally and tragically, these early treks through the forests, fields, and towns of Creek country—as well as the forts that facilitated the migrants' travel and the settlements their travels enabled—served to further put in peril, and attempt to colonize, Native lands and livelihoods.

Another major catastrophe and cause of loss and grief of this southwestward march of 1816 was the excruciating severing of the forced migrants from family members and other kin who remained enslaved in North Carolina. Concerning the frequency and impact of the fracturing of Black families as part of the domestic slave trade, a recent study drawing on available data puts it plainly: "Most enslaved people were sold without a single other family member; it is estimated that more than half of all enslaved people held in the Upper South were separated from a parent or child through sale, and a third of all slave marriages were destroyed by forced migration."[25] Wholly wrenching, these figures provide a glimpse into a further deepening cascade of crises and trauma.

It was through this cataclysmic trek that worked to weaken Muscogee autonomy and security, as well as the forced labor of these captive migrants often separated from their families, that Joseph Gee was able to establish a large cotton plantation in this rich river valley on newly ceded Native land before Alabama became a state. And

ever since, for what now has been over two centuries, this land in a curve of the Alabama River—a river bearing the name of a historic and contemporary Indigenous community—has typically carried his name: Gee's, or Gees, Bend.[26]

The US government's acquisition of Indigenous lands and the related expulsion of Native peoples from the Southeast in the 1810s, 1820s, and 1830s—most dramatically and definitively expressed in 1830, when President Andrew Jackson signed into law the Indian Removal Act mandating the relocation of southern tribal nations east of the Mississippi River to designated territory in the West—prompted a fierce grasping rush for the newly available lands among planters, enslavers, and speculators such as Joseph Gee. Within Alabama, the twenty-second state, this propulsive and contagious desire among tens of thousands of prospective settlers for potentially lucrative land was closely tied to the dispossession and forced expulsion and exodus of Native peoples—many of whom were already exhausted by war, disease, and loss—from the rapidly developing Cotton State.

This infectious "fever" also fueled slavery. For some of the policies and practices—and principles that prompted them—that caused the devastating and catastrophic forced westward migration of Native peoples living in the Southeast also, in turn, worked to propel the domestic, or internal, slave trade—the devastating and catastrophic forced migration of enslaved persons of African descent from the more established states of the Eastern Seaboard and Upper South to labor in the newly forming farms and plantations across the Deep South. Thousands of people were forcibly pushed off their land, while thousands more were forcibly pulled onto it.

A Family of Planters and Enslavers:
The Gees and Pettways

In 1824, when Joseph Gee died, eight or so years after his arrival on this land along the banks of the Alabama River, two of his North Carolina nephews, Sterling and Charles Gee, strove to inherit their

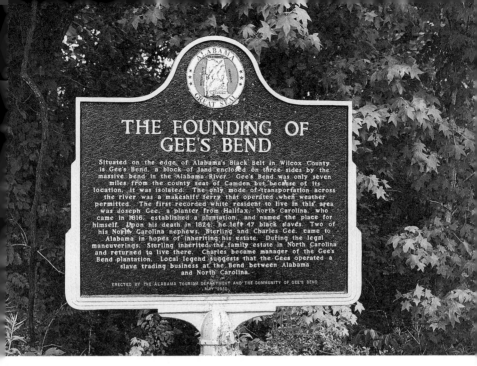

Historical marker installed by the Alabama Tourism Department and the Community of Gee's Bend in May 2010. Photograph by David Bruno.

uncle's Black Belt estate—an estate that, upon Joseph Gee's death, included forty-seven enslaved individuals.[27] After a few years of legal action, according to Wilcox County records, the matter was seemingly settled, with Sterling Gee returning to North Carolina to run a family estate there and Charles Gee remaining in Alabama to manage his late uncle's plantation, including the enslaved persons who worked it and made it work.[28] The business of bondage may have continued to link the two brothers, as well as other members of their extended family, as some memories recall that members of the Gee family ran a slave trading—a human trafficking—operation from the Bend, continuing the practice of forcibly moving persons from North Carolina to the Black Belt.[29]

In 1845, two decades after Joseph Gee's death, his former holdings in the Bend were transferred to another North Carolina relative, a Halifax County planter and enslaver named Mark H. Pettway. After acquiring this lucrative property, Pettway and his family packed and

moved—like Gee had thirty years before them—from North Carolina to Alabama. This move proved quite profitable for the planter and his family. Upon arrival, Pettway was the owner of a sizable cotton plantation—one his enslaved workers further expanded—at a time when cotton was king. Conditions were right for him. Steamboats that could carry cotton cheaply and swiftly via the steady southward tug of the Alabama River to Mobile Bay—a fluid waterway from plantation to port—further enabled the planter's profits. "In the heart of the cotton belt, with fertile soil and the river to carry the bales of white gold to the Gulf, Pettway prospered," one writer studying the situation remarked.[30]

After settling here during the antebellum era—about sixteen years before the start of the Civil War—members of the Pettway family would continue to own this land for the next half-century, until 1895.[31] Today, over two hundred years after their initial forced arrival, most of the African American residents of Gee's Bend, many of whom are descendants through birth or marriage of the enslaved individuals who worked the Gee and Pettway plantations, continue to carry the Pettway name, having long ago made it their own. Reflecting on the shift in the area's ownership during the period preceding the Civil War and the continuing legacy of this surname within the descendant community, writer and local historian Kathryn Tucker Windham once observed: "And so the Gees departed, leaving their name on the land. In came the Pettways, who left their name on the people."[32]

Reports and Accounts

It is said that over 100 African American men, women, and children were forced to accompany Mark Pettway and his family on their move to Gee's Bend in the mid-1840s.[33] As memories recall, these were individuals who had previously been enslaved on the family's North Carolina plantation. Census data can neither directly confirm nor deny these harrowing recollections. Pettway is listed in the 1840 census as a head of household in Halifax County, North Carolina,

and as owning 36 enslaved persons.[34] Ten years later, the 1850 census and accompanying slave schedule list the planter in Wilcox County, Alabama, and as owning 140 individuals—75 men and boys and 65 women and girls, ranging from eight months to sixty years of age.[35] Precise details of when, how, and from where these enslaved individuals arrived in Gee's Bend are likely out of public reach. Yet these captive migrants—like the 18 enslaved individuals who are remembered by the descendant community to have come three decades before them—are also remembered to have largely made this over seven hundred–mile trek by foot. Indeed, some of these forced migrants may well have been family and kin of the victims and survivors of earlier treks.

As the forced expulsion and westward migration of most Native peoples living in the Southeast had largely taken place in the decade or so before Mark Pettway moved southwestward in 1846, the caravan under his command crossed lands that had already experienced numerous trails of tears. Perhaps including both wagon train and coffles, individuals shackled together in chains, the planter and enslaver's procession of both forced and free migrants served to further deepen the grooves, as well as the grief, of the Federal Road—this road so central to the undermining of Indigenous territory and sovereignty and, relatedly, to the region's active internal slave trade.

Caravans such as the one led by Mark Pettway were not an uncommon sight along the routes leading to the rapidly developing Cotton Kingdom during the early nineteenth century. While traveling eastward through the southern United States in 1835—moving through (and furthering) the devastations of Creek country—George W. Featherstonhaugh, a British American geographer, bore witness to this mass internal displacement and migration directly and provided this firsthand report: "In the course of the day we met a great many families of planters emigrating to Alabama and Mississippi to take up cotton plantations, their slaves tramping through the waxy ground on foot, and the heavy waggons [sic] containing the black women and children slowly dragging on, and frequently breaking down. All

that were able were obliged to walk, and being wet with fording the streams were shivering with cold. . . . We passed at least 1000 negro slaves, all trudging on foot, and worn down with fatigue."[36]

Nearly a century and a half after Featherstonhaugh witnessed what he recalled as over a thousand exhausted enslaved persons forced to walk away from family and other kin and march west to the cotton-growing regions of Alabama and Mississippi, Gee's Bend resident Clinton Pettway shared a closely held account of this horrific journey to Alabama from his own family history. In an interview with writer Kathryn Tucker Windham in 1980 (which was later expanded into an essay), the fifty-eight-year-old man recounted how Mark Pettway, in preparing to move from North Carolina to his newly acquired plantation in Gee's Bend, had explicitly forbidden Clinton's enslaved great-grandmother from bringing her infant son, Saul, on the forced trek. Clinton Pettway recounted how his ancestor had defied the orders of the man who claimed to own her and kept her baby with her by hiding him within mattress ticking. Explaining how the sale and purchase of his great-grandmother had nearly left his future grandfather motherless, Clinton shared the following account, as remembered and passed down by his family: "He didn't buy him, he bought his Mama. And you know how a lady is about her chillun. And the man was selling her and got to leave the chile. He was just throwed away. And she stole him and put him up in a bed ticking. Sewed him up in a bed ticking. That's how she . . . got him here."[37]

Four generations later, Clinton Pettway—Arlonzia Pettway's contemporary—recounted how his great-grandmother had made a safe hiding place for her young son using needle, cloth, and thread. The bed ticking, the strong tightly woven utility fabric, served as shelter and cover. Clinton shared with pride that this decisive and determined use of what his great-grandmother held in her hands had enabled the exceedingly vulnerable mother and child to survive and stay together. Indeed, his grandfather, the family historian remembered, had lived to be well over one hundred years old, passing on around 1950.[38] With its focus on the anguished impetus, inner

resolve, and purposeful handiwork of his great-grandmother's life-saving sewing, Clinton Pettway's memory is reminiscent of Arlonzia's remembrance of the sack her mother sewed together to save her family's remaining food and fight off starvation during the devastating 1932 raid as well as the quilt Missouri Pettway made in mourning a decade later. Yet in this account—his family's history—the cloth is not holding and carrying the memory of one who has just died or protecting desperately needed food. Here, in this memory, the stitched-together fabric holds a precious hidden hope. Both cover and shelter, it carries a cherished child whose mother is determined to keep living, breathing, and close.

An Intimate Familiarity

Because of the interwoven regional, national, tribal, and transnational histories that led to the calamitous expulsion, the forced push, of Native peoples from the area and the calamitous entry, the forced pull, of peoples of African descent to this place now known as Gee's Bend, Alabama, during the first decades of the nineteenth century, this small Black Belt farming community has had a majority African American population for two centuries now. Over the course of this time, members of the community, the residents of this place, have been intimately familiar with the most challenging experiences of living: hunger, violence, sickness, dying, and death. And as the forced dispossession and displacement of Indigenous peoples from their ancestral lands, towns, and homes in the Southeast were integral to the formation of this community, this has long been the case. Staggering histories of grief and loss—as well as creativity and persistence—are woven within this land. These histories and memories are a powerful force in what has been said and done and thought and felt here as well as how and why it is remembered. And in what is cared for and carried forward. Traces of those who had lived their lives here, their suffering and hope, were present when Missouri Pettway, while in mourning, decided to make her quilt.

✕

Carrying History and Memory

In Close Company

Within her lasting remembrance of her mother's quilt made in mourning, Arlonzia Pettway recalled she had been about seventeen or eighteen years old when her father died, in 1941, and that she had been present, grieving herself, and in the close company of her mother, Missouri, when she started making her quilt in his memory. The way Arlonzia remembered it, she had ably and actively assisted in the quilt's early steps, bearing witness to why and how, and with what, her mother created her pieced cotton covering. By her account, Missouri had made the initial decision to piece together the quilt, and then both had shared in the next step of gathering, assembling, and preparing the quilting materials that would comprise it: Nathaniel's well-worn work clothes. Sharing in this work, mother and daughter transformed their loved one's clothes—handling the clothing never again to be needed or worn by him—with the aim of creating a wholly precious utility quilt. With metal shears and their bare hands, the two women cut and tore the faded work shirts and pants into usable

quilt strips and blocks. Looking back on this time and this effort at the turn of the twenty-first century, Arlonzia Pettway brought forth a memory of assisting her mourning mother with these preparatory tasks: "She take his old pants legs and shirttails, take all the clothes he had, just enough to make that quilt, and I helped her tore them up. Bottom of the pants is narrow, top is wide, and she had me to cutting the top part out and to shape them up in even strips."[1] With all hope, this early preparatory work offered mother and daughter a measure of time and space to sit with their loss and share in their sorrow while mutually engaged in this task of monumental meaning and purpose. Arlonzia's supportive decision to be present and with her mother during this time, to gather and shape the materials that would become the quilt—the pieces of worn familiar cloth—also holds in the light her later offerings and gifts as a vital carrier of culture, holder of history, and keeper of memory.

Lineage and Legacy

In early 2005, at the age of eighty-one, Arlonzia Pettway woke up one morning and penned her first poem, calling it "The Path."[2] In it the lifelong Gee's Bend resident and seasoned quilt maker, in her role as the poem's narrator—the self-declared "I" of this clearly drawn and artfully told homage—charts the extensive maternal quilting legacy she has inherited while also evoking its long and arduous trail of toil, hardship, and hope. Her poem, in its opening stanzas, pays tribute to three quilting women in her family who have come before her and who have passed on: her mother, her maternal grandmother, and her great-grandmother on her mother's side. Both creation and chronicle, Arlonzia's praise poem honors these women, her closely claimed foremothers, for making a way out of no way, for clearing and tending a resourceful and sustaining path—one they were grievously unable to journey upon to its earthly end.

At once chronicling and claiming her quilt making inheritance, Arlonzia Pettway's poem names three successive generations of female

forebears, a trio of maternal ancestors, whom the poet and proud heir affectionately refers to as "Great Grandmama Dinah," "Grandmama Sally, her daughter," and "Missouri Pettway, my mama." Lyrically linking these three generations of mothers and daughters—this female trinity bound by birth and blood, skill and hope—is the poem's searing refrain:

> With her quilt pieces and her thimble and a needle in her hand.
> But she never reached the intersection.
> She passed on.[3]

Charting a lengthy lineage of quilt makers within the intricate roots and branches of her family tree, Arlonzia's poem positions the maker of quilts as a fourth-generation inheritor and navigator of this lasting legacy of struggle, creative utility, and maternal descent. Like her mother's quilt made in mourning—Missouri's lovingly stitched lament—Arlonzia's reverently penned poem created over sixty years later threads the past through the present with marked tenderness, gravity, and grace.

Around the time when she penned her poem—during the years *The Quilts of Gee's Bend* exhibition was traveling across the country—this eldest daughter of Nathaniel and Missouri Pettway was in popular demand as a public speaker and was interviewed extensively. In the many interviews she granted at the turn of the twenty-first century, the quilt maker ably served as a local historian and memory keeper, verbally recalling and recounting stories of her family as well as her community and giving voice to the profound artistic and cultural legacies residing within and around her. Dwelling in Arlonzia Pettway's sought and saved words from this time, it is abundantly clear, like it is in her contemporaneous praise poem, that she proudly understood herself as heir to a maternal quilting legacy that spanned four generations—a surviving history and living tradition she had intently learned, sustained, and enriched; an abiding inheritance she proudly cared for and carried with her.

While in her seventies and eighties, Arlonzia Pettway served as

principal narrator not only of her own life but also of the lives of her mother, grandmother, and great-grandmother. By serving in this manner with great clarity and purpose, the Gee's Bend quilt maker shared for posterity some of the ways, words, and worlds of her maternal ancestors. Before her passing in 2008, she passed on some of the stories that had shaped their lives. And by way of comparison with some of Arlonzia's riverbend neighbors and peers, Linda Matchan, in her rich account of quilters and quilt making in Gee's Bend for the *Boston Globe*, contended that Arlonzia's living memory of her female forebears, including their ties to quilts, "reach back the furthest."[4]

"She Had a Little Quilt"

Quilts and cloth were central to the ways Arlonzia Pettway shared the life stories of her maternal ancestors in interviews at the turn of the twenty-first century. Born and raised in the same drafty log and plank house as her mother had grown up in, she recalled how her great-grandmother Dinah Miller had worked to cover gaps and deter dust by spreading a quilt on the floor, over its wide cracks, for the children of the household to eat on.[5] Arlonzia also remembered how her Great Grandmama Dinah (whose life dates, difficult to pinpoint, are possibly from about 1848–54 to about 1930) had regularly gathered her youngest descendants around her to share stories central to her life.[6] As she recalled, these were times when her earliest known ancestor—a victim and a survivor of slavery—had shared powerful accounts with a new generation of kin of what she had experienced during her long lifetime. Within this company, surrounded by children, Dinah Miller directly delivered accounts of what she had witnessed, practiced, endured, and survived—passing on, in this way, some of the things she carried. Bringing these times to mind over seventy years later, the quilt maker and family historian recalled how her truth-telling, tale-bearing elder, seemingly seeking an attentive ancestral audience, had encouraged her young relatives to "bow around her knees so she could tell us her stories."[7] "Lonnie," as Arlonzia fondly remembered

her maternal great-grandmother calling her as a child, was probably at most seven years of age during these seated councils of kin.

Arlonzia Pettway remembered, too, that these gatherings had taken place upon a special quilt. In a turn of the twenty-first century interview, she recalled that when Dinah Miller had gathered near her descendants, she had the children sit together on a small quilt in her possession—a quilt, she recollected, made of strips of red, green, and yellow cloth. Remembering this seemingly simple act—the spreading out of this quilt—as a frequent, even daily, one tied to the essential acts of eating and life sharing, Arlonzia brought forward an enduring early memory of how her mother's maternal grandmother had made use of this primary colored quilt: "She had a little quilt, not a big quilt, and it made out of red, green, and yellow. And every day she would spread it down on the ground, on the floor, for us to eat down there so she could tell us the story about Africa and how she came to America, and how she was punished and how she was beaten. And she would . . . every day she would spread that quilt down and say, 'y'all come here, and I'm going to tell you my life, a story about my life.'"[8]

Gathering her young relations together for mealtime, keeping their food clean, and holding space for them to listen to stories of her life—and learn their lessons—seem to have been some of Dinah Miller's aims and intentions in ritually laying out her small quilt. With its intimate size, her covering served to bring kin close, close to her and close to each other. As mealtime on Dinah's quilt was also life story time, her cover provided a site for both nourishment and learning. Of big consequence was her little quilt. On it children were fed food for the future and stories from the past. For a woman who had survived capture in Africa, forced passage across the Atlantic Ocean, slavery in the United States, and then over six more decades of struggle and sorrow after Emancipation—and who was drawn to tell some of the stories of this extraordinarily hard human history to her youngest descendants—her quilt seems to have been a central site for her to reckon with the past, make meaning, be heard, and have her stories carried into the future.

Arlonzia Pettway provided able and active assistance in carrying forward Dinah Miller's legacy. At the turn of the twenty-first century, and at a stage in life when she herself was a great-grandmother, the quilt maker repeatedly recounted what she had committed to memory, and what she had chosen to disclose in recorded interview settings, from these times—in the late 1920s or so—when, as a young girl, she had listened intently to her great-grandmother bearing witness to her truths.[9] Late in her own life, Arlonzia shared, with both generosity and intensity, memories from earlier times when Dinah had drawn her youngest descendants near. Describing the deep and lasting impact of hearing the life stories her African-born, formerly enslaved, forebear had sought to speak and to share, she explained: "I'd wake up at night and think of the stories she told. I didn't forget them. I pawned them in my heart."[10] Later, with intention, she picked up their narration.

In studying Arlonzia Pettway's sought and saved words, it is quite clear the lifelong Gee's Bend resident understood the maternal quilting legacy she had inherited in terms of generation and geography, in terms of both time and place. For not only did Missouri Pettway's eldest daughter understand herself as part of a lineage that spanned four generations, but she also understood this branch of her family tree as stretching back to the middle of the nineteenth century, to an era of illegal transatlantic slave trade and legal slavery in the United States.[11] When Arlonzia narrated her family history on her mother's side, her narrations often began in the African continent, with the complete catastrophe of her great-grandmother's entrapment and capture.

Narrating Capture

When sharing the story of her maternal family history, Arlonzia Pettway often started her story by explaining how her great-grandmother had gone from living freely in Africa to living enslaved in Alabama. Her oral testimony typically began with a startling and

agonizing account of her foremother's unwitting movement into bondage and utterly involuntary transition into the US system of chattel slavery. Within the accounts of the creator of quilts, holder of history, and keeper of memory, it was striking acts of deception, entrapment, and capture—some involving color and cloth—that had propelled the calamitous sequence of events leading to her African-born great-grandmother's forced homelessness and forcible deportation across the Atlantic Ocean on the hellish journey known as the Middle Passage.

Arlonzia Pettway's voiced chronicles of this catastrophic sequence of events, this succession of compounding crises, varied slightly. This is the nature of narrative. Yet central always to her telling of this harrowing history was that as a girl, her great-grandmother—along with her mother, father, and brother, as it was typically told—had been lured by the color "red" (or more precisely, things that were red) onto a docked and waiting ship along the West African coast. Deepening even further the horror of this intentionally planned and coordinated act, the quilter and narrator recounted, readily and repeatedly, that this docked ship, ready to set sail from Africa to America, was deceptively disguised. In one typical turn-of-the-twenty-first-century telling, the great-granddaughter of the grievously deceived and forcibly deported African girl child started the story of her maternal family history with these words:

> My great-grandmother came from Africa. She came with her mother and father and brother when she was just thirteen, and she died here at an old age. We used to sit and listen to her telling us about it. She told of back in Africa, how they couldn't get the Africans on the ship. For two weeks she said they kept them penned up, and they wouldn't go near the ship. Then they decked the ship up with red lights and red bow ribbons 'cause they understood that the Africans loved the color red so much, and then the Africans got on there.[12]

At once horrifying and astonishing, Arlonzia's narrated opening—her start to the story that had come down to her—belongs to

her and her extended family. At the same time, however, her genuinely singular familial remembrance is also an intimately plural one, as it is one shared by many others. Her family's account of capture reverberates with stories shared by people across time and place and connected (or bound, as it were, and sometimes united) by forces of history, geography, and worldview—or put somewhat differently, by structures of labor, feelings of affiliation, and ways of making meaning, especially in trying to make sense of an elusive and traumatic past and recover from its shared and still pulsing horrors. Slavery was—and remains—in these enduring testaments both past and present. As such, Arlonzia's startling and agonizing opening account is at once a powerful prologue to her own extended family history and a potent prelude to a linked and larger community history.

Arlonzia Pettway's oral accounting of her African-born, formerly enslaved, ancestor's exile and enslavement resounds with an African American community history that lives within and extends well beyond Gee's Bend. Evidence of this resonance is her emphasis on the color red—what she described as "red lights and red bow ribbons"—as a critical catalyst, or determining force, in the coerced deportation of African persons across the Atlantic Ocean. The quilt maker and family historian's emphasis on the color red, as well as what this focus on the primary color both conveys and conceals, reveals just how deeply woven her narration is within the thick fabrics and folds of African American history and culture.

Slave Narratives from the
Federal Writers' Project, 1936–1938

Linked closely to the complete catastrophe of being entrapped and taken captive on the African continent is the color red. Connection between the color and capture is recurrent within the over two thousand oral histories collected between 1936 and 1938 of surviving elderly African Americans who had been formerly enslaved in the United States—the transcribed autobiographical accounts that were sent to

Washington, DC, and deposited in the Library of Congress as part of the Federal Writers' Project (FWP) of the Works Progress Administration (WPA), a Depression era relief program.[13] Within these approximately ten thousand pages of typewritten testimonies of adults in their seventies, eighties, nineties, and beyond—the overwhelming majority of whom had firsthand knowledge and eyewitness experience of the institution of slavery in the United States—the primary color is consistently associated with entrapment and capture in Africa. Often depicted in the form of red cloth, and frequently in the form of red flannel, in these interviews conducted more than seven decades after the Civil War, red material and objects are directly linked to stealing, imprisoning, and deporting innocent African individuals for enslavement in the Americas. They are tied to deception and theft for the purposes of profit.

Given Arlonzia's accounts, Dinah seems to have shared her own memory of this tragedy with her great-granddaughter in the late 1920s, perhaps while she was seated on the small quilt made of strips of red, green, and yellow cloth. As such, these exchanges in which Dinah Miller shared her recollections of entrapment and capture in Africa took place in Gee's Bend, Alabama, about a decade before the Federal Writers' Project interviewers officially began spreading across the former slave South gathering firsthand accounts.[14] Dinah shared her memories with Arlonzia ten years or so before WPA interviewers listened to—and translated with ink onto paper—numerous accounts by Dinah's contemporaries of abduction in Africa quite similar to the one Arlonzia remembered her octogenarian great-grandmother sharing of a ship bedecked festively and falsely with "red lights and red bow ribbons." Indeed, many of the collected oral histories—alternately called "slave," "ex-slave," or "WPA" narratives—concerning capture begin quite similarly to Arlonzia's account with an initial deceiving distraction of Africans by Europeans using a sensory source of attraction such as the sound of bells or whistles or the sight of lights, beads, or trinkets.

Many of the interviewees during the Great Depression also

recalled to their interviewers that it was red objects and things that then entrapped African persons by luring them onto disguised slave ships. It was things that were red, the African American elders and testifiers repeatedly recounted—including "red handkerchiefs," "red flags," "red flannel," and even "red boats"—that were used so maliciously to beguile and betray unwitting African persons by those pursuing profit in the transatlantic slave trade.[15] More than sixty years after the WPA interviews were conducted, Arlonzia Pettway shared a kindred account—learned from her great-grandmother over seven decades earlier—of the role of red in the abduction, smuggling, and trafficking of African persons.

Woven within Arlonzia's opening to her family history—and integral to her account of how her great-grandmother went from living freely in Africa to living in slavery in Alabama—is a striking chronicle of the capture of captives. Clear and present in her account is the duplicitous enticement onto a readied and waiting boat, then entrapment, seemingly by non-Africans (the implicit and recurrent "they" in her testimony), of a keenly cautious group of African people who were already being held captive (by the "they"). Absent, however, from her vigorous telling is mention of the critical context that preceded and precipitated this disaster. Missing is how and why her great-grandmother and her family—as well as the other smuggled shipmates who accompanied them on the torturous boat journey—were initially made vulnerable, captured, and catapulted into the horrific state of being imprisoned, or "penned up," and held against their will somewhere along the African shore. This crucial prior history, this critical context, goes unspoken in Arlonzia's recounting of the forces and factors that propelled her great-grandmother's involuntary and permanent exile from her African homeland and subsequent landing as a girl—along with other surviving African captives—on the southern Alabama shore.

Telling is this absence, as what stays silent speaks. For it is precisely the association of red with capture in her account, as well as what this connection both conveys and conceals, that makes Arlonzia

Pettway's account of her great-grandmother's capture and enslavement so remarkably representative of African American history and culture within and beyond Gee's Bend. Like the numerous accounts preceding and resembling hers, including in their stresses and silences, these kindred chronicles of entrapment and capture may very well serve to support and complement the important work of community formation: specifically, the work of shaping, forming, and expressing collective memory out of extant source material and exigent needs and, through this coordinated effort, creating something of fundamental meaning and use—vital, necessary work that resonates with Missouri and Arlonzia Pettway's shared effort, while in mourning, of gathering the pieces of worn and remembered cloth, shaping them into usable strips and blocks, and, by way of this work, forwarding the process of piecing together a much wanted and needed utility quilt.

Meaning, Memory, and Capture

Historian Michael Gomez, in *Exchanging Our Country Marks: The Transformation of African Identities in the Colonial and Antebellum South*, an innovative study of the process of African American social and cultural formation within the context of slavery, suggests that enslaved peoples across the southern United States consciously and collectively reframed and rearticulated the critical history of the principal forces and factors that precipitated the forced expulsion of millions of African people across the Atlantic Ocean, the largest forced migration of people by sea in history. Gomez suggests this willed and strategic reshaping of history and memory was a significant achievement—somewhat akin to piecing together a monumental utility quilt across generations and geography—and that evidence of this success resides in the many accounts, spanning the South, that foreground the role of red in the entrapment and capture of beguiled and betrayed African people. Oral recollections and testimonies, like the one Arlonzia Pettway recounted hearing from her formerly enslaved great-grandmother, stressed it was the color

red—and red things in particular—that treacherously and tragically pulled vulnerable persons away from their homes and homelands and onto slave ships.

In *Exchanging Our Country Marks* Gomez carefully considers the numerous "red cloth accounts" that populate the WPA narratives. As a scholar, he was intrigued by the frequency and consistency of these capture stories as well as their meaning and purpose. And as a social and cultural historian of Africa and its diasporas, he was well poised to bring his transatlantic knowledge of life on both sides of the ocean to bear on these rich autobiographical records. For example, accounting for how the sight of red cloth might have sparked the interest of some African individuals during the period of the transatlantic slave trade, he explains that imported fabric held a powerful commodity status in West Africa at the time and that red foreign fabric was especially coveted. He further explains that European cloth was directly linked to capture. "To be sure," the historian explains, "textiles were the principal imports exchanged for captives in West Africa and were used for both currency and clothing."[16]

Despite the prevalence and relevance of the red cloth tales, however, Gomez stresses that these conspicuous accounts of African entrapment and capture should not be understood as precise records of the slave trade. Partly, he argues, that is because they make "no mention of African complicity in the procurement of slaves," the often hard to tell—and perhaps even harder to hear and to hold—participation of some Africans in fostering the slave trade.[17] The red cloth accounts exclude the workings of the internal slave trade on the African continent, the human trafficking over land that preceded and tracked so tragically with the human trafficking by sea. Instead, what these recurrent reports of capture reveal, the historian of slavery contends, is the successful end-product of a concerted and heroic effort: the culmination of ambitious, intergenerational, and cross-regional work by enslaved people during the eighteenth and nineteenth centuries to sort and synthesize the various accounts of African capture that "had circulated throughout the slave communities of the South." Put

another way, these accounts are the result of intently focused efforts to standardize the various capture chronicles into one shared and sanctioned narrative, to construct a speakable story and a tellable tale, that could convey "what the African-based community perceived as the essential truth of the experience"[18]—the human truth, that is, not necessarily a verifiable one. Concerning the mighty work that lies behind, and dwells within, these accounts of red cloth as well as the meaning and purpose of the massive successful undertaking to coordinate and unite them, Gomez writes:

> White southerners, so engaged in managing the machinery of plantation agriculture as the principal means of social control (at least from 1830 on), were quite unaware that right beneath their noses their supposed chattel were engaged in a complicated process of analyzing, debating, and collating their experiences. It was a mammoth undertaking, this business of arriving at an evaluation that was truthful as well as didactic. From the waters along the Carolina coast, the call would go forth, containing in it the collective experiences of Africans taken to Charleston; and from the swamps and plantations of the lower Mississippi, the response would eventually come, having absorbed the vantage points of the Carolinas and merged them with their own. By way of the domestic trade here, through pathways of escape there, slaves throughout the South exchanged data and created syntheses. Eventually, consensus was reached. A verdict was rendered. The white man was found guilty of guile, guilty of violence, guilty of horrors unimaginable. This is the fundamental truth that the African-born wanted their offspring to understand about the initial capture. This, the red cloth tales teach, is the underlying significance of the slave trade.[19]

Arlonzia Pettway's twenty-first-century testimony recounting her great-grandmother's entrapment and capture—lured by things that were red—onto a disguised slave ship ready to set sail from Africa to America suggests the strength and longevity of these ingenious, collectively created, and closely held stories of red cloth as well as their lessons. Indeed, Arlonzia, the family historian and fourth-generation

quilt maker, may have first encountered a red cloth account while sitting attentively on Dinah Miller's quilt made of red, green, and yellow cloth. Her recollection also suggests that residents of Gee's Bend—a place bound by slavery for much of the nineteenth century and with exceedingly close ties to the domestic slave trade—were active participants in the articulation, creation, and preservation of these epic chronicles of capture. In this effort, they were also key co-creators of an emerging and ever-evolving African American culture and history. Despite their location in a deep bend of the Alabama River (and perhaps more likely, related to it), residents of Gee's Bend were dynamic participants in a linked and larger community composed of people with related histories and experiences as well as ways of making meaning and sharing human truths. And this legacy of culture bearing and community formation continues. In countless ways, Gee's Bend is not, as oft-described, remote. It has been, and continues to be, at the heart of Black history, freedom, movement, expression, and struggle.

Middle Passage and Gulf Coast Landing

It is not only the association of red with capture in Arlonzia Pettway's start to the story of her maternal family history that is so richly representative of an expansive African American community history and evidence of the depth and power of community formation. The quilt maker's testimony carries another telling, resonating absence. Like many earlier accounts by formerly enslaved people and their descendants, her testimony dwells neither on the workings of the internal slave trade on the African continent nor on the details of the transatlantic slave trade. The Middle Passage is missing. Absent from Arlonzia's account is direct discussion of the cruel and coerced movement—the forced exile—of captured and imprisoned persons across the vast sea to labor in North America, South America, and the Caribbean that linked the coasts of West and Central Africa and the shores of the Americas for the ships' over ten million survivors.

In other words, the slavery, smuggling, and human trafficking carried out on tens of thousands of slave ships over the course of more than three centuries are missing. Aligned with many of the oral histories that came before hers, Arlonzia's sought and saved testimony does not explicitly reference her great-grandmother's perilous transatlantic passage—it does not speak directly of the imprisonment of her person across the ocean. Implicit, instead, is the life-stealing horror of slavery at sea.

When Arlonzia Pettway shared the story of the history she had learned, she typically began her account with her great-grandmother's entrapment and capture in Africa as a girl. Remaining silent on what transpired between the western coast of Africa and the southern shore of Alabama, she then stressed the horrors of sale and separation that befell her captive foremother—along with her mother, father, brother, and the other African captives—after their forced ocean crossing and forcible landing on Alabama's Gulf Coast. Dinah Miller's octogenarian great-granddaughter, in her role as family historian, shared this part of the story of their past: "My family came to Gee's Bend by Grandmama Dinah came from Africa in 1859. She was sold and bought with a dime. But her mother and her brother went another direction. They separated them, they were not together, and she never did get a chance to see her mama and her brother and her daddy anymore because she came this way, and I guess the others went to North Carolina somewhere and worked. But she never did get a chance to see them anymore."[20]

In another contemporaneous narration, Arlonzia—directly following her account of her great-grandmother's capture and enslavement on the deceitfully decorated slave ship—explained what happened after her great-grandmother was abducted in Africa and brought to America:

> This white man bought her, and she said she cost a dime. He paid a
> dime for her, and he carried her a different direction from her mama
> and her brothers. She don't know which way they went. She followed

this man what bought her with ten cents. I was real small when she told me the story, but it startled me so I kept it. . . .

When they landed on this side, there was seven white men waiting. One white man bought twenty-five of them, including her, but not none of the rest of her family. She was separated from all of them right there and never seen them again. The man that bought her and those other ones took them down to Mobile Bay to farm the land by the bay. They gave her the name Dinah. There weren't no Millers up around here; she say she come from Africa with that name.[21]

As recounted and told by her great-granddaughter, her foremother's account included both the adoption of a given name and the maintenance of a surname and stressed the trauma of her sale and separation from her family members.

Arlonzia's testimony, although, not surprisingly, difficult to determine definitively, echoes other oral histories by Alabamians concerning the illicit arrival of their enslaved ancestors—well after the 1808 ban on the importation of enslaved people into the United States—by way of Alabama's Gulf Coast. Within a 1930s WPA interview, for example, Josephine Howard, who was born near Tuscaloosa, explained that both her mother (at around the age of twelve) and her maternal grandmother had been captured in Africa and forced onto a slave ship heading to Alabama's port city of Mobile. Narrating a part of this surviving story that had been passed on to her, she recounted:

Dey allus done tell us it am wrong to lie and steal, but why did de white folks steal my mammy and her mammy? Dey lives clost to some water, somewheres over in Africy, and de man come in a little boat to de sho' and tell dem he got presents on de big boat. Most de men am out huntin' and my mammy and her mammy gits took out to dat big boat and dey locks dem in a black hole what mammy say so black you can't see nothin'. Dat de sinfulles' stealin' dey is. Dey captain keep dem locked in dat black hole till dat boat gits to Mobile and dey is put on de block and sold. Mammy is 'bout twelve year old and dey am sold to Marse Tim, but grandma dies in a month and dey puts her in de slave graveyard.[22]

Extending these remembrances of illegal slave trade into the United States during a time of legal slavery within the nation, Alabama historian Virginia Van der Veer Hamilton also experienced directly the prevalence of this enduring oral history within Gee's Bend as part of her research in the 1970s. Sharing her research on Gee's Bend in her 1982 guidebook, *Seeing Historic Alabama*, she explained: "Many of its residents have been told, by means of oral tradition, that they are descended from slaves smuggled illegally from Africa to Mobile long after the international slave trade was prohibited in this country in 1808."[23]

Complementing further these enduring histories, there are also extant written records (as well as recently recovered remains) of the *Clotilda*, a slave ship carrying the US flag that landed illegally near Mobile, Alabama, on July 8, 1860, with over one hundred enslaved persons aboard.[24] The Trans-Atlantic Slave Trade Database, a vast catalog of archival data of known slave trading voyages, documents this slave ship—a swift and unassuming schooner—and its illicit journey at the end of the era of illegal transatlantic slave trade and legal slavery in the United States. Owned by Timothy Meaher and captained by William Foster, the *Clotilda* completed a slave trading voyage—one 126 days in length—more than a half-century after the international trafficking of African peoples into the United States had been outlawed. According to shipping records, the *Clotilda* left Alabama's Gulf Coast on March 4, 1860, for the Gulf of Guinea on the western coast of Africa. By May 15, 1860—just over two months later—the ship had arrived at the port city and active slave trading site of Ouidah (in present-day Benin), and its captain and crew had mercilessly begun securing African captives for the slave vessel's return voyage. Then, on July 8, 1860—following a torturous six-week crossing in which at least two young people died on board—the *Clotilda* returned to a port near Mobile, and after the ship had been tugged up the Alabama River to a discreet spot, 108 enslaved African people landed, captive and homeless, on Alabama soil.[25]

Dinah Miller certainly could have been one of the 108 men,

women, and children who survived the Middle Passage from the Bay of Benin to Mobile Bay aboard the *Clotilda* during the spring and early summer of 1860.[26] In her award-winning book *Dreams of Africa in Alabama: The Slave Ship "Clotilda" and the Story of the Last Africans Brought to America*, historian Sylviane Diouf tells the story of this final recorded group of captive African people brought to the United States less than a year before the start of the Civil War. As part of her immersive research, Diouf documented the names—either the original "African" name, American name, or both—of 51 of the African individuals who were forcibly deported to Mobile aboard the schooner. Although the historian did not document any name resembling either "Dinah" or "Miller," the details of the other captives continue to remain either unknown or unaccounted for.[27]

The Way She Remembered It

As Arlonzia Pettway, a fourth-generation inheritor and navigator of this legacy of slavery, remembered it, her great-grandmother's early life resembled an epic odyssey and a tragic tale. Focused on the first twenty-five to thirty years or so of Dinah's approximately eighty years of life, she recalled that, before her passing, her foremother had passed on pieces of her harrowing life story. This was a woman, her great-granddaughter recounted, who had repeatedly witnessed and experienced horror both directly and firsthand, a woman who had been all too familiar with anguish and agony.

Within her narrations, Arlonzia Pettway repeatedly stressed that her ancestor's purchase into bondage—like stock and as chattel—upon the ship's landing in Alabama resulted in the permanent separation of her great-grandmother from her family (echoing the severing and fracturing of families decades earlier as a result of Joseph Gee's and Mark Pettway's forced westward marches as they furthered the domestic slave trade). Following this wrenching tearing apart, Arlonzia remembered that her great-grandmother's life experiences had included a period of enslaved farm labor near Mobile Bay, the

Alabama inlet of the Gulf of Mexico. "She say the first field she worked in was a place down there they called Mobile Bay," the quilt maker recalled, later adding, "She said she was worked real hard."[28] Next in the retelling of the story of this enslaved women's life through the lips and lens of her devoted great-granddaughter—an account that may well be the living legacy of a shared familial accounting spanning four generations—Dinah was purchased by a second planter and enslaver and subsequently relocated, along with other enslaved workers, to farm fields in Snow Hill, Alabama (about 150 miles northeast of Mobile Bay and about 50 miles from Gee's Bend).

While chronicling her foremother's dislocation and relocation along with other enslaved persons to work the Black Belt fields in Snow Hill, Arlonzia recalled having learned that two Native men and two white men had also been sent to this rural Wilcox County locale for the twin and tragic purposes of increasing simultaneously both the productive and reproductive labor of the enslaved female farmworkers. Describing the conditions of this move from the inlet Mobile Bay to the inland Snow Hill, its cruel and premeditated aims, and its life-changing consequences for her great-grandmother, Arlonzia stated: "At that time there wasn't nobody else farming that land but the Cherokee Indians. She worked down there, and another man bought them and took them to Snow Hill. Four big healthy mens, two Indians and two whites, was sent to Snow Hill to work with the slaves and get the womens pregnant. So that's when she got pregnant with Sally, my grandmama. She had to live with those four mens, and once the woman got pregnant, they moved them out and brought more womens in. They wanted big strong babies."[29]

As a decidedly living, breathing consequence of her foremother's relocation to Snow Hill and her subsequent rape—the coerced sexual intercourse forced on her while working there—Arlonzia's great-grandmother had given birth to a baby girl named Sally, an infant conceived under circumstances of horror who came into the world on the farms of Alabama's Black Belt, as remembered during slavery but seemingly occurring (based on chronology) during

tenancy.[30] Understanding this girl child to be of both African and Native American ancestry, the family historian also remembered learning that, as a baby, Sally had been fed and otherwise cared for in part by another woman while her own new mother, Dinah, had no choice but to continue laboring with hoe in hand. Concerning this merciless and deeply and disastrously gendered arrangement of labor, Arlonzia recounted: "Dinah still worked the fields after Sally was born. They get somebody to nurse the babies so the field slaves could still work." While still a young child, the lay historian then recalled, Sally was working—with a heavy hoe in her growing hand—alongside her mother on the fertile farms and fields of southwestern Alabama. "Mama Sally—that's what I called my grandmama—she got to be a big-enough girl and she started working in the fields with her mama," explained the granddaughter of this child who had come into the world by force, under circumstances entirely antithetical to establishing consent.[31]

Arlonzia also recalled at the turn of the twenty-first century that Dinah's life following the birth of her daughter Sally had included domestic work in a household close to Camden, the small town and county seat of Wilcox County. Possibly somewhat out of step with her other contemporaneous recollection of her great-grandmother's status and location as a laboring new mother forced to work in the fields around this time, she recalled: "After Dinah had Sally, they took her out of the field and she became a cook and housecleaner for the boss man's wife in a place called Vredenburgh, over near Camden. After that, she went back out in the fields and worked until Grand-mama Sally got about seventeen years old."[32] As Arlonzia repeatedly recounted that Dinah was the first in their family to make a life in Gee's Bend, perhaps it was around this time that she made her way across the river to the place where her great-granddaughter would later, while seated on her small quilt, listen to some of her life stories, the parts of the past she had sought to speak and share.[33] Bearing witness, in this way, to what her formerly enslaved forebear, born three generations before her, had witnessed, practiced, endured, and

survived. And beginning, as a child, the process of carrying forward her maternal family history. Late in life, Arlonzia Pettway served as principal narrator of the lives of her mother, grandmother, and great-grandmother, generously sharing what she remembered—and chose to disclose—in numerous interviews. She ably and actively gathered and shaped the stories that comprised her family history in a manner similar to how, in close company of her mother, she later gathered and shaped the materials—the pieces of worn familiar cloth—that formed her quilt.

CHAPTER THREE

Seeking Sanctuary

Graced Space

Missouri Pettway seems to have taken on the piecing of her quilt top on her own. For this step, she likely gathered onto her lap the readied strips and blocks of Nathaniel's former clothes, arranged and rearranged the familiar fabric into a design of her own creation, and then sewed the pieces together by hand. This work of "shaping" her quilt may have also served to give form and shape to her grief. Holding her late husband's well-worn clothes in her hands—clothing that may well have been made and mended by her—likely underscored the immensity and finality of her loss. At the same time, this task may have afforded the grieving quilt maker an opportunity to dwell inwardly in her sorrow by offering a soft sanctuary to touch and tend to it. Guided by her own pace and path and in a manner of her own making, this act may have provided the surviving spouse time to sit with her grief and a place to feel its weight and her feelings fully. Perhaps the rhythmic effort and ease of stitching and pulling her steel needle through the cotton cloth, again and again, offered the quilt maker—with her practiced hand—a way and means to process the pain, seek solace, and experience and express her love, loss, and

longing. With all hope, the steady abiding motion of the task at hand provided a haven for her to seek what she so likely sought: comfort and peace, strength and support, guidance and compassion.

Prayer and reflection can be integral to piecing together a quilt top. Like an extended meditation, sewing can offer a measure of stilled time and graced space conducive to introspection and connecting and communicating within and beyond the self. For well-churched people, including many of the creators of quilts in Gee's Bend, the making of quilts can be rooted in religion and part of the expression of their faith. Renowned Gee's Bend quilt maker Mary Lee Bendolph, who like many of her neighbors past and present is spiritually centered by her deep Christian faith, speaks of the immersive experience of piecing together a quilt as a welcome invitation for personal contemplation and religious communion. Confident in God's grace, Mary Lee Bendolph shares how the practice of sewing a quilt top serves as a site for her to experience God's presence and express her intimate relation and devotion to Him. Concerning the prayerful site of worship opened and offered by this act and art, she explains: "When I start to piece a quilt. I just sit there and pray. Sometime I cry. Sometime I sing, and it give me joy to do that. By sitting there, piecing the quilt, it give me a little joy. Just to sit there: to sing and pray. Talk to the Lord, tell him, because he know, he brought me from a long way."[1] Her daughter Essie Pettway also gives voice to the way quilt making can create a calm, affirming space to experience acceptance and communion and show gratitude. "When I'm doing my quilt, my mind is totally into it, and I don't have to be perfect. It give you a peace of mind. You can take time out and talk to God and say thank you," she shared.[2] Like a cloth hymn in their hands, piecing for these devoted quilt makers offers a rich opportunity to feel God's love, to pray, and to praise Him.

Complementing the words of her good friend and neighbor Mary Lee Bendolph and her daughter Essie, Arlonzia Pettway also shared how she experienced quilting as an activity that drew her closer to God, as an act especially conducive to worship and prayer. Touching

Mary Lee Bendolph reading the Bible in her living room while a documentary featuring Nettie Young plays on her television. Photograph by Linda Day Clark.

on how her relation to God was further enriched by her quilt making practice, she explained: "Sometimes you sit and quilt, and it just come in you to start praising God and thanking God that brought us and delivered us so far."[3] As a strong shared Baptist faith is part of the social fabric of Gee's Bend and a common commitment among many of the area's quilt makers, Missouri Pettway may, too, have experienced piecing as a path or portal for opening and deepening her communion with God and meeting the natural needs of her grief. Possibly she sought this soft sanctuary—this graced practice and place—to summon God's love, seek comfort in His presence and gather the necessary strength to support and sustain herself during this extraordinarily difficult time. With her head slightly bowed, her hands gathered in front of her heart, and the remains of Nathaniel's clothing lying on her lap, Missouri, at age forty or so, may have prayerfully sought sacred space to express the depth of her love and loss and begin to imagine her and her family's future.

Quilts, Mourning, and Remembrance

Quilts and loss have long been linked within various textile traditions. Surveys, studies, and stories of historical quilts in the United States reveal a range of connections between practices of quilt making and processes of grieving. These connections in some cases are quite visible, such as the presence of specific symbols, motifs, patterns, and fabric—especially material, including ribbons, linked to the deceased or the funeral—while in others they are subtle and more inwardly rendered. However, the common connecting thread among them—and with Missouri Pettway's quilt—is the context for their creation. The quilts' creators were all experiencing and expressing love and loss through cloth and, in this way, giving material form and shape to their grief. Survivors, in other words, were making use of their hands to speak and heal their hearts.

Eminently practical and infinitely wise, Missouri Pettway's decision to make a quilt while newly suffering loss resonates closely with decisions made by many others in mourning. One site where the recurrence of this creative intentional act is especially evident is within the literature devoted to quilts and African American lives, for running like a sturdy thread through these offerings are examples of, and accounts by, individuals who have drawn on quilts and their making and use as vital resources in the excruciating work of grieving a loved one. To highlight this strong running thread, I'd like to dwell here, albeit briefly, on this related literature and some of these resonant accounts.

Patricia Turner's important book *Crafted Lives: Stories and Studies of African American Quilters* implicitly engages this topic, casting some light on ways quilts and loss intersect. Interested in exploring the roles and meanings of quilts within people's lives, Turner, a folklorist and quilter, held extensive conversations with quilt makers who identify as African American creators. Of the nine individuals profiled in her book, five of them—through their words and their work—reveal links between practices of quilt making and processes of grieving.

For two of the quilters, Jeanette Rivers and Elliott Chambers, grief served as the impetus for them to make quilts. In the process, both surviving spouses found the expressive act and art of quilt making helpful, including in passing difficult time with meaning and purpose and in gently supporting remembrance.[4] After losing a son to street violence, Ora Knowell created a quilt in her son's likeness to simultaneously honor him, assist in the work of stopping violence in her community, and comfort herself. Six years later, when this tragedy horrifically repeated itself and a second son of hers was murdered, the traumatized quilter and activist responded once again by making a likeness quilt, achingly explaining that her quilt making provided "a fraction of healing by redirecting the inner pain."[5]

For Marion Coleman, another profiled quilter, it was the experience of seeing a quilt made of mourning clothes that inspired her to first take up quilting. Recalling what she remembered of this exceptionally moving and catalytic quilt and the exhibition where it was shown, she shared: "I do remember it had a very old quilt made by a woman who had taken all of her mourning clothes for it. They were all black. Something about that really touched me. Someone saving their garments and showing her respect and love for a relationship and showing that by dressing a certain way, then taking that and transforming that so that she could still have it to cover her."[6] While three of the quilters who linked quilts and loss in *Crafted Lives* shared stories of quilts and their making as supporting needs of their grief and one quilter shared a story of a mourning quilt that had held her heart and inspired her to take up the practice, a fifth quilter profiled by Patricia Turner shared a life story of needing to put her well-established quilt making practice on hold while newly suffering the death of her husband. Longtime quilter Daisy Anderson Moore explained that the experience of losing her beloved husband prompted her to stop making quilts for a while, precisely because her quilting had been so closely tied to his enthusiasm, encouragement, and joy for her work. Describing her painful predicament, she stated: "I can't get into quilting as much as I did when he was living because

every time I'd make something I'd say [to him], 'See this? Look what I made and I finished that.'"[7]

Maude Southwell Wahlman's classic work *Signs and Symbols: African Images in African American Quilts* also casts some light on the topic of quilts and loss, providing insight into how closely crafted and lovingly made objects can serve mourning and remembrance. Among the textile artists featured by the art historian are two sisters, Rose Perry Davis and Atlento Perry Warner, of Orlando, Florida. The adult sisters share how they decided, after the death of their mother, to make quilts and other sewn creations from the worn and well-remembered clothes left in her closet. When finished with their work, the artists—whose mother had taught them both to sew—generously presented these intimate memorials to members of their family. One especially cherished offering was the quilt the surviving sisters and loving daughters gave to their newly widowed father. Reflecting on the distinct utility of their precious gift, Rose Perry Davis recounted: "I think that the beautiful thing is that even though Momma is no longer with him, every winter he can sleep under something that she wore during their marriage."[8]

Pearlie Jackson Posey, another quilt maker profiled in *Signs and Symbols*, also highlights links between quilts, mourning, and remembrance. The quilt maker, whose farming mother died when she was a child, shared a story she carried close: how her dying mother had spent her last living days piecing quilt tops for her—her infant daughter—to remember her by. Pearlie Jackson Posey also shared how she had sustained, and passed on, her mother's loving intention and desire to have her handmade quilt tops assist in sustaining memory, supporting remembrance, and serving as sanctuary. For later, when Pearlie had children of her own, she made quilts for them with a similar sentiment—to hold her love and provide shelter—explaining to them: "Then if the Lord take me and I leave you . . . you'll have some covers."[9]

Roland Freeman's epic volume *A Communion of the Spirits: African-American Quilters, Preservers, and Their Stories* is laden with internal

and external evidence of links between quilts and loss. In it the photographer, folklorist, quilter, and quilt collector—and 2007 National Endowment for the Arts (NEA) National Heritage fellow, the nation's highest honor in folk and traditional arts—interweaves pieces of his own life story, and the centrality of quilts to it, within his extensive survey (and related traveling exhibition) of African American quilt makers living in the United States. Between his own testimony and the testimonies of the artists he interviewed as part of his decades-long fieldwork, Freeman's book includes many examples of how quilts are drawn on as resources for living, dying, and healing. Makers, users, and keepers of quilts share stories—both singular and collective—of quilts wrapped around and buried with the dead, of quilts (or pieces of them) placed in and on caskets, at gravesites, and in one case at a former murder site to cultivate healing.

Freeman's study, particularly his own life sharing, reveals ways in which quilts may be of use not only in serving and honoring the dead and comforting the grieving but also in healing the sick. Quilt-minded from birth, Freeman shares how, from his earliest childhood memories, he sensed that some very special quilts carried a powerful spiritual presence that could, when properly accessed, provide a means of connection with those no longer physically present and the world beyond. He sensed that quilts could serve as material crossroads, as potent sites where the human meets the divine. He was also aware that some quilts, like his own family's healing quilt, could support health and well-being. Freeman's insights were further strengthened when he was struggling with a life-threatening illness and he experienced—through a dream and a quilt—direct communion with a beloved deceased grandmother. This was a warm and welcome visit he credits with protecting him and supporting his own healing and recovery. Of this powerful "communion of the spirits," he writes:

> One night, in a dream, my grandmother Goldie appeared, putting a quilt over me and saying, "You'll be all right now." But it wasn't the family healing quilt. It was Betty Tolbert's red, black and white strip

quilt. In the middle of the night I got Mrs. Tolbert's quilt out of storage and slept under it. Little by little I began to feel better. My meditation room became my sanctuary: I would light all the candles on the altar and begin to look inward, past the pain, past the mental anguish, going deeper and deeper into the inner sanctum of my soul to find my inner light, to find the necessary strength to live.[10]

Carolyn Mazloomi's wonderful exhibition and accompanying catalog *Quilting African American Women's History* also offers insight into some of the things people in mourning might need and feel moved to do.[11] Founder of the Women of Color Quilters Network, Carolyn Mazloomi, a curator, scholar, and artist—and 2014 NEA National Heritage fellow—has brought into being numerous notable forums for showcasing contemporary quilts created by artists of African descent, including quilts linked to loss. One remarkable example is Marjorie Diggs Freeman's 2005 quilt titled *Momma's Eulogy*, which movingly recounts the passing of the quilt maker's mother. With earth-colored fabric at its base and bright blues at its top—and with ground and sky linked by a ladder made of cloth—this vertically oriented quilt portrays an ascension to heaven. Incorporating both ribbon and lace, the top of this mixed media quilt shows stars, angels, a united family, and a swath of sheet music stitched into its fibers. Echoing Missouri Pettway's quilt made in mourning and the memory of its making, Freeman's work is an offering of both textile and testimony. Accompanying the magnificent quilt are the words of its maker recounting the experience of her mother's transition from life on earth. Sitting bedside, holding her dying mother's hands while singing her favorite hymns, the adult daughter was fully present for her mother's final breaths, guiding her way home. Recounting her mother's passage and her own bearing witness, the surviving daughter and quilt maker described their last living exchange with eloquence and love: "We looked deeply into each other's eyes as the storm passed; as she passed over into heaven to join the celebration of her anticipated arrival."[12]

Rest and Respite

Wholehearted desires for release, relief, and remembrance encircle the powerful and continual connections between quilts and loss. Piecing together a quilt top may support intimate engagement with one's interior world by offering a stilled site for reflection and expression. For skilled quilt makers with experienced hands, stitching and pulling a threaded needle through yielding cloth may provide time and space to be with the fullness and depths of oneself. Sharing how her seated handiwork directly enabled her mind's work, Nettie Young explained: "I take time to think things over. I can work out a problem. While my fingers are working, so is my mind—working it out."[13] Importantly, too, the seated act of sewing also invites other parts of the body—from the crown of the head to the crook of the foot—to experience rest, an experience that was eternally elusive for the struggling farming families in Gee's Bend. Working the farms and fields and caring for the needs of households full of family was endlessly exhausting, and when Missouri Pettway pieced together her quilt top, the work of piecing—and the work of household sewing in general—was typically done by mothers when the demands of more strenuous chores and of caring for children were fewer. Given the complexities of labor and life, needlework may have offered, or at least coincided with, a rare opportunity to sit. After all the day's physical and emotional effort, it might now be possible to seek and find a little rest. Here perhaps was an opening to journey inward and process life's experiences and emotions at one's own inner pace. Here lay a way, in a sense, to come indoors and go inside. This respite from the more rigorous physical demands of other farm and household chores, by way of a familiar activity that combined effort and ease, may have been especially useful in processing and moving through grief.

In *On Grief and Grieving* Elisabeth Kübler-Ross, author of the classic text *On Death and Dying*, and David Kessler, a leader in the field of hospice and palliative care, describe grief both as a journey, or passage, and a process. Within their book—one that is part study and

part guide—the coauthors describe grief as "an emotional, spiritual, and psychological journey to healing" and also as "the healing process that ultimately brings us comfort in our pain." Central to their understanding of grief as a healing process and a necessary journey is the importance they place on a bereaved individual's successful search for much needed rest after "the emotional upheaval that accompanies a loss." And for those reading their words and seeking this essential respite, Kübler-Ross and Kessler encouragingly counsel: "Find what brings you some solace and lean toward it."[14]

Based on their findings and practices and informing their care, the authors of *On Grief and Grieving* confidently praise the psyche's self-protective capacity "to pace our feelings of grief" so the bereaved is not continually overwhelmed by the reality of suffering and the enormity of loss.[15] Explaining how a mind in mourning beneficially alternates between a focus on the pain and distraction from it, they write: "We can touch the pain directly for only so long until we have to back away. We think about our work, get momentarily distracted in something else, process the feelings, and go for more. If we did not go back and forth emotionally, we could never have the strength to find peace in our loss."[16]

Given their insights and recommendations regarding the needs of the grieving, Missouri Pettway's pronounced determination to create a quilt while newly facing the loss of her husband can be understood as an intentional decision to "lean toward" an activity that might offer some emotional rest and enable a semblance of solace during an exceptionally vulnerable time. Put another way, her decision can be seen as a wise act of inner instruction—drawing deeply on a sustaining resource, a steadying practice, and a source of comfort embedded within her community—to tend her grief. Following further, Missouri's stitching together of the strips and blocks that comprised her quilt may have also enabled the rhythmic cadence that Kübler-Ross and Kessler see as so beneficial for "a mind in mourning"—the supportive, steadying, and strengthening sequence enabling a bereaved individual to alternately process and pause the pain of loss. Balancing

effort and ease, the act of stitching and pulling a needle through cloth might well lend itself to this pace of grace by alternately keeping the mind busy and allowing it to dwell. In providing space for intimate engagement with one's shaken interior world interwoven with respite from it, piecing together a quilt top may well support this healing rhythm—and the essential inner work of mourning—by pairing the processing of emotion with the wisdom of when to rest.

Offering further insight on the creation of quilts as a helpful haven for healing, art historian Janet Catherine Berlo, in *Quilting Lessons*, her brave and generous book about suffering with depression—partially prompted, she explains, by a sense of loss—shares how quilt making was central to her regaining a sense of equanimity and well-being. Overcome suddenly one summer with a permeating sense of sadness and a loss of meaning and purpose, the renowned historian of Native American art with a deep interest and expertise in textiles found herself with an "unexplained craving" to largely transform her home writing study into a quilting studio and to surround herself with stacks of fabric sorted by color.[17] Day after day for about eighteen months, instead of her typical routine of reading and writing in her third-floor study, the art historian was drawn to an inner world where, as she explains, the noise is visual and "the only language is color and pattern." Over the course of long twelve- to fourteen-hour days, she felt compelled to cut and piece together brilliantly colored cloth and make bold improvisational quilts. Putting aside precision and paper patterns, her intuitive designs for these quilts, which she calls her "Serendipity Quilts," emerged from her own shaken interior landscape. Describing the fragile emotional state that drove her impassioned work with dazzling fabric, she explained: "When I wasn't quilting, I wasn't alive. On most days, I felt that I literally needed those vibrant hues in order to breathe. . . . My body craved the colors and the kinetic act of cutting and piecing, cutting and piecing."[18]

Carefully reminding her readers that for most quilters throughout US history, quilts have been a creative response to dire necessity—to help people retain heat and stay physically warm—the scholar shares

how she found herself in a somewhat different set of circumstances. For her, making quilts was an impractical activity as she had easy access to store-bought blankets and comforters. But as she makes plain, the act and art of quilt making had precious utility for her emotional health by providing sanctuary—"shelter and warmth"—for her psyche.[19] Conveying what she was experiencing during her struggle with depression, Berlo shares: "I was piecing for cover. I was quilting to save my life." Describing further what handling cloth and stitching it together meant to her while suffering with profound sadness, the art historian and quilter writes:

> To an old-time quilt maker, the notion of "piecing for cover" implies making something serviceable for everyday use, as distinct from a wedding quilt or the one put out for a special houseguest. But to me, "piecing for cover" describes what I did during the eighteen months of my depression. I see a vivid image of myself sheltered under a big quilt or surrounded by swaths of fabric, hiding within their protective coloration. I hear "piecing for cover" as a phrase akin to "run for cover" or "take cover." It evokes quilt making as an activity that protected and camouflaged me during a time that, in retrospect, can only be described as a breakdown of all "normal" systems.[20]

Berlo, from her post–emotional health crisis vantage point, reflects that at some level her "psyche knew what it needed" in seeking out this art form and creative practice that so actively engages and involves multiple means of perception and can serve as a refuge or haven. Based on her own intimate awareness and knowledge, she proposes that the making of quilts continues to remain essential because the practice can offer "an oasis of grace" and a needed "space in women's lives." Concerning this capacity of quilting to provide an interval of needed rest or relief, she writes: "We come to quilt making looking for a respite from one set of challenges by embracing a very different set—involving color, pattern, sensuality, skill, and order, in an ever-changing mixture."[21] The author's remembrances and revelations hold a light on how quilt making supported her needs and provided a

path for her healing; her lived experience also reminds us that quilting, like sanctuary or living room, is both practice and place.

Making and Making Do

Missouri Pettway, in making her quilt, made use of what was available to her and other local quilt makers at the time—old worn clothes. Born of necessity, both making and making do had long been integral to life in Gee's Bend. They were essential skills central to the farming community's persistence, resilience, and survival. Giving clear voice to this reality of scarcity and creative necessity, quilt maker Nettie Young, a contemporary of Arlonzia Pettway, remembered: "When I was growing up, you didn't have nothing to throw away, you used everything."[22] Sharing a similar recollection regarding the centrality of making and making do to the precarious livelihood of her family and

Nettie Young sitting in her yard, 2003. Photograph by Linda Day Clark.

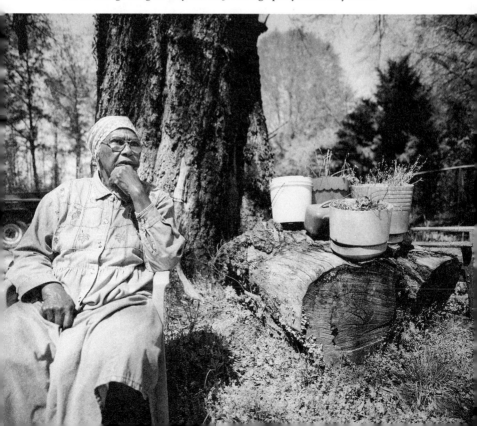

community, resident quilt maker Loretta Pettway—who along with her Gee's Bend neighbors Mary Lee Bendolph and Lucy Mingo was honored as a 2015 NEA National Heritage fellow—recalled, "What little we had, we took it and made it."[23]

Old worn clothing was the primary source of quilt material within the rural Black Belt community until the latter half of the twentieth century. Used cotton sacking, which originally contained flour, fertilizer, feed, or seed was also put to good use in the making of area quilts. And securing both materials—old clothing and used sacking—required effort and chance when Missouri Pettway pieced together her quilt. Recalling the absence of quilting materials during her 1920s childhood and how creativity and reuse were thoroughly intertwined in and around Gee's Bend, Nettie Young explained: "Any kind of piece you found, you picked it up and washed it." Elaborating further, the quilt maker and farmer recalled: "When they started putting flour in sacks, and fertilizer, we took those sacks and made clothes. That was a big help."[24] Given this context of material scarcity and poverty and the close ties between sewing and survival, Missouri's use of Nathaniel's former clothing—and remember Arlonzia's recollection that her mother had used "all the clothes he had, just enough to make that quilt"—was not uncommon. Missouri's use of what was available to her to create her "work clothes" quilt aligned with both an established precedent and a necessary practice.

Yet it is also quite possible that in piecing together the strips and blocks of her recently departed husband's worn shirts and pants, the quilt maker sought to directly imbue her quilt with the power of his life force or spirit. Beliefs that previously touched or held objects—especially objects that have been intimate with the body—can hold, carry, or radiate a heightened spiritual presence are widespread among us, including among some residents of Gee's Bend. Sharing her own preference for worn clothing precisely for its palpable potent presence, Mary Lee Bendolph explains: "Old clothes carry something with them. You can feel the presence of the person who used to wear them. It has a spirit in them. Even if I don't even know the person, I know

someone wore those pants, and it feels lovely and warm to me."[25] Quilter and neighbor Lucy Mingo shared a similar sentiment about worn cloth possessing a cherished imprint of the person associated with it, explaining: "I don't like new material. I always work with old material, because old material has a lot of love."[26] Missouri Pettway may have held a related belief regarding this warm sense of spirit carried within worn clothes. If so, then in choosing to make a quilt out of material that had recently covered Nathaniel Pettway's body like a second skin, she may have been seeking not only to remember her loved one's earthly presence but also to cultivate, invite, or enable a means of connection—or "a communion of the spirits," to borrow Roland Freeman's wise words—by way of his spirit carried within the cloth, making use of this fabric, both scarce and sacred, for a precious purpose.[27]

Cycles of Sorrow

Arlonzia Pettway bore close witness to her mother's act of creation in the face of suffering and loss and carried forward its wisdom. She observed how her mother made her pieced cotton covering, and she witnessed why. And in this way, her mother's quilt done by design became a model in her mind. Arlonzia had long lived with her mother's quilts before her father's passing. She had likely slept and dreamed, rested and reflected, and healed under—or wrapped within—her mother's handcrafted covers. At age seventeen or eighteen, Arlonzia had also long witnessed her mother's practice of making quilts. As a young girl, she had served as an apprentice, helping her mother with quilting tasks such as gathering and readying fabric and threading needles. By age nine, she was so adept with needle and thread that her mother had been convinced that two dresses her daughter had made by hand were actually "bought made." As she keenly recalled, her proud mother had "showed those dresses off to everybody."[28] By thirteen this first daughter of Nathaniel and Missouri Pettway had completed her first "Nine Patch quilt," the traditional American

patchwork design composed of three rows of three squares that new quilters often begin with.

By the age of eighteen, Arlonzia Pettway was a recognized quilt making member of the rich quilt culture of her Gee's Bend community. Late in life, this creator of quilts and holder of history shared with deep pride that she was an inheritor of an enduring lineage of resourceful and resilient creativity. "It was just born in me to make things," she proudly asserted while in her eighties. Supporting this claim, Arlonzia shared the early stages of her learning how to make quilts, a process set in motion by actively observing and assisting her mother:

> I can remember her piecing up quilts out of old pants legs, and shirt sleeves, and any old thing she could find. Times was hard back then when I was real small. I remember her tearing up a old overcoat to make a quilt out. When I was a little girl, too little to sew, I used to thread needles for her. She couldn't see too good and she say, "Tear the shirt sleeves and tails and pants legs," and I would pick out all the blue pieces and stack them together, and pick out the tan pieces and stack them together, and the dark pieces. I get all the colors arranged for her in stacks so she could just reach for what she wanted in a chair in front of her. She would start about nine in the morning making the quilt, and by four in the evening she was through piecing it."[29]

Arlonzia Pettway learned how and why and with what to quilt from her mother. While seated around a quilting frame at the turn of the twenty-first century, she looked back at this mother-daughter apprenticeship of the 1920s and 1930s, as well as the context for and continuing legacy of this training, and she explained: "What happened in those days, we didn't have anything to look forward for. When we got nine or ten years old, she gave us a needle and a thimble and told us to quilt. And that's why we quilted so much because that's what she gave us. And that's what we done, we use what our mother gave us—she gave us a thimble and a needle—and that's what we're using, and that's what we're still using now."[30]

A passing down from mother to daughter in the sustaining practice of quilt making within the process of grieving is present within Arlonzia Pettway's own life story. At twenty Arlonzia married Bizzell Pettway, a farmer raised in Gee's Bend who was also the son of an experienced quilt maker. The couple had twelve children, four girls and eight boys. To keep their large farming family feeling warm and protected, Arlonzia—like her quilt maker mother Missouri; her quilt maker mother-in-law, Jennie Pettway; and their quilting predecessors and peers—made many quilts over the next couple decades. Bizzell and Arlonzia Pettway were living out their lives in Gee's Bend (with him also doing seasonal farmwork in New York), with the continual demands and struggles of farming, parenting, and household chores, when one horrific day in May 1969, Bizzell suffered a fatal heart attack.[31]

On that unbearable, impossible day—nearly three decades after helping her mother with the preparatory work of her quilt made in mourning after Missouri's husband (and Arlonzia's father) had died at midlife—Arlonzia, at age forty-six, found herself similarly situated, suffering the early and tragic loss of her husband while being responsible for a household full of family. Echoing her mother's decision nearly three decades earlier, Arlonzia made a similar decision to piece together a quilt out of her husband's work clothes soon after he passed on. For this quilt, Arlonzia included blocks and strips of one of Bizzell's checkered shirts and a pair of his blue jeans within her pieced quilt top.[32] Her textile elegy—this covering giving form to her grief and shape to her sorrow—echoed the quilt she had assisted her mother with at the age of seventeen or eighteen. The daughter's quilt made in mourning was reminiscent of her mother's quilt in the anguished impetus prompting its conception, the choice of materials, and likely in the intimate yearning underlying its desired use.

˙ Like her mother before her, Arlonzia made a deliberate decision to piece together a "work clothes," or "utilitarian," quilt to tend her grief, knowing the task might be of comfort and of help with the healing during this excruciating time. Across two generations, the practice

of quilt making seems to have supported the process of grieving for the recently widowed women at midlife—women who were also mothers, neighbors, and kin, among other vital social roles, within the farming community of Gee's Bend—by offering time and space for the bereaved quilt makers to experience and express this profound emotion of distress associated with loss. Drawing from quilting skills learned as a young girl and her experience helping her mother with her quilt made in mourning, Arlonzia Pettway carried forward her mother's teaching and lived example and created a closely crafted and lovingly made utilitarian quilt designed to comfort its creator's outer body and provide solace for her inner world. After suffering another impossible loss, she summoned this sustaining practice, drawing on what belonged to her, what was hers to have, and what was needed and necessary, to tend to her grief—calling forward and drawing strength from a living lifeway and repeating its healing pattern.

CHAPTER FOUR

✕

Lined with Labor

Lining Her Quilt

Quilts, though often composed of three layers of material, are sometimes made of two. As Missouri Pettway's quilt lies iron flat when unfolded, it looks like hers consists of two layers: a pieced cotton quilt top and a plain cotton, sacking-like backing. Some kindred quilts of a similar time and place are lined with an additional layer of local cotton for batting. Although it does not appear Missouri's quilt made in mourning is padded in this way, her quilt made of cotton is thickly lined with the long hard labor history of her homeplace, this former cotton plantation community initially wrought by slavery and the domestic slave trade. Given this weighted state, I'd like to dwell here on some of the histories and struggles that lie within the quilt maker's cotton covering as well as her African American farming community with this historically life-claiming fiber, this catastrophic cash crop, never too far from view.

At the time when Missouri Pettway created her quilt, batting was typically cotton—the all-powerful entity that had fueled the institution of slavery within Alabama's Black Belt and the very commodity that had defined labor in Gee's Bend for over a century. Local

testimony suggests that well throughout the first half of the twentieth century, quilt makers used the cotton crop in a variety of its available forms to serve as the inner layer of their lined quilts. Some quilt makers, for example, used leftover field cotton to pad their quilts. Mary Lee Bendolph remembered her own farming family's use of this raw, unprocessed cotton for batting. "We was farming, so we had cotton in the barn. So we would have to go out and grab some cotton out of the barn," she recounted.[1] She also remembered how the field cotton was then cleaned, spread on top of the quilt's backing (or lining), beaten flat with a stick, and readied for the sewing, or quilting, of the three layers together: pieced top, padded cotton, and backing. Describing this physically active work, she explained: "When you go to quilt, you beat the cotton out on the floor, first thing, to get the dust out. Then sweep the floor—collect the cotton—spread the lining out and put the cotton back on the lining, beat it out, put the top on there, get your thread and needles and hook it in the quilting frame."[2]

Other local testimonies provide accounts of ginned, or lint, cotton—the product after the seeds have been separated from the fiber—serving as the quilt's middle layer. Born in 1939 to a quilt making mother, Bettie Bendolph Seltzer remembered this approach as well as the gendered division of labor underlying it. "Their husband or friend or neighbor bring cotton from the gin for the ladies to quilt with," she recounted.[3] A related recollection also provided by a proud descendant of an early-twentieth-century creator involved both raw and processed cotton as well as a helpful husband who would bring the fiber back home from the cotton gin for his quilt making wife: "Mama was a very hard working woman. At the end of the cotton-picking season, she would go to the field and 'scrap' cotton to make bed items (mattresses, pillows and quilts) with. Papa would take it to the cotton gin and bring back 'lint' cotton. She would hang those quilting frames from the ceiling and sew quilts throughout the winter months."[4] Originally sown from the soil of slavery, the cotton crop, as these memories attest, remained part and parcel of the land

for much of the twentieth century; the crop in its various forms was made use of for making and making do.

"We Lived the Hard Life"

Hunger and poverty were persistently present within this largely sharecropping and tenant farming community during the first decades of the twentieth century. By all accounts, it was a continual struggle to survive, made even more challenging while being responsible for a hungry household full of family. Surviving and raising a family in Gee's Bend and beyond under the dominant share-tenant system of labor—as well as racial and social control—required raising food to eat and crops to sell. As tenant farmers in Alabama's Black Belt, Nathaniel and Missouri Pettway likely borrowed money early each spring from an advancing agent, or furnishing merchant, for living and farming necessities—essentials that included food, feed, seed, and other needs that could not be produced or secured by other means. The fierce hope was to close the growing season with the best-case scenario: that the high quality and large quantity of their cash crops—especially the mighty commodity of cotton and its seed—would benefit from strong market prices and the integrity of power holders, and the couple would profit from their long year of hard labor. But as Black farmers caught within the controlling system of tenancy at a time when disenfranchisement of, and discrimination against, African Americans in the Deep South was thoroughly condoned by custom and codified by law—and fiercely backed by white supremacist violence and its threat—this hope was largely unattainable. Instead, Missouri and Nathaniel Pettway, like their forebears and neighbors, rented and farmed land with the exceedingly difficult and often unsurmountable goal of securing a fair and sustainable return on the cash crops grown by way of their enormous labors.

More stable at times than the return on their cash crops was the harvesting of their food crops. Farmers in Gee's Bend grew a range

of crops for food while also raising livestock. During the 1930s and 1940s, farming families like Nathaniel and Missouri Pettway's cultivated crops such as corn, beans, peas, peanuts, sorghum, sugarcane, sweet potatoes, and tomatoes as well as cotton. Each year resident farmers readied the land for a new growing season by clearing fields, cutting trees, chopping bushes, burning brush, knocking corn and cotton stalks, and plowing with, or without, oxen and mules. Over the course of spring, summer, and fall, they cared for crops: planting, hoeing, and harvesting. Harvested crops were hauled off the farms and fields for weighing, processing, transport, and sale throughout the summer and fall. And after a short winter, the whole cycle began anew.

Never far from fields and farms, most residents of Gee's Bend during the early twentieth century spent most of their days working acres owned by others and doing farm and household chores to sustain themselves and their families. Recalling the long, poorly paid days she spent working in the fields while still a child, quilt maker and former sharecropper Nettie Young, who was born in 1917 in Rehoboth, a few miles up the road from the heart of Gee's Bend, explained with pain: "We was used to being poor. Do you know—when I was a girl, I used to work from sunup 'til it lay down for twenty-five cents a day."[5]

To supplement their exceedingly limited cash income, some resident women also sold eggs and produce in the county seat of Camden, while some men—pursuing the southward tug of the Alabama River—headed to the Gulf shore and worked the docks in Mobile for shipyard pay during the winter.[6] There is also evidence that quilts were sold by women in Gee's Bend as early as the 1940s. Poet Sterling Brown noted this practice. After being introduced to two local women quilting on a porch by his Tuskegee-trained host and guide, the Howard University English professor and his travel partner each purchased one of their sewn creations—each of them choosing from a larger selection of quilts, which the poet described "as brilliantly colored as the patches of flowers in their yard"—for the offered price of six dollars apiece.[7]

As the remotely located and chronically underserved community

of Gee's Bend received neither electricity nor water service (or a paved road) until the 1960s and 1970s, work based in and around the home, like work based in the fields, was also never ending and endlessly demanding. Loretta Pettway, a cousin to Arlonzia Pettway, expressed the exhausting reality of daily life with a full house and no water source nearby. Describing herself as a woman who "never had a child life," this mother of seven, born in 1942, remembered and named her living conditions clearly and with clear distress: "It was rough. What little we had, we took it and made it back in the day. I come up on some of it, the rough times. We had to pump water, and I had to tote it. I didn't have a pump. I raised up all my children toting water: to cook with, to wash with, to take a bath in."[8]

Drawing and toting well water; chopping and carrying wood; cooking, cleaning, and washing; caring for farm animals (raising chickens, milking cows, feeding hogs, minding mules, tending goats); growing gardens and canning fruits and vegetables; and securing additional food (fishing, trapping, and hunting squirrels, possums, and rabbits) were some of the household chores Missouri Pettway and other farming women, men, and children woke up early to each day. Capturing with clarity the continually consuming day-to-day, season-to-season, year-to-year, generation-to-generation struggles of farm families within and beyond Gee's Bend, Nettie Young bore witness and testified to what she knew to be true: "We lived the hard life."[9]

Labor Histories

Many of the lifelong residents of Gee's Bend today are landowning descendants of kin who worked on the Mark Pettway family cotton plantation, the area's most extensive plantation before the Civil War. Many longtime residents are relatives of individuals who worked first as enslaved laborers and later as sharecroppers and tenant farmers, or "renters." Concerning this shift—or its lack—in labor relations that occurred with the end of the Civil War and the 1865 passage of

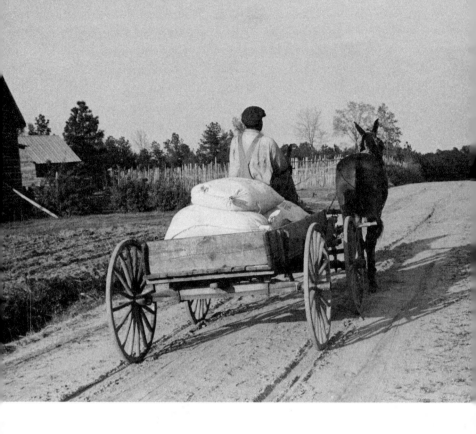

the Thirteenth Amendment to the Constitution barring slavery, and which lasted at least until President Franklin D. Roosevelt's New Deal programs arrived in Gee's Bend in the 1930s, one journalist gallantly, and all too glibly, wrote: "Benders went from slaves to sharecroppers, and barely noticed a difference."[10] Working with a somewhat different lens on rural southern labor history—seeing a broad span of the nineteenth century in Gee's Bend as well as the first decades of the twentieth from the perspective of the physical presence and absence of white landowners—a Birmingham-based correspondent for the *New York Times* noted in the 1930s: "The white masters became white landlords and then disappeared altogether."[11] Other individuals, both residents and nonresidents, have understood and expressed aspects of this labor history with more complexity and insight.

When Nathaniel Pettway died at midlife at the age of forty-three,

left A community mill for grinding grains was established as part of the New Deal programs in Gee's Bend. Plain cotton sacking that held flour or feed can be found in some of the era's quilts. Marion Post Wolcott, *Bringing Home Meal from Cooperative Grist Mill, Gee's Bend, Alabama*, 1939. Library of Congress, Prints & Photographs Division, FSA/OWI Collection, reproduction number LC-DIG-fsa-8a40008.

below Photographer Marion Post Wolcott noted Martha Mosely's extensive skill set in 1939, writing: "She manages and runs her own farm and made three bales of cotton last year." Marion Post Wolcott, *Martha Mosely Coming from the Store. Gee's Bend, Alabama*, 1939. Library of Congress, Prints & Photographs Division, FSA/OWI Collection, reproduction number LC-DIG-fsa-8a40089.

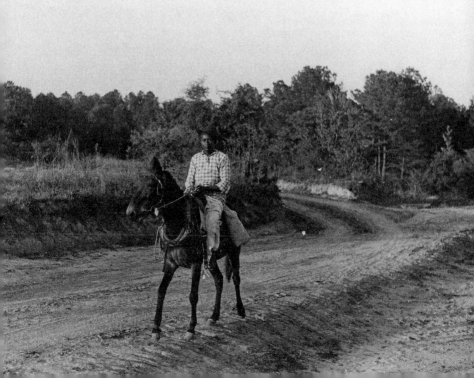

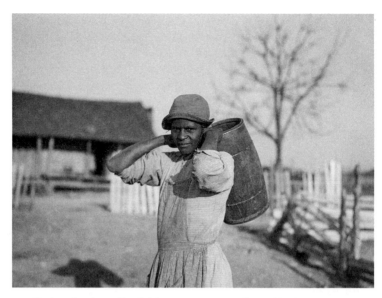

Quilt maker Annie Bendolph carrying water in front of her house in 1937.
Arthur Rothstein, *Carrying Water. Gee's Bend, Alabama*, 1937. Library of Congress,
Prints & Photographs Division, FSA/OWI Collection, reproduction
number LC-DIG-fsa-8b35937.

the Fisk University sociology professor Charles S. Johnson and his
colleagues were working to draw attention to the persistence and
impact of unjust and exploitative systems of labor in the South since
slavery. In his *Statistical Atlas of Southern Counties* (1941), the tireless
African American sociologist meticulously documented measurable
connections between crop systems and socioeconomic conditions to
make plain the truth that "counties which raise cotton are dominated
by it socially as well as economically." Writing of Wilcox County as
well as other Black Belt counties defined by the cash crop of cot-
ton and the system of sharecropping and tenant farming, Johnson
explained how the "share-tenant system" of labor was, in effect, an
adaptive modification of plantation slavery:

Traditionally, cotton and the plantation system have gone hand in
hand. In the wake of reconstruction the plantation system of chattel

slavery was replaced by the share-tenant system. The share-tenant system, however, is the plantation system, modified in its legal form but retaining most of its vital features. The statistical characteristics of the cotton counties reflect the continued existence of the plantation system: a large, untrained, Negro laboring force, few industrial or non-farm occupations, low per capita incomes, a great gulf between the white-owning and white tenant population and between the white and Negro population, and rigid enforcement of racial restrictions.[12]

Sharecropping and tenant farming were, as the Fisk University sociologist showed in his interwar study, slavery by another name. Lived experience and human memory make present this reality time and time again, testifying to its truth.

Noted Black Belt midwife Onnie Lee Logan was born around 1910 on a farm in Marengo County (just northwest of Wilcox County). In becoming a midwife, she followed the path of her mother and

Nellie Pettway carrying wood for her fireplace in 1937. Marion Post Wolcott, *Aunt Nellie Pettway, Carrying Wood from Yard for Fireplace. Gee's Bend, Alabama,* 1939. Library of Congress, Prints & Photographs Division, FSA/OWI Collection, reproduction number LC-DIG-fsa-8a40070.

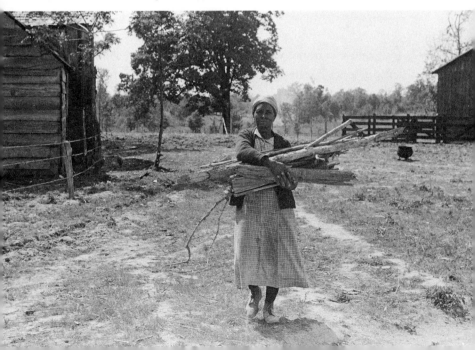

her grandmother, who, as she explained in her oral autobiography, had survived "slavery days" on a plantation and had "lived on after the war."[13] Logan's recorded testimony provides critical perspective on this long era, especially its deep violence. Carrying forward what she had learned about post-Reconstruction race relations from her parents—members of the first generation to be born after the Civil War on the Black Belt farms of neighboring Marengo County—she recalled that during this era of legal and extralegal Jim Crow terror and injustice, practices of slavery persisted. Or put another way, the present resembled the past. "This wasn't durin slavery but they still treated em the slave way," she explained in her autobiography."[14] Like Arlonzia Pettway, Onnie Lee Logan lived closely with the memories of her enslaved ancestors, as she had absorbed their life stories both directly and through their descendants. And like her Black neighbors in surrounding Black Belt farming counties, she had also inhabited and experienced firsthand a society shaped by slavery and its continuing tolls. In very real ways, as another peer midwife explained, the "dark days" of slavery were experienced as "just moments away."[15] Slavery was both past and all too present, and a strong and strongly felt knowing concerning the oppressive regime lived on. Revealing how and why she could so readily recall a world that had supposedly existed two generations before her birth, Onnie Lee Logan explained: "During slavery they was pushed to do what they did. They didn't ask em to do it nicely. You know what I'm talking about. I can just picture that. I've heard so much of it. I can just picture—I can see it right now."[16]

Quilt maker Loretta Pettway, a lifelong Gee's Bend resident, explained the state of labor relations—and its ties to slavery—from the clear vantage point of her own lived experience, her own lived truth. Looking back on her own mid-twentieth-century life in and around the farms and fields of Gee's Bend—over eight decades after African Americans had sought to claim their freedom with the Civil War—Loretta Pettway gave voice to the continuing everyday reality of economic inequality and exploitation, stating with potent clarity

and force: "We worked for the white people, and made them rich and left us poor. . . . We worked hard; we worked like slaves."[17]

Quilt maker Nettie Young also stood witness to the long history of slavery, including its afterlives and legacies. In an interview with Johnnetta Cole in 2008, she stated with force when freedom was first felt by Black farmers in the Black Belt, insisting it was not felt until a century after the Civil War. It was the civil rights movement, she attested, that first enabled a sense of freedom by opening options beyond the life-claiming cotton fields and the systems of racial and social control maintaining them. A heroic labor and civil rights activist—one who emphatically combined marching and prayer—Nettie Young offered this truth when Johnnetta Cole, the former college president of both Spelman and Bennett (the two HBCUs dedicated to the education of women) asked the ninety-one-year-old former sharecropper if her mother had been enslaved or free, and Young replied: "She wasn't free, wasn't none of us free. All of us were slaves. I was a slave. You know when us got free? When the Civil Rights come through. That was us freedom. We got free then."[18]

New Deal

It was not until the late 1930s and early 1940s—as part of FDR's New Deal programs—that a sizable number of Gee's Bend households (about one hundred) were able to purchase their local land and build modern homes on it.[19] Deemed "fields of promise" by the seller (the federal government), some of these plots of farmland had formerly been part of the Mark Pettway family cotton plantation—the land some of their families had worked since the time of slavery. With the aid of low-interest, long-term mortgages, New Deal program participants were able to purchase, and participate in the construction of, their own so-called Roosevelt houses. Known also as "project houses," these were modest, multiroom frame homes with strong roofs, paned windows, screened doors, porches, indoor cast-iron cooking stoves, outdoor toilets, and fenced-in gardens. Although there was

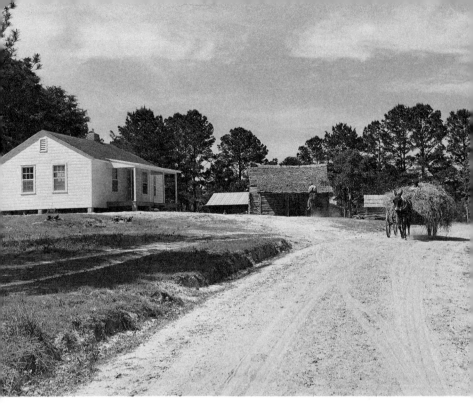

A resident's old home next to his new "Roosevelt house." Marion Post Wolcott, *New and Old Home of Clay Pettway. Gee's Bend, Alabama*, 1939. Library of Congress, Prints & Photographs Division, FSA/OWI Collection, reproduction number LC-USF34-051546-D.

no electricity or running water, there was a well with a hand pump in the yards of these new homes.

As new homeowners, these farming families continued to work the land. But now they farmed as small independent landowners, working parcels of the same former cotton plantation land some of their relatives had been forced to labor on. "You'll be farmin' for the government, you know, for Mr. Roosevelt," is how one New Deal relief administrator explained this shift in labor-management relations to a resident tenant farmer.[20] Writing eloquently on the community of Gee's Bend for the *Los Angeles Times* over sixty years after this profound shift, journalist J. R. Moehringer expressed how President Roosevelt's signatory support of this New Deal program—which

purchased land from white landowners and redistributed it through sales to resident Black farmers—had proved pivotal for some local families: "At last, with the stroke of a pen, the owned of Gee's Bend became its owners. A giant plantation with a sordid past became a quilt of small farms, a patchwork of independent families. Those were days of hope and glory, when competition from mechanized farms was beyond imagining."[21]

Nathaniel and Missouri Pettway and their family were likely just beginning to experience these considerable changes in housing and landownership when Nathaniel fell ill and passed on in December 1941. Their firstborn daughter, however, benefited directly from these historic changes. The following year, in 1942, Arlonzia married Bizzell Pettway, and the couple moved into one of the newly constructed Roosevelt houses.[22] This house they owned, and the home they made of it, served as a long-term anchor for the community historian and quilt maker. Despite the steady flow of out-migration from Wilcox County (which has continued for around a century now), Arlonzia Pettway stayed to live her life in Gee's Bend, remaining in her New Deal home. Although she took numerous trips well beyond the Black Belt, she defined herself as a lifelong resident of this place, explaining to an interviewer around 2005: "The first day of May I be living here eighty-two years. Since I was born—never went no place but here."[23]

Working Rhythms

As Arlonzia Pettway remembered at the turn of the twenty-first century, the rhythms of her mother's early-twentieth-century work routine had changed in relation to her marital status and life stage. According to Arlonzia's recollection, a couple years after marrying, and at her husband's insistence, Missouri stopped working in the fields to provide in other ways for the needs of her growing family. Concerning this shift in the focus of her mother's labors as well as its impact on her quilt making, the elderly daughter recalled: "She worked two years in the field after she was married, and then Daddy

Arlonzia Pettway on the porch of her updated "Roosevelt house."
Photograph by Linda Day Clark.

made her stay home and take care of children. That's when she started
piecing quilts all through the summer, and she would farm a garden
around the house, but she wouldn't go to the swamp and work those
fields." Arlonzia's account suggests her mother's creation of pieced
quilt tops at that time in her life—as a mother of young children in
the 1920s—was a seasonal activity, a task associated with summer, the
height of the cotton growing season. Her recollections also suggest
Missouri's piecing during this period was both purposeful and pro-
lific. Regarding her mother's hurried hands and rapid pace, Arlonzia
recalled: "She would start about nine in the morning making the quilt,
and by four in the evening she was through piecing it. She would not
start quilting until she had made about ten tops."[24]

Oral history suggests makers of quilts in and around Gee's Bend

possessed a range of responsive rhythms in creating their quilts. In sharing the stories of their early- and mid-twentieth-century lives, some quilt making residents recalled spending the overwhelming majority of their days working in the fields, seeing to farm and household chores, and tending to the people in their midst who most needed care. Given all this, these residents recalled only having time to work on quilts while utterly exhausted late at night. Voicing this reality, Loretta Pettway late in life remembered, as if it were yesterday, all the tasks that confronted her after a long day working in the fields: "When I come home I'd do my chores. I washed. I cleaned yard. I mopped. I cooked. I kept my kids cleaned. I fixed their clothes. I ironed their clothes and then I would go to quilting and I would quilt then until about two or three o'clock in the night. I would get tired, but I had to do it. I had to do it 'cause I had a family and I had to keep them warm because nobody would give me any quilts and I couldn't buy no blankets. . . . I made what I could make."[25]

Loretta Pettway's remembrances also reveal how for her, as a farming mother struggling to survive and make ends meet, quilt making was experienced as and yet another necessary task, albeit a seated one, she needed to perform to sustain her family. In another account, she continued to make clear the unrelenting labor that defined the seasons and determined her days: "I had to work farming cotton, corn, peas and potatoes, making syrup, putting up soup in jars. I was working other people's fields too. Saturdays I would hire out; sometimes I would hire out Sundays, too, to give my kids some food. When I finished my chores, I'd sit down and do like I'm doing now, get the clothes together and tear them and piece. And then in summer I would quilt outside under the big oak."[26]

While sharing her own memories of the rhythms of work in Gee's Bend at midcentury, Mary Lee Bendolph recalled how quilt making was woven within the cycle of the long cotton growing season. She remembered that "lay-by time," the window when weeding had largely been won (after the cotton crop was established around summer's official start and before the cotton bolls began opening later in the

season, signaling the start of extensive and intensive labor) was an opportune time for working on quilts. "In them days, they farm three months, then when the lay-by time come—'round the last of May, June—they go to piecing quilts. August, go back to the field. October and November, up into December—and then after Christmas and New Year over with—back to piecing and quilting," Mary Lee Bendolph recalled.[27] Farming women found time to quilt when the work of the cotton fields was less demanding. Quilt maker Joanna Pettway, born in 1924, remembered it similarly: "This time of the year the cotton opens up. We pick cotton and go to quilting. After you finish with the cotton, you go back to quilting. All the time, something to do all the time."[28]

Offering her own recollections on the matter, Lucy T. Pettway shared another way in which quilts were made. Born in 1921, the Gee's Bend resident remembered working on quilt tops while working in the fields, piecing as part of her noontime meal. When interviewed at the age of eighty-one, she recalled, "I always had taken me some quilt pieces in the fields when I was working there," explaining further, "When I knock off work at twelve to eat, I make me a block or so till I go back to the fields."[29] For her, piecing was woven within, and likely a respite from, the physical demands of her farmwork.

Fields and Farms

Arlonzia Pettway carried forward a powerful account of quilt making as a form of social support and creative collective resistance within the searing terror of slavery. Continuing the narration of a story her maternal great-grandmother had shared about her life "in slavery," she recounted how Dinah Miller, along with other enslaved individuals, had expressly defied those who claimed to own them by way of their quilt making. While hiding in brush near the cotton fields they had just been forced to farm, Arlonzia shared, the enslaved creators had determinedly engaged in the act and art of "making quilts in secret from torn-up old clothes." They were seeking, it seems, not only

rest and relief from axe and hoe with needle and thread but also an outlet for beauty and creative expression, making use, in this way, of the very fiber that fueled their enslavement to feel free. Concerning this cultivation of community, creativity, and resistance, Arlonzia recounted: "They was in slavery. They worked all day, then they'd go under the pile of brushes, and set the log down to sit on and make a quilt. The slave masters didn't allow them to piece a quilt. They didn't want them to do nothing, they didn't want them to learn how to write, they didn't want them to have no beautiful quilts, they didn't want them to have no correct language. That's what she told me."[30] Arlonzia may have learned this history—her history—by listening intently as a child to the words of her great-grandmother Dinah while seated on her unfolded quilt. Absorbing, in this manner, some of the stories that had shaped her foremother's life; being present for—and lining herself with—the survivor's truth.

J. R. Moehringer, in his Pulitzer Prize–winning feature story "Crossing Over" on continuity and change in Gee's Bend, evokes this striking history of creative resistance and quilt making carried forward by Arlonzia Pettway. At the same time—and in the same passage—he also alludes to the trajectory and future possibility of this art form, writing: "For generations, their secret art—created in slavery, perfected in solitude—had kept them warm. Now it promised to set them free."[31] With its mighty insistence on creative resistance, the powerful quilting story shared by Arlonzia Pettway also resounds with Alice Walker's classic essay "In Search of Our Mothers' Gardens" (1974), in which the writer, a quilt maker herself, invites her audience to contemplate the trials and tenacity of the artistic spirit among African American women throughout our long hard histories of labor and struggle. Within her generative, field-opening essay, Alice Walker—whose vital work consistently centers the twin and inter-twined resources of creativity and spirituality—calls out with courage, honesty, and compassion: "What did it mean for a black woman to be an artist in our grandmothers' time? In our great-grandmothers' day? It is a question with an answer cruel enough to stop the blood."[32] As

if responding to Walker's critical call, Arlonzia Pettway brings forth her own great-grandmother's story, in which heroic acts of artistry are met with concrete horror—where material expressions of creativity and imagination are rigorously, though not fully, suppressed.

As Arlonzia's memory recalled, Dinah and Sally Miller, mother and daughter, had worked together hoeing rows in Black Belt cotton fields as soon as Sally "got to be a big-enough girl." Later, when Sally was about seventeen years old, the family's collective biographer recounted, Sally—surviving both assault and the exploitation of her productive and reproductive labor—"got pregnant for a white man," under circumstances entirely antithetical to establishing consent. A son, Tank, was born. Soon after—and much to Sally's horror, sadness, and profound distress—the mother of the man who had forced her pregnancy took, and kept, this beloved baby boy. Then, sometime after this complete crisis of forced family separation, Sally Miller met and married Esau Pettway in Camden, Wilcox's county seat. And later, as remembered and told, "they came across the river to Gee's Bend"—possibly along with (or perhaps following) the couple's mother and mother-in-law Dinah Miller—"and worked on the Pettway plantation." As their granddaughter remembered, Esau and Sally Pettway had a large family, and they named their first son after the infant child who had been mercilessly stolen from his mother. "Grandmama Sally named him Tank . . . after the one got taken away from her by the white lady," Arlonzia recounted.[33] The couple named their fourth child, a girl, Missouri.

Labor and Birth Work

By midlife, according to Arlonzia's account, Sally Pettway was working as a midwife and supporting laboring mothers and their families within the community centered around Gee's Bend. Concerning the ancient vocation of her grandmother—this woman so intensely familiar with both productive and reproductive labor and so intimately and achingly aware of separation and loss—Arlonzia explained: "Sally

Midwife Sally Pettway, Missouri Pettway's mother and Arlonzia Pettway's grandmother, in 1939. Marion Post Wolcott, *Aunt Sally, Old Midwife, the Only Doctor or Nurse Ever Heard of in Gee's Bend before Project Was Started. Gee's Bend, Alabama*, 1939. Library of Congress, Prints & Photographs Division, FSA/OWI Collection, reproduction number LC-DIG-fsa-8a40121.

became a midwife when she was thirty-six years old, that's what she said. She was the main person people would call here when they get in labor. They get a wagon pulled by two mules and get Sally, take her back to their house to deliver the baby."[34]

Sally Pettway's prominent role as a community nurse and lay midwife is also held within the visual record, for a quiet photograph converses with this oral history and memory. On file in the Library of Congress is a black-and-white photograph, dated May 1939 and accompanied by its original caption description: "Aunt Sally, old midwife, the only doctor or nurse ever heard of in Gee's Bend before project was started."[35] Noted photojournalist Marion Post Wolcott took this Depression era picture while on a federal assignment to visually record living conditions within the farming community after a half-decade of direct support from FDR's New Deal programs. In this picture, Sally Pettway—whose identity has been confirmed by

her family—appears to be looking out toward the photographer and her camera while seated on a narrow wooden bench with her back against the side of a building.[36] Wearing a dark hat, a long-sleeved checkered shirt or dress, and an apron, her clothing calls to mind a memory Onnie Lee Logan shared about her own mother, who also worked as a midwife, within her as-told-to autobiography. Onnie Lee, whose midwife mother attended at the births of both Black and white women within the post-Reconstruction Black Belt, remembered times when her mother, while working in her gardens, was approached by men, nervously arriving by buggy, wagon, or horse, requesting she come with—or follow—them home to tend to a woman in labor and deliver her baby. Upon their anxious arrival, Onnie Lee Logan recalled, her mother—dressed in a long dress, apron, and small hat—would quickly ready for the skilled and patient work of tending to birth:

> I could just see right now my mother workin and goin on delivery. I could see it right now. I can just see when they came for her. I can remember she loved to work the gardens. She would work those gardens and I can remember the man comin for her to ride in that wagon for miles. If the buggy was gone and the boys had the wagon, they'd come for her in their buggy or if he was on a ho'se she would walk for miles. They would come and say, "I come after you. Miss Jane, she fixin to have a baby." Mother just start gettin ready. She'd get on all those long aprons. I don't care how hot it was—you know they wore those long dresses then. Every time I see a granny midwife she be in this form. Her long dress, her long apron, her old coat and lil hat. That's how my mother looked. In those days that's the way since they was a woman. That's the way they wore their clothes since they were women and chil'rens. A wife and mother wore their dresses long always, even in summer. Most women would look like this anyway especially the midwife with them long aprons.[37]

Onnie Lee Logan's description of her midwife mother perhaps speaks in some small way to the still photograph of Sally Pettway, Missouri's

mother and Arlonzia's grandmother—this woman who the community of Gee's Bend relied on for her expertise in caring for birthing mothers and their babies; this survivor of horrors and holder of hopes, whose knowledge and labor helped usher in life.

Sally Pettway, in this photograph by Marion Post Wolcott, sits with her arms crossed just below her chest, her forearms resting atop her aproned lap. Tucked behind her elbows, her hands in this pose are entirely out of view. Yet these hidden hands—her two wise, practiced, capable hands—were integral assets within her work. For Sally Pettway was both a maker of quilts and a midwife, as conveyed by sources such as her granddaughter Arlonzia's praise poem "The Path" and the New Deal photograph. And linking those who bring forth babies and those who bring about quilts—as well as those who grow food and fiber from soil—are wise and experienced hands. Deep knowledge, patience, and practiced hands make possible these essential acts of creation.

When Sally Pettway's picture was taken in 1939 (just a couple years before her daughter Missouri faced the loss of her husband and created her quilt made in mourning), Gee's Bend was a small African American farming community accustomed to living with and through quilts. It was also a rural and remote community quite familiar with midwifery and homebirth. This is likely how things were in the nineteenth century too. Midwives were often the ones to welcome new lives and encourage breath taking, helping if needed to initiate the sustaining cycle of inhales and exhales that enable life outside the womb. Describing the all-important work of a midwife—or one who "catches" babies—and her singular impact on her newborn charges, Onnie Lee Logan explained: "She delivered you. She was the first one to put her hands on you. She's the one that made you cry, got the breath in you."[38]

Midwifery, midwives, and the direct beneficiaries of their labors, mothers and babies, are intimately bound with quilts—with good reason, as more than a few babies have been conceived under them and more than a few have been born atop them. Onnie Lee Logan

also recalled how her mother, while practicing as a lay midwife in rural Alabama, made good use of repurposed work clothes quilts during a woman's labor and delivery. She described how worn pieced-together cotton quilts were first boiled and sterilized in cast-iron pots, then dried in the hot sun, and later, when the time was right, strategically positioned beneath a laboring mother to absorb the fluids that so naturally accompany birthing—providing comfort to the new mother in this way as well as protecting her bed:

> In those days they didn't use pads that you threw away. They would use in the country you know they had these quilts that they pieced up. The old clothes that we wore and wore out, the skirt part of the dress wasn't hardly tore up. We would take that and cut it into blocks and sew it together to make quilts. We had quilts stacked up like that. Clean. We needed all of em. They would always save those old quilts, raggedy ones, and they would boil em and sterile em. Put em under to protect the bed. Didn't use newspapers and then a small pad like we use now thank goodness. It's sterile. It's sterile when they get through boilin it. The type of water that we wash with is hot. But I'm talkin about boil in them old black pots they got. Outside. Big old pot. And they just push it down and push it down until it boils and boils and boils. And when they get it outa there it's sterile and no stains at all. No stains. Then hang it out in that hot sun. They would wash those same old quilts and fold em up and pack em back and use em again.[39]

Quilts could also be used as a pallet or cover for tired mothers and their sleepy infants. Midwives in Gee's Bend and in similar farming communities, as remembered and told, could also be paid for their labors with quilts. In her portrait of the riverbend community based on interviews and published in the *Boston Globe*, journalist Linda Matchan shines light not only on the reliance on midwives but also on some of the ways they were compensated for their services. Matchan's rich portrait includes this telling memory and exchange: "And everyone remembers the midwives who were frequent visitors, and how hard it was to afford them, given they had so many babies and

so little money. How did they pay? 'With a hog,' says Lola Pettway. 'With a quilt,' says Arlonzia Pettway."[40] Alice Walker carried forth a similar recollection of quilts used as currency within her childhood community in rural Georgia. Offering a story from her own mother's memory and lived experience of some of the creative ways midwives were paid, Walker shared: "My mother, who is a walking history of our community, tells me that when each of her children was born the midwife accepted as payment such home-grown or homemade items as a pig, a quilt, jars of canned fruits and vegetables."[41]

From making a baby to catching a baby to paying the midwife, quilts were deeply woven within the social fabric in Gee's Bend and beyond, particularly while life was organized around work in the farms and fields—serving as cover, comfort, and currency. Worn quilts were also well used for shelter and protection. Born during the Great Depression, local quilt maker Nell Hall Williams shared a memory of how cotton coverings were used to protect new life. Her memory reverberates with the family history Clinton Pettway recounted of how his enslaved and defiant great-grandmother—just before being forced to trek from North Carolina to Gee's Bend—had hidden her infant son Saul in sewn cloth, enabling him to survive and stay with her. With echoes of this heroic history and story of survival, Williams recalled how, in her day, mothers working in the Black Belt fields would swaddle their babies in quilts and lay them in improvised cradles, determined to keep their babies safe, secure, and close by as they farmed: "We farmed cotton, corn, peas, peanuts, sweet potatoes. When you born, you went to the fields. You growed up in the fields. Soon as your mama, she'd just wrap the baby in a old quilt and make the wooden box, put the baby in. Sometimes you have a dog you put to watch the babies. He wouldn't be going to leave—somebody come up and you at the other end of the field, that dog bark to let you know."[42]

Folklorist Gladys-Marie Fry, in the "Quilting in the Quarters" section of her important book *Stitched from the Soul: Slave Quilts from the Ante-Bellum South*, brought forward a similar story of how

quilts were used to protect babies while their enslaved mothers were forced to farm fields. Drawing on the Works Progress Administration interviews of individuals with eyewitness or near experience of slavery as her primary source material, she found that quilts were used to hold infants when their mothers were unable to hold them—when they were instead forced to hold a hoe or pull a plow. Based on her findings, Fry writes: "Nursing babies were carried by their mothers to the field. Between feedings, they were placed on pallets. One ex-slave described this practice: 'When de wimen who had babies wint to de fiel' dey took dem babies wid 'em, an' made a pallet out uf a old quilt in de fence corner, an' put dem babies dar while dey hoed and plowed.'"[43] Embraced as cover, comfort, currency, shelter, and protection, quilts lined life as it was lived.

Birth and Death

Securing professional medical care for residents of Gee's Bend has long been difficult. Although the county seat of Camden is only five miles across the river from Gee's Bend, it is about forty-five miles away by land. When Nathaniel Pettway was gravely ill, travel between the two involved either a poled cable ferry (resembling a rickety raft) and a toll from the riverbank or a lengthy overland trip by horseback or mule-drawn wagon along a dirt road that a heavy rain made impassable. It was a long trip along a rough rural route one observer described as "choked with dust in the summer and mired in mud in the winter."[44] Both the river and the road were deterrents to coming and going. Although medical doctors resided in Camden, the county seat was small in size (the population in 1940 was 909) and big on segregation. In a 1937 article "Life at Gee's Bend" published in *Christian Century*, Renwick Kennedy, a white minister based in Camden, shed some light on the state of professional medical care in Gee's Bend at the time and how the 700 or so African American residents living in the heart of the community had to go about trying to secure medical care in the county seat: "There is no doctor in the

Bend. People get sick and die or get well, as the Lord wills. A doctor is rarely present at childbirth. When the event hangs fire for a day or so, in the desperate emergency someone rides a barebacked mule to Camden, crossing the ferry, finds a white man to guarantee the doctor's bill, and then begs a doctor to come."[45]

Like other persons living in economically distressed, chronically underserved, hard-to-reach and hard-to-leave places, people living in the small Black farming communities within Alabama's Black Belt at the time when Nathaniel passed from this world and Missouri made her quilt were fully familiar with both the preciousness and the precariousness of life. They knew intimately that the specter of death is present at birth. They knew that pregnancy and infancy, historically and persistently, were life stages of special vulnerability for Black women and their babies—that pregnancy loss was common and infant mortality rates were high.[46] Knowledge of these tragedies, both firsthand and less directly, is widespread within the archive;

Pole operator on cable ferry between Camden and Gee's Bend, Alabama, 1939. Marion Post Wolcott, *Old Cable Ferry between Camden and Gee's Bend, Alabama*, 1939. Library of Congress, Prints & Photographs Division, FSA/OWI Collection, reproduction number LC-DIG-fsa-8a40088.

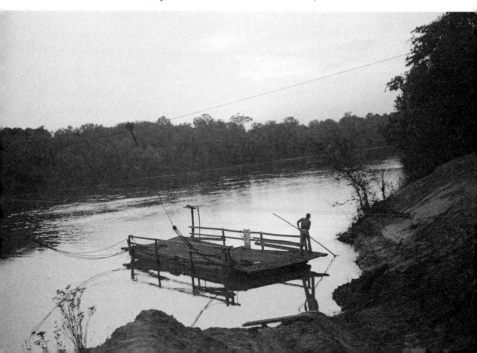

evidence of this grief is clear and present in sources ranging from oral histories, memoirs, and contemporary conversations as well as surveys and social science research.

At the start of her path to becoming a medical anthropologist in 1967, Nancy Scheper-Hughes (whose widely known work has often centered suffering and infant mortality) worked as a member of the field staff for the Southern Rural Research Project. As part of this civil rights movement initiative affiliated with the Student Nonviolent Coordinating Committee, the young activist and scholar was tasked with helping conduct a survey of, as she explains, the "working, living, and health conditions of tenant farmers and sharecroppers in eight so-called Black Belt counties of southwest Alabama."[47] Her assignment included going door to door asking frank and candid questions of African American farming families across Wilcox County, including in Gee's Bend. After completing the data gathering part of this project, the fieldworker returned to live and work in Gee's Bend for several months in 1968 while writing two final reports based on the collected survey data.[48] Decades later, while recalling this research (and remembering the quilts), Scheper-Hughes recounted one of its central findings: the frequency of pregnancy loss and infant death within the strategically under-resourced and disenfranchised Black farming communities throughout the Black Belt. Drawing on the survey data from 1967–68, she described the dire statistics behind the poor birth outcomes for mothers and babies: "The average African American woman in a farm household in southwest Alabama had experienced over seven pregnancies by the age of forty and at least one miscarriage, stillbirth, and two infant or early childhood mortalities. It was the portrait of an endangered population in a Third World nation."[49]

Early in her autobiography, Onnie Lee Logan also gave voice to this private and public health crisis, this epidemic of maternal vulnerability and child mortality. When describing the size of her family of origin, the longtime midwife included both siblings who had survived infancy and early childhood as well as a sibling who had

died prematurely before reaching adulthood. Bringing forward and expressing this loss of a young family member, she shared: "It was a big family of us. Sixteen of us and fifteen got grown."[50]

This reality of premature loss, especially the loss of young children, was made painfully clear to me during a brief phone conversation I had with a granddaughter of Nathaniel and Missouri Pettway. Carelessly, I asked this kind and patient woman a question I thought, at the time, was straightforward and easy to answer: How many children did your maternal grandparents have? Before picking up the phone, I knew that, according to the 1940 census, there were ten children—seven sons and three daughters, ranging in age from three to nineteen—living in the couple's household in Gee's Bend when the census taker had made the rounds. Yet the government record had not instilled much confidence in me, as it was clearly rife with errors and inconsistencies, and further, it was quite possible the enumerator's household count had not captured the full complexity of the family's lived demographics. So, while I had the great privilege of talking on the phone with a granddaughter of Nathaniel and Missouri Pettway, I asked her directly about the size of her grandparents' family. At this she paused, and then she replied that my question was a difficult one for her to answer. Slowly—and much, much too slowly, as this loaded question would also give me pain and pause—I began to sense why. What, exactly, was I asking (and why)? Was I asking how many of her maternal grandmother's pregnancies had resulted in live births? Was I asking how many of Missouri Pettway's children had survived infancy? Had entered early childhood? Had achieved adulthood? My sloppy, nervous question thoughtlessly scratched at grief and loss and, regrettably, offered no balm. However, I learned a lesson. After this exchange, I started to see more fully the reality of this tragedy and continuing crisis of maternal vulnerability and child mortality. It is a recurrent presence in the oral histories and testimonies of women from Gee's Bend. This catastrophe of loss is held in the historical accounts, particularly while women are recounting their pregnancies or attempting to answer questions about the size or composition of

their families. This resounding sorrow is also carried in the quilts. Lucinda Pettway Franklin, a great-granddaughter of Sally Pettway (and Arlonzia Pettway's niece), shared how pieced-together quilts could serve as sites of memory for mothers to mourn their departed children: "We didn't have cameras growing up. We had quilts. . . . When we had babies to die, you'd see this little piece of baby clothes in the quilt. It was a meeting place for us."[51]

Embedded within the social fabric, quilts, like midwifery, are the most intimate of art forms. Babies are conceived under them, mothers labor on top of them, infants are wrapped in them, children sit and eat and sleep on them, and people come of age within them. We turn to them for rest, warmth, solace, and shelter, and some truly fortunate people die well loved, at peace, and free of pain surrounded by them. Bed is where many people take their first breath and where some take their final one, and quilts can accompany and assist at every life stage, from conception and birth to dying and death. As we all know, both coming into the world and passing from it require support and care. Alice Walker speaks directly to this human need for mutual aid and communal care when recalling her mother's homeplace. "It went without saying," she recounted, "that birth and death required assistance from the community."[52]

At the time when Sally Pettway served as a community midwife in Gee's Bend and when Nathaniel Pettway became gravely ill, family members provided much of the supportive comforting care for those nearing the end of life. Alongside neighbors and kin, they worked to meet the ailing individual's physical, emotional, and spiritual needs, determining what was needed by way of drawing on their experiences of being with and caring for the dying. Picturing this time with some romance, J. R. Moehringer, in "Crossing Over," his essay on continuity and change in Gee's Bend, envisioned this bedside vigil: "Things used to end differently in Gee's Bend. Times were hard, but death was soft. People would reach ripe old ages and die in bed, encircled by five generations of loving kin, tucked under quilts older than their mortal coils."[53] A soothing tender image of the

past, for certain, and yet something of the heritage and history that lies behind this pictured portrait lines Missouri Pettway's handmade quilt and her former cotton plantation community. Lining it, too, is the quiet, determined act of a surviving spouse—a woman quite familiar with axe and hoe, soil and seed—transforming her husband's cotton clothes, steeped with the stains and sweat of labor and life, into an object of memory and love, creating something needed and necessary by way of her hands and her heart.

CHAPTER FIVE

Shared Care and Prayer

Local Practice

With the eyes of her heart, Mary Lee Bendolph affirmed the community-minded aspects of farm life in Gee's Bend as she chose to remember them late in life. "Families down here, they like to do together. See, we farm together, and the ladies in the family get together for quilting," she recounted. As part of her lasting, loving remembrances, the celebrated quilt maker also recalled that unlike the typically solitary step of piecing together strips and blocks of cloth to make a quilt top, the work of sewing together the quilt's layers often involved a small group of friends, family, and neighbors. The former was generally a singular task, while the latter was a collective one. "Piece by yourself; quilt together," she explained.[1]

To prepare for this final quilting stage, the quilt's layers were typically fastened into a frame—sometimes one made simply of pieces of wood laid across chairs or workhorses—to keep them taut and together. Then, after the quilt was put in the frame, the work of putting up a quilt began. It is unclear how exactly Missouri Pettway handled this part of the process, how she went about completing her quilt. Her daughter's testimony makes no mention of this step. What

is clear upon close looking is that her quilt is bound, or "quilted," by hand with long stitches of cream-colored thread. This stitching may be entirely the work of her own possibly hurried hand as some area quilt makers, then as now, sometimes quilt their own quilts. Yet perhaps we might imagine otherwise, for when Missouri created her quilt—as the words of Mary Lee Bendolph and others attest—it was common local practice for female kin and other neighborly women to visit a quilt maker's home, gather around her quilting frame, and assist in the final step of sewing together, or quilting, the layers.

This supportive, collaborative effort of "putting up" a quilt after it was put in a frame is both recurrent in memory and enduring in practice. Widely and warmly recounted, it is a revered ritual of reciprocity and treasured expression of connection, kindness, and community care. Regarding this ritual—as well as the fellowship residing at its heart—Georgiana Pettway, a close friend and contemporary of Arlonzia Pettway, remembered fondly how neighborly women of her mother's generation shared in the work of completing their quilts by rotating their time, energy, and expertise among their individual homes. "They used to go from house to house quilting. If mama put up a quilt today, the women going to come and help her quilt her quilt out. The next day, the other woman going to put up one, she's gotta go house to house quilting," she recalled.[2] Sharing a similar memory of the quilting women who came before her, Nettie Young remembered, "Sometime two or three women come together and help one another quilt their quilts."[3] Furthering these recollections, Gee's Bend resident Bettie Bendolph Seltzer, born in 1939, conveyed the way this caring collective practice worked in the 1940s, around when Missouri was facing her husband's dying and death. Recalling something resembling a moving mutual aid society of women dedicated to assisting each other in the completion of their much needed quilts, she remembered: "When I was growing up, Mama made quilts to keep us warm. The ladies then piece their quilts at home and go to each other house to help quilt."[4]

These vivid recollections of community care and support, shared

work, and neighborhood trust within Gee's Bend extend beyond the domain of quilting quilts. Within these proudly kept remembrances, mutual aid and assistance—enactments of the great value placed on one another and the well-being of their community—take multiple forms. Arlonzia, for instance, carried forward a memory her father had instilled in her of how neighborly men had shared in the hard work of house building. Bringing attention to a way of coming together and being in community akin to the roving resident quilters, she described a related history of a caring and cooperative cohort of willing and able builders—of men, like her father, who gathered together to share in work and a meal. Forwarding Nathaniel Pettway's memory—and his modeling—of a responsive, reciprocal, and sustaining local practice around home building, she recounted: "Everybody had a log cabin when I was young. Every family built their own log cabin. The family would get together; all the men would help. About seven or eight men would get together to build a house. They would do it for each other for nothing. You didn't have to do nothing but cook some food for them. But that was before I was born. That's what my daddy tell me that's what they do. And they went from one place to another. If you needed something, they do it for you—no charge."[5]

Telling are these testimonies, like Arlonzia's, of adult children carrying forth memories of the strong networks of mutual aid and assistance that preceded them. When recalling the lives of their parents and the generation that came before them, the proud descendants seem to share the stories and tell the tales of community support with a tenderness coupled perhaps by a trace of wistfulness, lauding and emphasizing the generosity—and the spirit of reciprocity—of their relatives' and ancestors' effortful acts. Yet when sharing stories even more closely tied to the self, sometimes other, often harsher, contours of human truths emerge. For example, when speaking of her own childhood in Gee's Bend in the late 1950s and 1960s and the extraordinary challenges of Black Belt farming, Essie Pettway, Mary Lee and Rubin Bendolph's daughter, bravely stared pain in the face and gave voice to another layer of history and truth. Instead of placing

emphasis on the generosity of the collective acts, she highlighted their necessity for survival. Stressing the grinding nature of working the farms and fields day in and day out, the searing poverty surrounding their lives, and the fundamental need for community support for the area's struggling farm families, she stated frankly: "I picked cotton. I didn't like it. Not at all. But it was life. We had to do what we had to do to make a living. When my parents finished their farm, then we go over and help our neighbor get their farm. We just worked together."[6] Working in this manner, Essie Pettway made clear, was not only a way of life but also a matter of life.

Gathering

Coming together and sharing in the task at hand can be both a strategy for survival and an expression of care for one another. The women who made their way to another quilt maker's home and gathered around her filled frame were there for a reason. They were on hand to assist in the final step of sewing together the layers of her quilt by hand. Participating in this ritual of reciprocity, they had shown up to help complete her quilt. Within this sometimes hard-to-leave and hard-to-reach quilting community, this task-oriented gathering likely served other important purposes as well, such as providing a relaxed setting for socializing and nurturing relationships. Arlonzia Pettway, at the start of the twenty-first century, spoke on this matter with character-istic clarity and candor. While being filmed for a 2006 documentary, the lifelong Gee's Bend resident—who by then had been making quilts for sixty-some years—recalled the pleasures of quilting, especially in relation to the rigors of farming (and in the time before television). Seated around a wooden quilt frame, alongside longtime friends who were enthusiastically affirming her presence and her remembrances, Arlonzia reflected on a central social benefit of quilting together: "It was a pleasure to us, to sit and quilt. When we gather our crop, that's the only pleasure we had, to sit around the quilt and talk and sing like we doing now, and eat. It was a pleasure to us at the time. That's all

the pleasure women had at that time—the quilting. Sitting around the quilts and make quilts. You had nothing else to look forward to but to quilt."[7]

Nettie Young shared a similarly fond memory of quilting with friends in each other's homes, stating appreciatively: "I had some friends. I'd go to them and set down and quilt with them. They'll come to me, set down and quilt with me. That's the way us did. And us just have a hallelujah times quilting. That's what us done in the winter. Summer's go in the field. It was good."[8] Quilting together in this manner clearly served not only a practical material purpose but also essential social and emotional ones as well: meeting needs both seen and felt. In coming together to quilt, friends, family members, and neighbors took the time to help finish another woman's quilt and ready it for use. There was a striking utility in both the finished quilt and the process of its completion. By giving their time, demonstrating their care, and sharing their presence in this way, those who gathered created a space of grace and ease that worked to strengthen social ties as well as the larger social fabric. The work of connecting the quilt's layers deepened their connections to one another.

As memories positively affirm, these gatherings around quilt frames were often lively and layered, involving various complementary activities. Talking, singing, eating, sharing stories, praying, and discussing the Bible are all regularly remembered as being integral to the collective effort of putting up a quilt. Sharing her memory of what the women of her mother's generation did while gathered together shoulder to shoulder in this way, Georgiana Pettway stated: "That's all they do—sit around the quilt and sing, pray, and read the Bible. Old souls. They were old souls. They quilt they quilt, and they pray their prayer, and they sung their song, and they ate what they could eat—around the quilt."[9]

Within this active and action-oriented faith community comprised of many individuals spiritually centered by a deep Christian faith, congregating around the quilting frame also provided a favorable site for communal prayer, praise, and worship. Interwoven, in fact,

were these acts. "We'd get together and make the quilts just like we're praying together," reminisced Mary Lee Bendolph, a central member of her community's Ye Shall Know the Truth Baptist Church as well as its gifted and talented choir.[10] The devoted quilt maker recalled how the shared work of putting up a quilt simultaneously addressed shared needs for social, emotional, spiritual, and physical nourishment. "When we be sitting around the quilt, we be talking about the Lord and talking about how kids act, and we be praying, and we be singing, we be moaning, and then sometime we'd be snacking on the quilt," she recalled with palpable reverence and joy.[11]

Lucy Mingo, also a devoted and decorated resident quilt maker, shared a similar sentiment regarding the true benefits and gifts of neighborly women gathering to assist in the completion of each other's quilts. Like Mary Lee Bendolph, her faith-led neighbor and peer, she, too, experienced and embraced the work of putting up a quilt as an opportune setting for shared worship and prayer, as a special site for holding fast to their faith and carrying forth the call. Lucy Mingo explained how time spent together around the quilt frame, matched by mutual devotion to the Lord, worked to nurture friendships among the quilting women, furthering feelings of closeness and deepening their connections to one another. Expressing her love and longing for the women she regularly quilted with (before she was called to provide more hands-on care at home), she exclaimed: "You know, we all work together. I work in a quilting group. And I miss it so much since my husband's been sick. We sang together, we prayed together, we eat together, and we serve the Lord. You know, when you're serving God, he'll draw you more closer. Closer and closer. I can't rest at night unless I call them to see how they're getting along. They'll call me one night, and I call them the next night. 'Cause I miss them. They're just like my own family. I just really miss them."[12] Of invaluable holistic utility, the enduring ritual of reciprocity of visiting a quilt maker's home, gathering around her quilting frame, and assisting in the final step of sewing together the layers of her quilt—a familiar ritual when Missouri Pettway created her covering—served to complete quilts

and, at the same time, to cultivate community. Giving voice to the connections enriched by this slow, kind, caring act as well as other related forms of kin work in which one's well-being is held by all, Lucy Mingo affirmed with affection: "We all know one other. We're kinpeople."[13]

Collective Ministry

Layered with song, prayer, and praise, this common local practice and enduring ritual of tightly knit groups of women—neighbors, congregants, and kin—guided by God and quilting together resounds with what quilt maker and cultural historian Carolyn Mazloomi sees as the workings of a "collective ministry" among some quilt makers who are led by the strong force of their faith. In *Threads of Faith: Recent Works from the Women of Color Quilters Network*, the catalog accompanying her acclaimed 2004 exhibition at the American Bible Society, Mazloomi offers the term *collective ministry* when she considers the intentions and impact of the quilts on display created by African American quilt makers actively pursuing and expressing the paths of their Christianity. In her essay, the curator, scholar, and artist considers ways quilt making, for some of the devoted makers, may be woven with principles, practices, and rites of their faith: "For African Americans, the process of quiltmaking is itself a spiritual journey, where the Holy Spirit pours out an anointing over both the quilter and the quilt. It is not uncommon for the Christian quilter to pray over and into the quilt, just as handkerchiefs and aprons touched by the apostle Paul were anointed to miraculously heal the sick (Acts 19:11–12). It is a sacred and consecrated experience. The journey of the African American quilter is indeed a journey of hope. It is a calling. It is a ministry."[14]

While gathered together to finish their neighbor's or family member's quilts, some quilt makers of Gee's Bend may well extend and expand this journey—this calling and this ministry—of which Mazloomi so elegantly speaks. Within this rich religious community where

many residents are grounded and guided by a strong, shared Baptist faith, congregating around the quilt can serve as a powerful extension and expression of activities such as Bible study, prayer meetings, choir practice, and lay worship. Convening around the cloth, in this way, can serve as a trusted site for quilters to affirm their faith and the sanctity of their lives.[15] Nettie Young expressed this holy and wholly precious dimension of quilt gatherings. When asked what women talked about while gathered around the quilt frame, the farmer and former sharecropper, in her ninth decade of life, replied: "Us talk about how us came, what us done come through, how we done had hard times. And then we all talked about God. And then we all go to singing songs praising the Lord. Just praising him for what he done done for us. We'd praise the Lord. And the Lord brought us out. Nothing but the Lord. He brought us over that hump and set us feets on solid ground."[16]

Mary Lee Bendolph's daughter Essie Pettway held close her memory of experiencing faith-filled quilt gatherings such as these as a young girl. She remembered holding a prime position as a child at the quiltings held at her family's Gee's Bend home. Nestled within the tented space directly below the quilt under construction, she recalled sitting along with other young kin and feeling a sense of enchantment and awe, captivated by the rapid appearance and disappearance of the women's dancing needles above her head. "I remember when my mom and my grandmam and their neighbors used to come by to quilt together, and I used to just sit there and look up under the quilt and wonder how they was going up and down, up and down, with that needle," she recounted. She also recalled how these early experiences left her feeling both eager for the time when she would learn to quilt and bathed in love. As she remembered, the quilters—tenderly attentive to the children gathered under the quilt and around their knees—made use of the charmed space to express their faith and hope and to share their love. Now a renowned quilt maker like her mother, Essie expressed what it felt like, as a child, to experience this priceless gift of loving affirmation surrounded by mothers and other-mothers

within the warm sanctuary of their quilted creation: "They would teach us when we were under their quilt listening to them, praying and talking to God about their children, how they wanted them to grow up and be men and women, to love their children and to teach them the value of life. They understood what it was about family. You could *feel* the love."[17]

If the work of finishing Missouri's quilt followed common local practice, then those who made their way to her home to assist were perfectly poised to draw on their life-affirming ritual of communal care and connection. Those who gathered were on hand to complete the quilt Missouri had expressly made to support her grieving self, and they were there to support its mourning maker. Sensing suffering and rightly responding to the call to care, they gathered in supportive community, providing what was certainly needed—comfort, presence, and understanding. By tending the quilt, they tended its maker. By holding the cloth, they held her. Within this healing practice of presence—meeting her where she was and allowing what is to be—they held space for feelings to be felt, silence to be heard, words to be spoken, stories to be shared, songs to be sung, and prayers to be prayed. Lay ministry in action, the quilters tended to the natural needs of loss through their communion around the cloth and the laying on of hands.

The custom of completing a quilt collectively, coupled by the individual act of creating a quilt top, persists within Gee's Bend. Artist members of the Gee's Bend Quilters' Collective, the organization established in 2003 to aid in the promotion and sales of the work of living quilt makers, continue to draw on this union of the personal, internally focused dimensions of piecing and the communal, externally oriented aspects of quilting. Describing this way of working and the shared vision for their creative process, the expert quilt makers— who proudly understand themselves as inheritors and sustainers of an over-150-year-old quilting legacy—explain: "Each quilt top is an original design by a member of our collective, made in a process called 'piecing.' Its creation is a highly personal, solitary experience. Once

the piecing is complete, the sewing begins. The designs are entirely unique, but the process is collaborative. Through our collective, we sew our designs with our mothers, daughters, and friends in the community."[18] Between piecing the quilt's top and sewing together its layers, this method of making a quilt experienced in the round offers time and space for both inner reflection and shared communion. A union of two essential practices and holistic at heart, the making of a quilt in this manner holds space both for tending within and seeking the kind of support that is innermost and for experiencing the care of kin gathered in supportive community—a lifeline and a touchstone, carrying the healing wisdom of the quilters who came before them.

Singing Prayers and Quilts

Music and song are integral to life in Gee's Bend. Religion, their frequent source, is too. One prominent local pastor vigorously defined the role of faith in the tightly knit Black Belt community, declaring it as "the most important part of this community" and "the source for all we do."[19] Deeply rooted in religion and spirituality, music, especially sacred song—prayerful singing to draw on, express, and deepen one's relationship to God—was at least as integral to living and being as quilts and quilt making when Missouri Pettway created her quilt made in mourning. Prayerful singing—"lifting up a hymn" and/or "rising up in song"—often accompanied the ordinary as well as the extraordinary acts of life within her African American farming and faith community. Praise and prayer, song and story, quilts and quilt making, were all, then as now, sustaining resources woven within this rural riverbend community, with its staggering history and striking creativity. Likely devoted to God and convinced of His infinite goodness and grace, Missouri Pettway may have drawn on the rich resources of religion and song—resources that were very much hers to have—while making her desired quilt.

Her daughter Arlonzia's life and testimony shine light not only on how prayer, music, and making quilts were woven within their

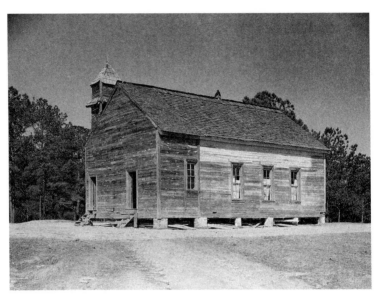

Pleasant Grove Baptist Church in 1937. Arthur Rothstein, *Church at Gee's Bend, Alabama*, 1937. Library of Congress, Prints & Photographs Division, FSA/OWI Collection, reproduction number LC-DIG-fsa-8b35954.

community but also on how these supporting lifeways were woven together, integrated and united, within the landscape of their lives. Raised within the Black Baptist religious traditions, practices, and beliefs that give shape and form to life in Gee's Bend, the lifelong resident learned, drew on, and further enriched her community's spiritual, musical, and quilt making legacies. Central to Arlonzia's life, like many who came before her, was the singing of church songs, sacred hymns, and spirituals: the living musical tradition of the Black church. Carrying and furthering this part of her heritage and upbringing, she—along with close friends and fellow quilt makers and churchgoers Leola Pettway, Georgiana Pettway, and Creola Pettway—formed the White Rose, a community gospel group, in the late 1960s. The women conceived of the singing group and honed their musical repertoire and skills while quilting together, joining together, in this way, the supporting lifeways of quilt making and

music making. Initially, however, Arlonzia was reluctant to perform publicly. It took prayer and a repeated religious vision, she explained, for her to fully receive and accept this calling. Recalling the origin of the White Rose, including the divine encounter and exchange that enabled it, the dedicated quilt maker and gospel singer recounted at the turn of the twenty-first century:

> We've been singing thirty-seven years. We started around the quilt at my house. Somebody told me say you have to ask the Lord what he would have you to do. I asked the Lord to show me what he wanted me to do in his vineyard. And he showed me that I was standing up singing. And I told him I couldn't sing. And I prayed again not to sing. And he showed me the same thing, standing up singing. So we've been singing about thirty-seven, thirty-eight years. Started around the quilt, just like we doing now. Started our singing right around the quilt.[20]

For the churchgoing members of the White Rose, both quilting and singing were ways of being in and practicing community and expressing their faith. By shifting on occasion from the seated, re-laxed work around the quilt frame to the standing, full-bodied work of spiritual singing, the women expanded the reach of their shared prayer and collective ministry. For them, singing—prayer set to mu-sic—was another way to pray. By standing together with each other in this way, these women of God and faith, in a sense, increased the size of their intimate quilt gatherings, broadening their sacred circle of supportive community. Powerfully singing hymns, spirituals, and gospel songs within Gee's Bend and well beyond, they shared with grace and joy their love of the Lord while inviting others to join them in offering Him glory and praise.

In an interview at the age of ninety-one with former college pres-ident Johnnetta Cole, Nettie Young, a former guest at the White House, shared how prayer, song, and quilts have been linked for many who have lived on this land and known Gee's Bend as home. Within their extraordinary exchange in 2008, the quilt maker and hymn singer told the trained anthropologist how prayer and song had

been faithful, consistent companions throughout her own long life in Alabama's Black Belt. Describing the profound impact of these steady sources of courage, confidence, and calm—including while marching for freedom during the civil rights movement—Nettie Young explained: "When we fall on our knees and call on that man above, and strike out on those hymns, you gonna feel freer. You ain't scared a bit. All of it leave you. All of it leave you. And you feel so free and so happy. The peoples what got them gun, they couldn't shoot you, 'cause God had you fenced in."[21] Singing, she knew, bred bravery, kept one safe, and set one free.

Nettie Young, born in 1917, was raised just a few short generations after slavery: at a time and in a place when it felt like the grievous, life-stealing institution was "just moments away," to borrow the wise words of a midwife peer.[22] The quilt maker was born and raised within a world of economic despair and, as she also emphasized repeatedly, of community care. She was one of thirteen children in her share-cropping family, twelve of whom, she explained, "lived to get grown." Responsible for a household full of family during the terrors of Jim Crow, her mother was "a praying lady" who showed her children that prayer could take place anywhere, for she, as her attentive and appreciative daughter remembered, "prayed at home just as well as she would at church. She prayed amongst us." At age seven, Nettie started working in the fields and by thirteen had "found the Lord." She also shared that at some point early in her life, she had asked God to teach her how to read the Bible, and her prayer had been answered, for not only did she learn to read but also each of her eleven children finished high school, with some deciding to continue on to college. Like her neighbor and fellow quilt maker and singer Arlonzia Pettway, Nettie Young served as a vital community historian. Holding history, carrying culture, and offering the teachings of her inherited wisdom—what she called "these things what I know deep down low"—she shared how prayer and song and the singing of prayers had a long legacy in Gee's Bend, how they were, in fact, paramount to the community's intergenerational survival.[23] Linking prayer and

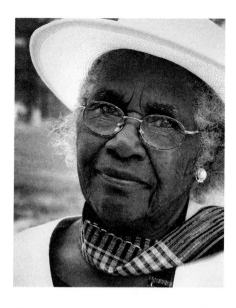

Nettie Young. Photograph by Linda Day Clark.

faith, song and joy, the personal and the collective, Nettie shared what she knew to be true about how her ancestors had affirmed the dignity of their lives, sustained hope, endured, and survived:

> Prayer changes things. What's going on wrong, if you go to God, he change these things. They [enslaved ancestors] trusted God for everything. They believed in God, they had faith that God would take care, and he did. You see the slaves, they sang. And that's where they get their joy from. They did sing and they did sing them old slave gospel songs. And they were proud of themselves to be able to sing with one another. That was their joy. That was part of their way of living. You sing, you forget. It made joy in their heart. It brings peace to themselves. And singing and praising God was the best way to get there. Through all them years, having joy by singing and praying.[24]

Song and prayer had led the way and carried them through. For those who came before her, Nettie Young explained, prayer and sharing in song had served as a righteous reminder—by releasing yearning and invoking hope—that there is always more to life than suffering and sorrow. Singing spirituals with each other, she was certain, created

space for people to connect and care for each other, lift their sights and spirits, and experience the joy and love that reside within.

Seeing strong ties between sacred song and pieced quilts, the quilt maker also sensed that the joy experienced when singing together in community could also be felt when beholding the community's quilts, the pieced-together quilts made by quilters, like herself, who had inherited and sustained the living cultural legacies of their forebears. Sharing this connection while *The Quilts of Gee's Bend* exhibition was traveling to museums across the United States, Nettie Young exclaimed: "Now we got joy up on the wall to look at. It's a blessing. It's a good feeling. What my mother taught me to do. Look where it at. All in Texas, all in New York, all in Mobile, every which way. Look where it at. That's a good thing. That's a blessed thing."[25] Soaked in song and infused with grace, Nettie understood her community's quilts—like their singing—as woven with prayer. She held, too, that it was precisely because their quilts had been stitched and sung with prayer, like cloth carriers of praise, that they had been lifted divinely into the light for all to witness and behold. Concerning this blessed rise, she avowed: "They sung in the field, they sung around the quilts, when they quilting the quilt, they sung around that quilt. They prayed around that quilt. That mean that quilt, God lift that quilt up. He brought it from the bottom and brought it to the top. . . . God done it. He done it 'cause them quilts had been prayed over so much, sung over so much, he gave those quilts an uplift."[26]

"Swing Low, Sweet Chariot"

China Pettway, some of whose everyday roles include quilt maker, song carrier, history holder, and home health care worker, also shared what she knew to be true about the connections between singing prayers and making quilts in and around Gee's Bend. Her mother, Leola Pettway, an avid quilter and member of the White Rose gospel group, introduced her to both art forms. Recently, China—a committed member, along with Mary Lee Bendolph, of her community's Ye

Shall Know the Truth Baptist Church Choir—described the transfer of these teachings. Explaining how she came to quilt making, she stated directly, "My mother learned me how to piece quilts and quilt when I was eleven."[27] Her explanation of how she also came to possess supreme singing skills, however, was notably more circuitous. In charting this learning path, China first heralded powerful influences such as "going to church" and "listening to my elders" before stating who, in the end, she understood as ultimately responsible for her exceptional talent and gift. "My mother taught me how to sing, but really this is a gift from God," she testified. The devoted caregiver also affirmed that both these inheritances—quilting and singing—were forms of faith and forces of healing. Both were compositions of cloth and sound for tending the soul and strengthening the spirit. Defining them in this way and stressing the importance of their safekeeping, she offered: "Quilting is a healing, just like singing. Quilting and singing is a healing for our soul. . . . Preserving the quilting and singing play a great part in African American cultures, because they look forward to prayer, quilting and singing. Preserving means to keep up and maintain. So I think we should maintain our singing and quilting as long as God allows us."[28]

China Pettway has been central to preserving and enriching these richly reinforcing expressive traditions. She, along with Mary Ann Pettway (the manager of the Gee's Bend Quilters' Collective and a member of the Pleasant Grove Missionary Baptist Church Choir), regularly share their expert quilt making skills by leading highly popular workshops—immersive learning experiences brimming with stories and laden in song—at places such as the Alabama Folk School.[29] Both women, along with contemporary quilters Larine Pettway and Nancy Pettway, have also been central to carrying forward the remarkable sacred music traditions of Gee's Bend. The four singers and song carriers gathered in 2016 and again in 2017 at the Gee's Bend Quilters' Collective on County Road 29 to record their own soaring renditions of traditional sacred songs. Released in 2019, their album, *Boykin, Alabama: Spirituals of Gee's Bend*, is the result of

these professional recording sessions, which took place in the space where they typically gather to work on, show, and sell their quilts.[30] Surrounded by their quilt making inheritance on their land in a near loop of the Alabama River, the gifted women artists came together to share their musical inheritance. Singing side by side, they encircled themselves, too, with song deeply rooted in faith. Carrying the past into the present—and carrying prayers—they lifted their voices to praise God, and in doing so, they shared the beauty and majesty of their community's spiritual singing tradition for all the world to hear.

One song they sang was the celebrated spiritual "Swing Low, Sweet Chariot." Consistent with many African American religious practices, and in keeping with this fundamental form, the traditional spiritual honors and affirms Black humanity by addressing suffering, holding hope, and supporting full and open expression of the depths of human emotion, including the profound intensity of grief. Like Missouri Pettway's quilt made in mourning, the sacred song offers shelter, a sanctuary of comfort and solace for the grieving in harmony with their faith. A perennial presence at homegoing services, tributes, and other celebrations of life, the so-called sorrow song is dearly held and widely sung because it gives wholehearted expression to both loss and the everlasting cycle of renewal. Simultaneously of the moment and of the ages, the song speaks to the anguish of grief, the dignity of the human spirit, the strength of faith, the tenderness of yearning, and the sweet release of joy. Drawing on the biblical story (2 Kings 2:11) in which the Prophet Elijah is taken by fiery chariot from the banks of the Jordan River into heaven, the spiritual exults in the resplendent triumph and glory of ascension: the transition from an earthly life to an everlasting one in a heavenly home. China Pettway, Mary Ann Pettway, Larine Pettway, and Nancy Pettway (their shared surname a direct reminder of the lasting legacies of slavery and their descendant community), in their recently recorded rendition of this Scripture in song—this soul-stirring "old slave gospel song," to borrow Nettie Young's words—delivered it a cappella, accompanied solely and wholly by their steady, abiding faith:

Pleasant Grove Baptist Church in 2022. The church moved to its present lot in 1961 and was rebuilt in 1977. Photograph by David Bruno.

The Gee's Bend Quilters' Collective building on County Road 29, 2014. Photograph by author.

Swing low, sweet chariot, coming to carry me home.
Swing low, sweet old chariot, coming to carry me home.

If you get there before I do,
Tell all my friends, I'm coming home too.

I looked over Jordan, and what did I see,
A band of angels was coming after me.[31]

"Swing Low, Sweet Chariot" was also central to the repertoire of the White Rose, a close predecessor to the contemporary female quartet. Led on occasion by Leola Pettway, China Pettway's mother, the White Rose frequently sang this story of ascension. Arlonzia Pettway, in her role both as a member of the singing group and as a key keeper of her family's and her community's history, carried forth the song's meaning for her parent's generation and those who preceded them—for her family and forebears who had seen and felt firsthand the suffering wrought by slavery and its tolls: "They were ready to go home. They had such a hard time, they were ready to go home. They were singing that song 'Swing low, sweet chariot coming for to carry me home.'"[32] After experiencing many of the horrors and hardships of history and struggling mightily to survive, they reached a place in their life's course, consistent with their spiritual commitments, where they greeted and embraced the radiant promise of the journey home. "They were ready," the memory keeper and culture bearer recounted, to take leave of pain and suffering and accept the invitation to enter a place of eternal rest and peace, reunited with loved ones joyously welcoming their return.

Quilting quilts, like sharing in sacred song, holds space for some of what matters most: expressing our innermost longings and experiencing true belonging—deepening connections, that is, within and among ourselves. Cherished expressions of connection, kindness, care, and support, including the ritual of reciprocity—the collective completion of quilts—are called forth and carried on time and time again through acts of memory, presence, and practice in Gee's Bend.

They are like a connective thread or a sturdy stitch running through the histories and stories of this place. Gathering together in supportive community has taken many forms here: from helping each other out in the fields, putting up quilts, building homes, keeping each other company, offering a meal, expressing devotion, making music, and joining in song to laying loved one's to rest. Within this active faith community, these acts—meeting needs both seen and felt—are entirely exquisite practices of shared care and prayer.

CONCLUSION

×

Sacred Utility

Yearning

Not long after her husband's passing, Missouri Pettway set out to create a quilt of his worn familiar clothes with the expressed intention "to remember him, and cover up under it for love."[1] Led by her intention to find comfort in his memory, she made her way through the steps in the quilt making practice that was her birthright. Seeking sanctuary and softness, she wound her way around this healing pattern, stitch by stitch, piece by piece, with the crown of her head bowing toward her heart. Missouri Pettway's deliberate pursuit of this path—of this sustaining resource and practice deeply rooted within her homeplace—supported the grieving quilt maker and surviving spouse in making her way from holding the pieces of her loved one's clothes in her hands and on her lap to being held by the precious utility quilt she conceived of them. Her quilt, as remembered, was done by design. From its initial conception, the ultimate aim for her completed covering was to cover her, to wrap it around her body and being—to remember her husband and experience their love.

At the heart of Arlonzia's enduring memory of her mother's quilt made in mourning lies a love story. This is absolutely no surprise; love

is why we grieve. As remembered by the couple's eldest daughter, the covering's creation and its intended use were steeped in yearning. Following the early loss of her husband of over two decades, Missouri sought to cover her body with cloth that had recently covered his own. Clothing and cloth never again to be needed by him were now needed by her. Guided by intention and desire, she turned to a most intimate of art forms—one, like a second skin, that holds the body and moves with the breath—and created and completed her yearned-for quilt.

After Missouri Pettway completed her quilt—after the sacking-like backing had been brought around front to form and finish its edges—how might its presence and use have helped tend to her loss? Her extant textile and her daughter's enduring testimony are silent on this matter. With a few words here to close, I would like to imaginatively consider—grounded by an understanding of grief as at once a profound experience of distress and a profound expression of love—some of the ways Missouri Pettway's utilitarian quilt made of her late husband's work clothes may have been of sacred utility.

Beds know grief and for good reason. While lying in bed, there is no longer the need to hold oneself up or carry one's weight. As a result, effort lessens and loads lighten. As grief can be exhausting and heavy, this can feel like a welcome respite. Beds physically support and stabilize the body, enabling ease and inviting rest. Quilts can assist with this, too, offering a warm cradle or caress. Supported and held by her bed in this way, perhaps Missouri Pettway's sage and simple act of pulling her cotton quilt over her body sent a soothing signal to her mind that it was now the time for a soft pause or rest. Once swathed by the sheltering cover of her quilt, perhaps its gentle heft furthered this calming, steadying effect. With all hope, she rested in this way: braced beneath by her bed and protected on top by her cover. The former supported the weight of her body; the latter supported the weight of her grief.

Lying under her quilt, with its familiar fabric touching her skin, may have felt something like a familiar embrace. And perhaps this felt

sense, this experience of seeing and feeling her loved one's well-worn and well-remembered clothes in this way, offered the quilt maker a tender path to feel his love, remember his presence, and closely carry his memory. As memory, emotion, and the sense of smell are linked and share wide-open doors, perhaps his lingering scent, alive within the warp and weft of the cloth, also offered an opening to cultivate and continue their connection.

With the sounds and silence of the night and the giving way of the light, grief can give way to a more private, solitary mourning. While under cover of the night—and a quilt—being in bed can provide a place for needed rest and desired communion, as sleep can serve as a site of reunion, a place where lost loved ones can be found. At the same time, lying in bed leaves us alone with our innermost self and our secretly whispered words, leaving us with little choice but to meet face to face our suffering and fears. For while the body is quiet and still—while it has nowhere to go and nothing to do—the mind continues to move, sometimes, distressingly, with increased intensity. When Missouri Pettway was engaged in the seemingly solitary step of piecing her quilt top, this purposeful task may have enabled the quilt maker to shift between processing and, mercifully, pausing the pain of her loss. By contrast, this protective pacing—direct reckoning with one's shaken inner world paired with a respite from it—was probably difficult to come by while lying awake in bed within the thick grip of grief, where the only pause to pondering the enormity of her loss was likely the elusive release of a deep sleep.

Loss and longing might be felt especially acutely as one rests the body and tries to transition into sleep. For the long nights of mourning are a time when those who are grieving a loved one are pressed to confront what they are achingly coming to realize is true: someone they love is no longer here with them on earth. That come morning, they will still be in mourning. If Missouri and Nathaniel Pettway routinely shared a bed, his missing presence would have perhaps been especially potent and palpable while lying under the

warm weight of her quilt of his clothes—the now empty space that had recently held his body figuring as stark evidence of his physical absence and his lingering scent serving as a direct door to memory.

Intimately associated with life and death, beds are bound with sickness, dying, and death as well as birth. Sites of healing and love as well as loss and remembrance, beds are where we often take our first breaths and sometimes our last ones. Following nearly a year of sickness and sorrow, Nathaniel Pettway likely died at home. Struggling for nearly a year with a terminal illness, he may have spent the very last part of his journey on earth in bed, as both caregiving and homegoing commonly happen here. Bound by bed and hopefully wrapped within a warm and comforting quilt, his shrouded body, likely weak and weary, readied for eternal rest. And during this extraordinarily difficult and delicate time—when life narrows to the four corners of the bed, while its meaning infinitely expands—Missouri Pettway may have sat bedside, caring for her husband, providing a reassuring presence and supporting his dying needs. Perhaps during his final hours, she, along with other family members, kept vigil posed in prayer.

The bed where Nathaniel Pettway made his transition may also have been the same one where Missouri mourned his loss. As such, it may have been both the site of his dying and his passage and a place of her mourning and remembrance. Moreover, this soft space where the husband and father was cared for before passing on and crossing over may have also been the site where the couple's children were conceived and first breathed life. This bed—their bed—was a place of passage. On it, with all hope, Missouri lay under her quilt of Nathaniel's clothes and fully experienced what she had expressly sought: "to remember him, and cover up under it for love." Embraced in this way by her quilt—tucked under its protective cover—she may have tended her grief, remembering her husband, who had recently lay dying and been laid to rest, processing his long illness and early death, facing her fears for their family's future, feeling the immensity and finality of her loss. Held and supported by the quilt of her own

creation, she likely sought the strength and found the faith to make it to morning and begin a new day. And ever so slowly—at the pace of healing—moving toward the time when the memory of her beloved would feel less like pain and more like peace, sustained by the love that lies here.

CODA

X

Pulled to This Place

1930s: American Red Cross disaster relief workers; Renwick C. Kennedy (Presbyterian minister and writer); Olive M. Stone (sociologist); Nathaniel S. Colley Sr. (Tuskegee Institute student and later lawyer and Tuskegee trustee); Alice Reid (sociologist); New Deal relief workers: teachers, nurses, agents, officers, managers, supervisors, and administrators; Farm Security Administration (FSA) photographers Arthur Rothstein and Marion Post Wolcott; John Temple Graves II (journalist); Beverly Smith (journalist); **1940s:** Robert Sonkin (folklorist); Sterling Brown (poet and literary critic); Morton Rubin (anthropologist); **1960s:** Martin Luther King Jr.; Francis X. Walter (Episcopal priest and activist); Elizabeth Walter (artist and art historian); Bob Adelman (photojournalist); William Hood (art historian); Nancy Scheper-Hughes (activist and later anthropologist too); Mary McCarthy (quilt maker and Freedom Quilting Bee manager); Lois Deslonde (home economist); Veronica Parker Boswel (VISTA volunteer); Lee Krasner (artist); Bernice Johnson Reagon (singer, activist, and consultant who facilitated appearance of Gee's Bend quilters at Smithsonian Folklife Festival in 1967 and 1968); Calvin Trillin (writer and one of about two hundred guests who attended the dedication of the Freedom Quilting Bee Sewing Center

in nearby Rehoboth on March 8, 1969); **1970s:** Mennonite farmers and conscientious war objectors; Maude Wahlman (art historian and quilt collector); Virginia Van der Veer Hamilton (historian); Kathryn Tucker Windham (writer); **1980s:** John Reese (photographer); Nancy Callahan (writer); Robert and Helen Cargo (art dealers and quilt collectors); M. G. Trend (anthropologist); John DiJulio and Bruce Kuerten (filmmakers); **1990s:** Roland Freeman (folklorist and quilt collector); J. R. Moehringer (writer); Clarence Williams (photographer); William Arnett (collector, dealer, and curator) and his business partner sons; **2000s:** Alvia Wardlaw (art historian and curator); Joe Minter (artist); Thornton Dial (artist); Lonnie Holley (artist); Amiri Baraka (writer and activist); Jane Fonda (actress and activist); Vanessa Vadim (filmmaker); Shelly Zegart (quilt collector and curator); Jane Livingston (art historian and curator); John Beardsley (art historian and curator); Joanne Cubbs (writer and curator); Linda Day Clark (photographer); Patricia Leigh Brown (journalist); Jeffrey Brown (journalist); Debbie Elliott (journalist); Linda Matchan (journalist); Amei Wallach (art critic); Bernard Herman (art and cultural historian); Johnnetta Cole (former college president and museum director); students and faculty affiliated with Auburn University's College of Architecture, Design, and Construction; Elyzabeth Gregory Wilder (playwright); Irene Latham (writer); Patricia McKissack (children's book author); John McCain (senator and presidential candidate); Bridget Cooks (art and cultural historian); **2010s:** Carol M. Highsmith (photographer); Lisa Gail Collins and family; Joe Cunningham (quilt maker); Bill Frisell (musician); Jason and Alicia Hall Moran (musicians); Maris Curran (filmmaker); James Ransome (artist) and Lesa Cline-Ransome (writer) . . .

Outside Visitors

Disaster relief workers were perhaps the earliest twentieth-century outside visitors to Gee's Bend. After the devastating raid of over sixty local families for their tools, animals, and crops during the fall of

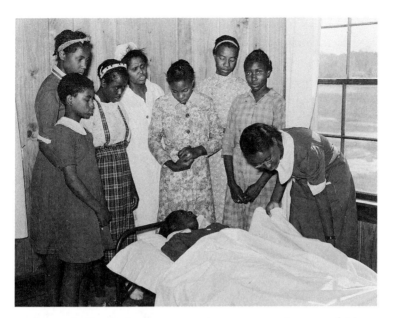

As part of a New Deal program, a nurse instructs an attentive group of girls (with one acting as a bedbound patient) on clinical bed making procedures. Arlonzia Pettway (with a scarf in her hair) stands second from the left. Marion Post Wolcott, *Nurse Shamburg Directs Group of Girls in Making Sick Bed in Clinic. Gee's Bend, Alabama*, 1939. Library of Congress, Prints & Photographs Division, FSA/OWI Collection, reproduction number LC-USF34-051583-D.

1932—amid the nation's Great Depression—many residents of Gee's Bend were on the verge of starvation. In response, the American Red Cross sent workers to the area to deliver emergency food and supplies during the dire winter of 1932–33. This encounter was the start of many. Throughout the Depression, numerous government agents and officers came to Gee's Bend to initiate, implement, administer, supervise, assess, and document a range of New Deal programs. Ever since, a steady stream of projects of various kinds—service, labor, research, creative, documentation, collecting—have taken place within this small Black farming community.

The pull to this place has been mighty. For nearly a century now, there has been a near continual procession of individuals from away

who have made their way here. They have come with a wide range of aims and intentions: to study, observe, and write; to assist, serve, and support; to work, grow, and learn; to speculate, share expertise, and offer advice; to preach and campaign; to gather data and conduct research; to test theories and pilot programs; to teach, tutor, and train; to hunt, fish, honeymoon, and vacation; to interview, photograph, record, and report; to gather source material for books, plays, films, and music; to explore, experience, and bear witness; to celebrate, honor, and share gratitude; and to buy and collect quilts. In many ways, the flow of this traffic echoes the extended history of outside visitors to the Sea Islands off the coast of South Carolina and Georgia, the small and at times isolated barrier islands, some of which were—from the colonial era until the Civil War—largely defined by the transatlantic slave trade and domestic slavery and ruthlessly run by enslavers as indigo, rice, and cotton plantations. Although sustained outside interest in the Atlantic coastal communities started earlier (during the mid-nineteenth century), like the Sea Islands, visitors from outside the community, myself included, have continually been drawn to Gee's Bend.

Some visitors to this land situated in a deep curve of the Alabama River have come from nearby Camden, the county seat just five miles south across the river yet about forty-five miles away by land. Others have traveled across a county line or two and come from other Black Belt locales such as Selma, Montgomery, and Tuskegee. Still others have trekked across state lines or even, in some cases, over international waters. Over the last century, recorded visitors to the area have included numerous religious figures—a Presbyterian minister, an Episcopal priest, a Catholic nun from Upstate New York, a lay sister from New Orleans, Mennonite farmers and conscientious observers, and, most famously, the Reverend Dr. Martin Luther King Jr., who delivered an electrifying speech in February 1965 at Pleasant Grove Baptist Church as part of the civil rights movement's catalytic voter registration campaign.[1] Other twentieth- and twenty-first-century visitors to Gee's Bend who have left a clear trail include sociologists

and social workers; photographers, filmmakers, and journalists; government agents and officers; agricultural experts and economists; teachers, tutors, and nurses; anthropologists, folklorists, and ethnomusicologists; civil rights activists; artists and art historians; singers and musicians; poets and literary critics; authors and playwrights; salespeople; quilt collectors, curators, and dealers; students and faculty of architecture, design, and planning; quilt makers, quilt enthusiasts, and cultural tourists; and at least one presidential candidate.[2]

For my own part, I have traveled three times to Gee's Bend: in 2012, 2014, and 2018. The second time, in April 2014, my family of four had the great pleasure of a night's homestay—for which we were charged and paid sixty dollars—with Mary Ann Pettway, expert quilt maker, singer, and manager of the Gee's Bend Quilters' Collective. The next day, after signing her brimming guest book, touring the town, visiting with Mary Lee Bendolph in her home, and seeing the quilts for sale at the community's former daycare center, we drew from the privilege of our savings and purchased a large denim and corduroy strip quilt made by our exceptionally kind, welcoming, and talented host for her suggested price of five thousand dollars.[3] Her quilt holds pride of place in our Hudson Valley home and continually reminds us of our altogether appreciated time in Gee's Bend.

Seeking and Finding

What has drawn such a steady succession of visitors to this African American farming community in the heart of Alabama's Black Belt for nearly a century? Not surprisingly, there is no one common thread. Instead, there are a whole host of forces and factors that have compelled so many of us, since the 1930s, to have either taken the ferry from the county seat of Camden (before it was shut down in 1962 by white county officials trying to suppress Black voting or after it reopened forty-four years later, in 2006, when the local quilters had gained international acclaim) or followed the ruts along County Road 29 to Gee's Bend. Driven by a range of reasons and an

assortment of impulses—blends of curiosity, compassion, conviction, concern, connection, and conceit—nonlocals, people whose family lines do not necessarily lead here, have continually sought out this now long-renowned Black Belt community. Time and time again, people rightly perceived by residents as "folks not from around here" have journeyed to this tiny epic place.

Some relatively recent clues about why so many people are drawn to Gee's Bend can be found by studying the ways visitors have expressed in writing their understandings and imaginings of the community, its significance, and their reasons for making the trip and devoting their time and energy. For instance, some researchers and writers point to the staggering history and striking demographics of Gee's Bend, keenly conscious that this is a community where many lifelong residents are descendants of kin who worked the area's cotton plantations during and after slavery and where some families continue to live on, or near, the land on which their enslaved ancestors were forced to labor. Perceiving this is a place where slavery and sharecropping and their ongoing legacies are evident, they see it as a site where the past inhabits the present and the present opens to the past.

As part of this explanatory thread, some who stress the significance of the particular past and present at Gee's Bend point not only to the deeply interwoven histories of labor and land but also to the rarity—and the promise—of this land in Black hands. Highlighting in this way the reality that since the New Deal, Gee's Bend has been a rare rural community comprised of a sizable number of African American homeowners and landowners. J. R. Moehringer's Pulitzer Prize–winning piece for the *Los Angeles Times* is a prime example of this interpretive thrust, this emphasis on Gee's Bend as unique due to the ways slavery, segregation, and the possession and habitation of the land happened here. Layering history and legend, Moehringer, in his acclaimed essay "Crossing Over," offers this understanding of the community, its significance, and how it came to be: "The South was once dotted with such places, where slaves lingered long after Lincoln freed them, most famously the sea islands off Georgia and

South Carolina. But Gee's Bend is the only place anyone can think of where the slaves did more than linger. They conquered. They outlasted the masters, bought back the plantation and lived upon it in blissful isolation, not a collection of historical anomalies, but a vast family, sharing the same few names and the same handful of fables, like some hybrid of Alex Haley and Gabriel García Márquez."[4]

Other visitors offer another angle—a related and overlapping one—on the community's uniqueness and why they were pulled to this place. Within their written rationales, they emphasize the distinctiveness of Gee's Bend in direct relation to its geographic location—its somewhat hard-to-reach and sometimes hard-to-leave setting within a deep river bend (despite significant out-migration nearly every decade since the early 1900s). Seeing the Alabama River surrounding Gee's Bend on three sides largely as a barrier, nonlocal observers and writers who lean toward this explanatory thread generally stress the location's seclusion, some likening it to a "river island" or a "virtual island."[5] Conceiving of the area as geographically remote and stressing its sociocultural separateness, they understand the community that took—and takes—shape here as both distinct and distinctive. John Beardsley, in his essay "River Island," a chapter in the exhibition catalog *The Quilts of Gee's Bend*, draws on and extends this interpretation of the place as unique because of its secluded setting. At the same time, however, the art historian and curator also ably unravels a central paradox of this seemingly hidden, hard-to-reach place: that it has also, again and again, been highly and successfully sought out. Elaborating on this key contradiction—that the continuing perception of the community as "isolated" and "separate" has worked to continually attract visitors and prompt various "incursions" and "interventions"—Beardsley writes: "Isolation occasionally seems to inspire its opposite in the Bend, in the incursions of people who would remake the community in their own image. A pattern of segregation disturbed by intervention has created a culture at Gee's Bend that, for all the clichés about the place, *is* unique. In some ways, the settlement *has* been an island: a place apart that attracts people precisely for its

separateness. And like an island, it has produced cultural, social, and religious practices more magnified, homogeneous, and sharply drawn than those of places more prone to cross-pollination."[6] Beardsley's wise words here also posit a relationship between the geography of Gee's Bend and some of its rituals and other cultural creations. Because of the community's similarities to an island (in terms of the way it is situated, imagined, and encountered), he suggests, the distinctiveness of its sociocultural forms is deeper and more apparent—"more magnified," he contends—than those created in places with busier two-way traffic and easier access to paved roads, highways, train stations, and airports.

More interested in the shapes of political and economic power than the forms of cultural expression, historian Cynthia Griggs Fleming, in her study of the struggles for civil rights in Wilcox County, also makes a critical case for the special significance of this small Black farming community centered around former cotton plantation land. Within her book *In the Shadow of Selma: The Continuing Struggle for Civil Rights in the Rural South*, the social movement scholar stresses the community's (as well as the larger area's) geographic and economic "isolation," the history and legacy of exploitative labor and systemic racism that underlie and inform it, and the surrounding county's persistent position near, or at, the bottom of many standard measures of social welfare. Sharing her understanding of the significance of this place, Fleming writes: "In fact, the significance of this southern, rural, impoverished, majority-black area is rooted in its isolation. It is both geographically and economically isolated from much of the rest of the South and the country, and it is that isolation that affords even the most casual observer an unobstructed view of the horrific consequences of more than two centuries of brutal racial oppression and economic exploitation on African Americans. . . . In the isolated environment of Wilcox County we can view this damning connection between past sins and present problems with frightening clarity."[7] As part of her explanation, Fleming posits that part of what makes this place unique is the vantage point, or view, it propels. Casting light

on why, in part, so many people have been pulled to this place, and why it has captured the imagination of many more, she contends that interested observers of this rural Black Belt community gain a sharp clear view of some of the horrors of human history—slavery, slave trading, sharecropping, disenfranchisement, impoverishment—that have happened here and beyond as well as some of the living legacies of these horrors of humanity, including strategies of survival, persistence, and resistance. Direct encounters with this descendant community of struggle and determination, she suggests, enable deeper understandings of these lasting injustices and continuing inequities as well as the reparative work that remains.

Citing history and myth, geography and demographics, poverty and isolation, community and creativity, struggle and activism, visitors to—and observers of—Gee's Bend have variously interpreted the community's significance and their reasons for making the journey to this land in a near loop of the Alabama River. And yet in what is understood and imagined and what is sought and found—despite some differences in emphasis and with much overlap—what is certainly shared is a profound pull to this long-storied place.

Collecting Quilts

Perhaps the first visitor to Gee's Bend to note the practice of quilt making and put to pen his experience purchasing a quilt was the poet Sterling Brown, a Howard University English professor. One hot summer Saturday in the early 1940s, as part of an extended visit with colleagues at Tuskegee Institute, the scholar of African American literature and culture made the seventy-five-mile trip south and west of the renowned Alabama school established by Booker T. Washington. Upon arrival—and after being introduced to two local quilt makers by their Tuskegee-trained host and guide—the poet and his travel partner, a physician, each purchased one of the residents' "brilliantly colored" quilts for six dollars apiece, the price requested by the makers.[8]

From at least the time of Sterling Brown's visit in the early 1940s—right around when Missouri Pettway was making her quilt—and continuing to the present day, many visitors to Gee's Bend and its neighboring communities have purchased quilts produced here. Quilts created here have consistently been sought, secured, and savored.[9] No visitor, however, has amassed as many quilts from the area centered around the town of Boykin as the late collector, dealer, promoter, and curator William Arnett. As the oft-told story goes, William Arnett's interest in the quilts of Gee's Bend was first inspired in 1997, upon seeing Roland Freeman's photograph of local quilt maker Annie Mae Young and her great-granddaughter, with two of Young's quilts spread out across a pile of logs behind them.[10] Freeman's color photograph was included in *A Communion of the Spirits: African-American Quilters, Preservers, and Their Stories*, his immersive survey based on more than twenty years of traveling across the nation—including a 1993 stop at Gee's Bend—to document quilts and their makers.

In his role as a private collector, William Arnett acquired hundreds and hundreds of quilts from more than 150 quilt makers, starting with his initial visits to Gee's Bend and nearby neighborhoods in 1997, with former Freedom Quilting Bee manager Mary McCarthy serving at times as his guide.[11] Journalists reporting in the early 2000s—while *The Quilts of Gee's Bend* exhibition was crisscrossing the country—estimated that the white Atlanta-based collector had acquired somewhere between 530 to over 700 quilts over the course of four or so years of collecting.[12] Estimates have varied not only on how much money Arnett spent in acquiring and purchasing the quilts but also on the average price paid for the quilts, the range of the payments, and the forms and scope of compensation. Writing for the *New York Times* on the day of the exhibition's opening at the Whitney Museum of American Art in November 2002, Patricia Leigh Brown reported that, according to Arnett, he had "paid an average of $275 each."[13] Around the same time, Barbara Pollack reported in *House and Garden* that the collector had "purchased more than 700 works in varying condition, for prices ranging from $2,500 to $100 apiece."[14] Adding to

these numbers, Linda Hales, writing for the *Washington Post* in 2004, when the exhibit was on view at the (now closed) Corcoran Gallery of Art, reported that some of the quilts were purchased for as little as $40 apiece.[15] The 2020 obituary for William Arnett published in the *Washington Post*, cited in his *New York Times* obituary, provided further figures concerning his collecting of quilts in and around Gee's Bend beginning in 1997: "Over four years, he bought more than 500 quilts for $1.3 million."[16]

William Arnett's collecting and dealing of a substantial portion of a community's surviving quilts has not been without legal challenge and controversy. Key issues concerning ownership, compensation, contracts, copyright and other forms of intellectual property, royalties, licensing, and marketing have been contested by some stakeholders both in and out of court.[17] For years the multiple moving arms of Arnett's and his family's business enterprise and its mix of corporate and nonprofit arms and branches—including Tinwood Alliance, Tinwood Books, Tinwood Media, Tinwood Ventures, Souls Grown Deep Foundation—sowed some confusion in terms of their various organizational structures and statuses, financial arrangements, partnerships, contracts, dealings, and products.[18] Maneuvering between the processes of discovering, collecting, brokering, and dealing and those of preserving, promoting, and profiting is always fraught, especially so when it centrally involves individuals who have long struggled against racism, discrimination, disenfranchisement, and economic injustice, and a community in which the pressures of poverty both predate its acclaim and continue to remain persistent and pervasive. As in 1940, when Nathaniel and Missouri Pettway were raising their family in Gee's Bend, sixty years later, in 2000, when William Arnett was actively collecting quilts in the area, Wilcox County was one of the poorest counties in the nation, and Gee's Bend was one of the poorest places within it. At the start of *The Quilts of Gee's Bend* exhibition in 2002, *New York Times* journalist Patricia Leigh Brown reported that the community was comprised of "300 families, where 42 percent of the residents earn less than $10,000 a year."[19]

It is also true that along with the criticism, confusion, and suspicion, there has also been strong praise voiced by numerous Gee's Bend quilt makers for William "Bill" Arnett, his four business partner sons, and the collection, exhibition, promotion, and preservation of their commanding quilts.[20] Powerful affirmations are recurrent within the firsthand testimonies, as several of the women artists—perhaps most notably Mary Lee Bendolph, Nettie Young, and Arlonzia Pettway—have attested to how the traveling exhibition was a life-affirming and life-enhancing experience for them, one that repeatedly pulled them out of Gee's Bend and propelled them to cities across the country for museum openings, gallery talks, award ceremonies, and television and radio segments. All three quilt makers shared publicly how the widely popular and highly celebrated exhibition and its aftermath enabled them to improve their lives economically and how they valued and benefited from the recognition and affirmation of their quilts, their community, and their lives. Conveying this view, including her gratitude and praise for William Arnett and his tireless promotion of her community's quilts, Nettie Young asserted: "Bill started this whole thing with the Gee's Bend quilts. . . . He has opened doors for the Gee's Bend women."[21] Arlonzia Pettway shared a similar sentiment: "The quilts have made a difference in the way I see myself getting up in the world."[22] Looking back on the exhibition and its aftermath in 2015—on the occasion of being named a NEA National Heritage fellow—Mary Lee Bendolph testified similarly: "I thank the Lord that my quilts could be out there in the world where people could enjoy them. And they would tell me how much they love the quilts that I had made."[23]

Purchases and Gifts

Acknowledging, respecting, and striving to hold all these telling truths in my head, I personally continue to carry questions and concerns. Thinking broadly, I worry and wonder: what happens to a community accustomed to living with and through quilts when an extensive

number of its extant quilts—the material legacies of a surviving history and a living tradition generations in the making—are collected and taken away? When the singular creations of an inheritance—the act and art of piecing together quilts—that was intently carried forward are carried off to be sold and stored and, in some cases, put on public display? When extraordinary objects and exceptional resources intimately interwoven with personal memory, family history, and community life are gone? And crucially, when all this is happening within a community that was established two centuries ago by way of grievous, life-claiming terrors of forced removal and migration, enslavement, exploitation, and extraction and whose surviving, freedom-seeking residents have continued ever since to struggle against the ongoing legacies of these human horrors, including systemic racism and discrimination, structural neglect, and limited economic and educational opportunities? Given this history and our present, outside claims of ownership and possession seem to me to be particularly potent, and worrying, here.

After Missouri Pettway's passing in 1981, Arlonzia Pettway, as she recounted, kept the quilt her mother had made while newly mourning the loss of her husband. According to her narration, the lifelong resident of Gee's Bend lived with it in her home for nearly two decades until William Arnett acquired it during one of his early collecting trips to her Black Belt community. Journalist Jeffrey Brown's 2003 interview with Arlonzia for the *PBS NewsHour* shines some light on the contours of this encounter and exchange:

JEFFREY BROWN: Arlonzia Pettway's mother made this quilt in 1942 out of her husband Nathaniel's old work clothes.

ARLONZIA PETTWAY: He had passed that year. And she said, "Lonnie, you know what I'm going to do? I'm going to take Nathaniel's old clothes and make a quilt out of it, where I can remember him."

JEFFREY BROWN: Arlonzia kept the quilt for its family meaning. But she says she was amazed when William Arnett first came to her home, and saw art.

ARLONZIA PETTWAY: He said, "oh, this is beautiful." I said, "how can the thing be beautiful? It got mud on the knee. Why, he used to crawl around and dig sweet potatoes." And he said, "oh, this is beautiful." I said, "Bill, you think that thing's beautiful?" He said, "this is beautiful." It must be, hanging up in a museum.[24]

Based on this conversation as well as the full transcript from which it came, it seems Arlonzia Pettway willingly sold, or otherwise transferred, her mother's quilt to William Arnett and, a few years later, was pleased and proud to be present at both the Museum of Fine Arts, Houston, and the Whitney Museum of American Art in New York and to see it prominently displayed and eagerly appreciated.

Writer Andrew Dietz also shines some light on the acquisition, display, and reception of Missouri Pettway's handmade quilt. In his book on William Arnett called *The Last Folk Hero: A True Story of Race and Art, Power and Profit*, Dietz recounts an exchange he witnessed between William Arnett and the artist Thornton Dial concerning Missouri Pettway's quilt composed of her late husband's clothes. According to Dietz, on the day that art critic Michael Kimmelman's glowing review of *The Quilts of Gee's Bend* exhibition at the Whitney appeared in the *New York Times* (November 29, 2002), Arnett visited Dial at his Bessemer, Alabama, home with a copy of the newspaper in hand. While the two were discussing the catalytic review, Dietz heard this exchange:

"You remember Arlonzia Pettway?" Arnett asks Dial. "There's a quilt in the Gee's Bend show that Arlonzia's mother made about sixty years ago. When her husband died she took his old dirty clothes and cut them up and made a quilt to honor him. This was in 1941 or '42. So at the exhibition some woman comes up to Arlonzia and asks, 'Are you sorry you sold this quilt?' and Arlonzia says, 'If I hadn't sold it to Bill Arnett it would have ended up getting torn up and thrown away, and now it's up on a wall in a museum and we're all proud to be able to come see it.'"

"That was great. That was really great," Dial says.

"They were trying to get Arlonzia to say, 'Yeah, I'm really sorry I sold that, and I wish I had it back.' They're trying to play that shit up," Arnett complains.[25]

As I've shared, I continue to worry and wonder about the dynamics behind the transfer of this quilt (and others), given our nation's enduring structures and systems of inequality and inequity. Since 2014 William Arnett (who passed away in August 2020) and the Souls Grown Deep Foundation he founded have been strategically gifting and selling works from their extensive collection of art by African American artists, including many quilts from Gee's Bend, to major arts institutions across the country (and, increasingly, outside the United States). Beginning with a transfer of fifty-seven works, including twenty quilts by artists based in and around Gee's Bend, to the Metropolitan Museum of Art in November 2014, there has been a steady, well-publicized stream of selling and gifting—accompanied by press releases, newspaper coverage, related exhibitions, publications, and public relations announcements.[26] Some of the other arts institutions that have acquired work from the foundation's collection through gift-purchase agreements include the High Museum of Art; Museum of Fine Arts, Boston; New Orleans Museum of Art; Philadelphia Museum of Art; Fine Arts Museums of San Francisco; Montgomery Museum of Fine Arts; Ackland Art Museum at the University of North Carolina at Chapel Hill; Minneapolis Institute of Art; Dallas Museum of Art; and the Phillips Collection in Washington, DC.[27]

Over the years, as notice of these acquisitions appeared in my inbox, I would routinely scan the accompanying roster to see if it included Missouri Pettway's quilt made in mourning. While working on this project, I assumed her quilt, when not being exhibited, remained folded or rolled up in an Atlanta-area storage facility. I had seen Missouri's quilt twice: at the Whitney Museum in 2003 (years before I began this project) and at Nashville's Frist Art Museum in 2012 (at the start of my research). Then, on December 28, 2020—at the end of a year altogether shaped by overlapping pandemics, compounding

crises, loss, and grief—another press release crossed my desk. This one announced: "National Gallery of Art Acquires Forty Works by African American Artists from Souls Grown Deep Foundation."[28] As was now my custom, I promptly looked at the list of acquisitions. With some surprise and unease, I saw Missouri's quilt on it, listed as "*Blocks and Strips Work-Clothes Quilt*, 1942." Her quilt—which, it seems, had been held by her family for nearly two decades and then, when not on display, warehoused in its collector's storage facility for at least another twenty years—would now be part of the holdings of the National Gallery of Art.[29] The press release explained that Missouri Pettway's quilt, like the other acquired works, was obtained from the Souls Grown Deep Foundation through a gift-purchase agreement, a mix of proffering and sales.

But for me the question remains: was Missouri Pettway's quilt—her tender textile elegy, which carries the palpable presence of its maker; her beloved husband, whom she sought to remember; and their eldest daughter, who shared its story and the memory of its making—truly theirs to give? As someone who has had the gift of dwelling on this extraordinary, exemplary quilt for over a decade now, I am not so sure. Recently, I had the good fortune to see Missouri's quilt made in mourning in its new home on the National Mall in Washington, DC. Once again, it drew me in, close and still. I experienced the quilt in the exceptionally skilled and thoughtful presence of its current steward, the senior conservator of textiles at the National Gallery of Art, who is fully committed to its long-term care. I look forward to visiting Missouri's quilt regularly and continuing to learn from its essential lessons (and sincerely hope others do too). At the same time, I can also imagine a loving heir or someone with close ties to the quilt and its source community wanting it close to home, or close at hand, and seeking its rightful return. Right now—when the world is broken open and humanity is in search of hope—it seems to me that what matters most is honoring the needs and wishes of the descendants of the creator of this wholly precious utility quilt.

NOTES

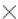

Introduction

1. Arlonzia Pettway, quoted in John Beardsley, William Arnett, Paul Arnett, Jane Livingston, and Alvia Wardlaw, *The Quilts of Gee's Bend* (Atlanta: Tinwood Books, 2002), 67. Regarding the statements made by Arlonzia Pettway included in the book, the "Notes on the Interviews" section explains that the statements are taken from interviews conducted by William Arnett, collector, curator, and founder of the Souls Grown Deep Foundation, in August 2000 and February 2001 (181). Arlonzia Pettway's recollected chronology of her family history, an outgrowth of these interviews, appears in Shelly Zegart and Paul Arnett, "My Way" (92–97). In a 2003 PBS interview with Jeffrey Brown, Arlonzia Pettway (known as "Lonnie" by her family) also shared the history of this quilt her mother made soon after the passing of her husband, Nathaniel Pettway. Discussing her parents, she explained: "He had passed that year. And she said, 'Lonnie, you know what I'm going to do? I'm going to take Nathaniel's old clothes and make a quilt out of it, where I can remember him.'" Jeffrey Brown, "The Quilts of Gee's Bend," *PBS NewsHour,* July 1, 2003.

2. Here I am borrowing a concept from Eli Leon. See his book *Models in the Mind: African Prototypes in American Patchwork* (Winston-Salem, NC: Diggs Gallery, 1992). Missouri Pettway's quilt was first published in William Arnett and Paul Arnett, eds., *Souls Grown Deep: African American Vernacular Art* (Atlanta: Tinwood Books, 2001), 2:23.

3. Arlonzia Pettway, in J. Brown, "Quilts of Gee's Bend."

4. In 1937 Renwick Kennedy, a Presbyterian minister, writer, and resident of nearby Camden, Alabama, estimated that the population of Gee's

Bend—defined by him as the eleven thousand–acre area at the lower end of the Bend (the area most enclosed by the river's near loop)—included approximately 700 African American residents and one white family. Kennedy also estimated that the greater Gee's Bend area, the area extending north from the lower end and including some twenty-three thousand acres—had a population of 1,400 African American residents and 5 or 6 white families. Renwick C. Kennedy, "Life at Gee's Bend," *Christian Century* 54:35, September 1, 1937, 1072. At present the southern end of the Bend is officially known as Boykin, and the neighborhood is centered around the post office on County Road 29 (zip code 36723), with an estimated population of 230 residents, while the greater Gee's Bend area, largely served by the Alberta Post Office (zip code 36720), has an estimated population of about 1,000 residents.

5. Throughout this book, I rely on the family-determined birth date (December 3, 1900) inscribed on Missouri Pettway's headstone resting in the cemetery behind Pleasant Grove Missionary Baptist Church. The 1940 census lists seven sons and three daughters as living in Nathaniel and Missouri Pettway's household in Gee's Bend, Wilcox County, Alabama.

6. Amelia Peck, "Quilt/Art: Deconstructing the Gee's Bend Quilt Phenomenon," in *My Soul Has Grown Deep: Black Art from the American South*, by Cheryl Finley, Randall Griffey, Amelia Peck, and Darryl Pinckney (New York: Metropolitan Museum of Art, 2018), 67.

7. Original exhibition venues (2002–8) included: Museum of Fine Arts, Houston; Whitney Museum of American Art; Mobile Museum of Art; Milwaukee Art Museum; Corcoran Gallery of Art; Cleveland Museum of Art; Chrysler Museum of Art; Memphis Brooks Museum of Art; Museum of Fine Arts, Boston; Jule Collins Smith Museum of Fine Art at Auburn University; High Museum of Art; de Young Museum; and the Museum of Art, Fort Lauderdale. There was also a sequel traveling exhibition that included quilts from the original exhibition called *Gee's Bend: The Architecture of the Quilt*, curated by William Arnett and Alvia Wardlaw, which opened at the Museum of Fine Arts, Houston, in 2006 and traveled to eight museums between June 2006 and December 2008.

8. *The Quilts of Gee's Bend* exhibition varied somewhat in size across the various venues. For a glowing and catalytic review, see Michael Kimmelman, "Jazzy Geometry, Cool Quilters," *New York Times*, November 29, 2002. For a crucial critique of the dominant evaluative comparison of the quilts to modern abstract painting, see Ulysses Grant Dietz, "From under the Bedcovers:

A Culture Curator's Perspective," in *Unconventional & Unexpected: American Quilts below the Radar, 1950–2000*, ed. Roderick Kiracofe (New York: Stewart, Tabori, & Chang, 2014), 143. See also Amelia Peck, "Quilt/Art: Deconstructing the Gee's Bend Quilt Phenomenon," in *My Soul Has Grown Deep: Black Art from the American South*, by Cheryl Finley, Randall Griffey, Amelia Peck, and Darryl Pinckney (New York: Metropolitan Museum of Art, 2018), 53–91. For a contemporaneous critique of the exhibition, see Thelma Golden, "The Quilts of Gee's Bend," *Artforum International* 42:4 (December 2003): 126; see also "To the Editor," a rebuttal to Golden's review by Rennie Young Miller "on behalf of the fifty-four quilters of Gee's Bend," in *Artforum International* 42:7 (March 2004): 22. For other helpful discussions of the exhibition and responses to it, see Bridget R. Cooks, "Back to the Future: *The Quilts of Gee's Bend*, 2002," *Exhibiting Blackness: African Americans and the American Art Museum* (Amherst: University of Massachusetts Press, 2011), 135–54; and Bridget R. Cooks, "The Gee's Bend Effect," *Textile: Journal of Cloth and Culture* 12:3 (November 2014): 346–65.

Chapter One | Woven within the Land

1. Arlonzia Pettway, in *Do Not Go Gently: The Power of Imagination in Aging*, dir. Melissa Godoy (Green Bay, WI: Newist / CESA 7, 2007).

2. Patricia Leigh Brown, "From the Bottomlands, Soulful Stitches," *New York Times*, November 21, 2002; Arlonzia Pettway, in *Do Not Go Gently*.

3. Census data lists the population of Gee's Bend (Precinct 17) as 1,169 in 1900 and as 976 in 1910. My understanding of Gee's Bend during the 1930s is informed in part by the Presbyterian minister and nearby Camden resident Renwick C. Kennedy's close-to-primary published accounts: "Rehabilitation: Alabama Version," *Christian Century* 51:46, November 14, 1934, 1455–57; "Roosevelt's Tenants," *Christian Century* 52:19, May 8, 1935, 608–10; "Life at Gee's Bend," *Christian Century* 54:35, September 1, 1937, 1072–75; and "Life Goes On at Gee's Bend," *Christian Century* 55:50, December 14, 1938, 1546–47.

4. Arlonzia Pettway, quoted in Shelly Zegart and Paul Arnett, "My Way," in John Beardsley, William Arnett, Paul Arnett, Jane Livingston, and Alvia Wardlaw, *The Quilts of Gee's Bend* (Atlanta: Tinwood Books, 2002), 94. Arlonzia Pettway's recollected chronology of her family history is an outgrowth of interviews with her conducted by William Arnett, collector, curator, and founder of the Souls Grown Deep Foundation, in August 2000 and February 2001.

5. For a close account of the raiding of 368 people—68 families—living on

Gee's Bend during the fall of 1932 as well as the disastrous impact of the raid, see Kennedy, "Rehabilitation," 1455–56.

6. Amei Wallach, "Fabric of Their Lives," *Smithsonian Magazine*, October 2006.

7. Kathryn Tucker Windham, *Twice Blessed* (Montgomery, AL: Black Belt Press, 1996), 31.

8. Arlonzia Pettway, in *The Quiltmakers of Gee's Bend*, dir. Celia Carey (Birmingham: Alabama Public Television, 2004).

9. Arlonzia Pettway, quoted in Wallach, "Fabric of Their Lives."

10. Throughout the twentieth century and continuing into the twenty-first century (despite the acclaimed quilts), Wilcox County, Alabama, has been one of the poorest counties in the nation. The Economic Research Service of the US Department of Agriculture consistently ranks this rural Black Belt county in the lowest per capita income quintile. For the Gee's Bend (Boykin) community, according to 2019 census estimates, median household income was $12,292, per capita income was $8,650, and 55.8 percent of the population (of 269) was living below the poverty line.

11. Nettie Young, in *The Quilts of Gee's Bend*, dir. Matt Arnett and Vanessa Vadim (Atlanta: Tinwood Media, 2006). Nettie Young was born in the neighboring community of Rehoboth, a few miles up County Road 29 from the heart of Gee's Bend; she moved down to Gee's Bend around 1955.

12. Arlonzia Pettway, in Carey, *Quiltmakers of Gee's Bend*, production interview.

13. Arlonzia Pettway, quoted in Beardsley, W. Arnett, P. Arnett, Livingston, and Wardlaw, *Quilts of Gee's Bend*, 67.

14. For a concise overview of the site, see John H. Blitz, *Moundville* (Tuscaloosa: University of Alabama Press, 2008).

15. Vincas P. Steponaitis and C. Margaret Scarry, "New Directions in Moundville Research," in *Rethinking Moundville and Its Hinterland*, ed. Vincas P. Steponaitis and C. Margaret Scarry (Gainesville: University Press of Florida, 2016), 2–3.

16. C. Margaret Scarry and Vincas P. Steponaitis, "Moundville as a Ceremonial Ground," in Steponaitis and Scarry, *Rethinking Moundville*, 256.

17. Blitz, *Moundville*, 13–19. See also Erin E. Phillips, "The Distribution of Hemphill-Style Artifacts at Moundville," in Steponaitis and Scarry, *Rethinking Moundville*, 99–120. Also see the section on Moundville in *Visualizing the Sacred: Cosmic Visions, Regionalism, and the Art of the Mississippian World*, ed.

George E. Lankford, F. Kent Reilly III, and James F. Garber (Austin: University of Texas Press, 2011).

18. Vincas P. Steponaitis and Vernon J. Knight Jr., "Moundville Art in Historical and Social Context," in *Hero, Hawk, and Open Hand: American Indian Art of the Ancient Midwest and South*, ed. Richard F. Townsend (Chicago: Art Institute of Chicago, 2004), 175. See also Steponaitis and Scarry, "New Directions in Moundville Research," 14–15.

19. F. Kent Reilly III, "Thoughts on the Preservation of Traditional Culture: An Interview with Joyce and Turner Bear," in Townsend, *Hero, Hawk, and Open Hand*, 188. In her interview Joyce Bear also discusses the living tradition of leaving items with the departed, including blankets and quilts, for use as they pass from this life and make their journey (188). See also the "Mounds of the Chickasaw Homeland" resource on the Chickasaw Nation website, https://chickasaw.net/Our-Nation/Heritage/Mounds-of-the-Chickasaw -Homelands.aspx.

20. Nancy Callahan, *The Freedom Quilting Bee* (1987; reprint, Tuscaloosa: University of Alabama Press, 2005), 32.

21. Callahan, *Freedom Quilting Bee*, 32.

22. The 1820 Alabama State Census, including population schedule, Wilcox County. The Alabama census lists the total population of Wilcox County in 1820 as 2,755 people (1,395 white individuals and 1,360 persons of African descent).

23. For histories of the Federal Road—which, during the trek Joseph Gee commanded in 1816, sought to connect Washington, DC, and New Orleans—see Henry deLeon Southerland Jr. and Jerry Elijah Brown, *The Federal Road through Georgia, the Creek Nation, and Alabama, 1806–1836* (Tuscaloosa: University of Alabama Press, 1989); and Angela Pulley Hudson, *Creek Paths and Federal Roads: Indians, Settlers, and Slaves and the Making of the American South* (Chapel Hill: University of North Carolina Press, 2010). See also Claudio Saunt, *Unworthy Republic: The Dispossession of Native Americans and the Road to Indian Territory* (New York: Norton, 2020).

24. Hudson, *Creek Paths and Federal Roads*, 117.

25. Equal Justice Initiative, *Slavery in America: The Montgomery Slave Trade* (Montgomery, AL: Equal Justice Initiative, 2018), 27.

26. See Blue Clark, "Alabama-Quassarte," chapter in *Indian Tribes of Oklahoma: A Guide*, 2nd ed. (Norman: University of Oklahoma Press, 2020), 28–29.

27. Kathryn Tucker Windham, "They Call It Gee's Bend," unpublished

narrative history of Gee's Bend, in Gee's Bend Project Papers and Photographs, Department of Archives and Manuscripts, Birmingham (AL) Public Library, 3.

28. Harvey H. Jackson III, *Rivers of History: Life on the Coosa, Tallapoosa, Cahaba, and Alabama* (Tuscaloosa: University of Alabama Press, 1995), 195; Windham, *Twice Blessed*, 28; Callahan, *Freedom Quilting Bee*, 32.

29. The Founding of Gee's Bend plaque, erected May 2010 by the Alabama Tourism Department and the Community of Gee's Bend, reads: "Local legend suggests that the Gees operated a slave trading business at the Bend between Alabama and North Carolina." Sociologist Olive M. Stone compiled a "Chronology of Gee's Bend's Economy" during the 1940s. Under the heading "1830 (or early 1830s)," Stone writes: "Peninsula of about 10,000 acres purchased by Charles & Sterling Gee of Halifax, North Carolina, who established headquarters for slave trading on the new property. Charles Gee ran the Alabama end of the deal and two nephews, John and Mark Pettway, were in charge at the N.C. end." Her chronology is filed in Gee's Bend Project Papers and Photographs, Department of Archives and Manuscripts, Birmingham Public Library.

30. Wilma Dykeman and James Stokely, *Seeds of Southern Change: The Life of Will Alexander* (Chicago: University of Chicago Press, 1962), 311.

31. Windham, "They Call It Gee's Bend," 6.

32. Windham, *Twice Blessed*, 29.

33. Jackson, *Rivers of History*, 195; Windham, "They Call It Gee's Bend," 4–5; Callahan, *Freedom Quilting Bee*, 32.

34. US Census for 1840, Halifax County, North Carolina.

35. US Census for 1850, including slave population schedule, Wilcox County, Alabama. Drawing on public records, Windham states that 101 enslaved persons were transferred from Sterling and Charles Gee to Mark H. Pettway as part of the deeding of Joseph Gee's estate. "They Call It Gee's Bend," 4.

36. George W. Featherstonhaugh, *Excursion through the Slave States* (New York: Harper and Brothers, 1844), 152.

37. Kathryn Tucker Windham, "Interview with Clint Pettway," September 25, 1980, in Gee's Bend Project Papers and Photographs, Department of Archives and Manuscripts, Birmingham Public Library, transcript, 1. See also Windham, *Twice Blessed*, 40–41.

38. Windham, "Interview with Clint Pettway," 15–16. Clinton Pettway's memory is also reminiscent of the extraordinary family history Tiya Miles eloquently unearths in *All That She Carried: The Journey of Ashley's Sack, a Black Family Keepsake* (New York: Random House, 2021).

Chapter Two | Carrying History and Memory

1. Arlonzia Pettway, quoted in John Beardsley, William Arnett, Paul Arnett, Jane Livingston, and Alvia Wardlaw, *The Quilts of Gee's Bend* (Atlanta: Tinwood Books, 2002), 67.

2. Linda Matchan, "With These Hands," *Boston Globe*, May 15, 2005.

3. Accompanying Linda Matchan's article in the *Boston Globe* online is "The Path," in its entirety, as well as an audio recording of Arlonzia Pettway reading her February 2005 poem, www.boston.com/ae/theater_arts/articles/2005/05/13 /Arlonzia_Pettways_poem.

Contemporary quilt maker Loretta P. Bennett (b. 1960), a relative of Arlonzia—Arlonzia was her mother's first cousin—shares a similar realization regarding her quilt making inheritance: "I came to realize that my mother, her mother, my aunts, and all the others from Gee's Bend had sewn the foundation, and all I had to do now was thread my own needle and piece a quilt together." Loretta P. Bennett, "Dinah, Sally, Tank, Mother, and Me," in *Gee's Bend: The Architecture of the Quilt*, ed. Paul Arnett, Joanne Cubbs, and Eugene W. Metcalf Jr. (Atlanta: Tinwood Books, 2006), 163.

4. Matchan, "With These Hands."

5. Patricia Leigh Brown, "From the Bottomlands, Soulful Stitches," *New York Times*, November 21, 2002.

6. The 1880 census lists Dinah Miller as twenty-six years of age (b. ca. 1854) and living in a household with her husband, Gasway Miller (age twenty-seven); a son, Shade (age five); and two daughters (Minerva, age nine, and Sallie, age three). Difficult to discern, the 1900 census seems to list Dinah Miller's birth date as 1850. Alabama death records give a birth date of "abt 1848" and a death date of July 31, 1933, for Dinah Miller (recorded in the Deaths and Burials Index as "Denale Miller").

7. Arlonzia Pettway, quoted in Shelly Zegart and Paul Arnett, "My Way," in Beardsley, W. Arnett, P. Arnett, Livingston, and Wardlaw, *Quilts of Gee's Bend*, 92.

8. Arlonzia Pettway, in Jeffrey Brown, "The Quilts of Gee's Bend," *PBS NewsHour*, July 1, 2003. Brown, in "From the Bottomlands," a wonderful piece partly based on interviews in Gee's Bend, including with Arlonzia Pettway during the fall of 2002, understands this quilt somewhat differently. Brown writes about Arlonzia Pettway: "As a little girl . . . would sit with her siblings and baby cousins on her great-grandmother's string quilt every day after the

noontime dinner. Grandmama Dinah Miller, a slave who died at age 102 in the 1930s, would lay down the quilt, the single material legacy of her mother, on the gaping floorboards as protection from the wind, cold, and dust. Then the stories unfolded."

9. Arlonzia Pettway's recollected chronology of her family history, an outgrowth of interviews conducted by William Arnett in August 2000 and February 2001, is included in Zegart and P. Arnett, "My Way," 92–96. Arlonzia Pettway also shared parts of her family history in numerous interviews prompted by the traveling exhibition. She also shares the story of her great-grandmother Dinah coming over from Africa right before the outbreak of the Civil War and being sold in the United States and permanently separated from her mother, father, and brother, in the documentary *The Quiltmakers of Gee's Bend*, dir. Celia Carey (Birmingham: Alabama Public Television, 2004).

10. Arlonzia Pettway, quoted in Brown, "From the Bottomlands."

11. Congress approved and President Thomas Jefferson signed into law an act outlawing the importation of enslaved people into the United States effective January 1, 1808.

12. Arlonzia Pettway, quoted in Zegart and P. Arnett, "My Way," 92.

13. Digitized online archival collection Born in Slavery: Slave Narratives from the Federal Writers' Project, 1936 to 1938, Library of Congress, https://www.loc.gov/collections/slave-narratives-from-the-federal-writers-project-1936-to-1938/about-this-collection.

14. It is likely that Dinah Miller (ca. 1848–54 to ca. 1930) was sharing her life story with her young kin around the same time Oluale Kossola, known in the United States as Cudjo Lewis (ca. 1841–1935), was sharing his life story with the novelist and anthropologist Zora Neale Hurston in Mobile. In July 1927 Hurston first began interviewing the then eighty-six-year-old formerly enslaved Yoruba man, who had been taken captive during a raid at age nineteen, in 1860, and then held in the barracoons at the port of Ouidah before being forced on a slave ship bound for Alabama. Cudjo Lewis died in 1935 in Africatown, Alabama, a small settlement north of Mobile he helped found, and was the last survivor of the *Clotilda*, the last recorded slave ship to the United States. Zora Neale Hurston, *Barracoon: The Story of the Last "Black Cargo,"* ed. Deborah G. Plant (New York: Amistad, 2018), xiii, 6. See also Sylviane A. Diouf, "Cudjo Lewis" (2007, 2009) and "Africatown" (2007, 2021), in *Encyclopedia of Alabama*, http://encyclopediaofalabama.org.

15. Michael A. Gomez, *Exchanging Our Country Marks: The Transformation of*

African Identities in the Colonial and Antebellum South (Chapel Hill: University of North Carolina Press, 1998), 199–210.

16. Gomez, *Exchanging Our Country Marks*, 200–201.

17. Gomez, *Exchanging Our Country Marks*, 207. Gomez writes, "The trade in African slaves usually required the consent and cooperation of African polities of varying types, from large empires to small homesteads" (206). In her foreword, "Those Who Love Us Never Leave Us Alone with Our Grief," to Zora Neale Hurston's narrative of Cudjo Lewis, Alice Walker offers insight on why the narrative, which was completed in 1931, was not published until 2018. Walker writes:

> Reading *Barracoon*, one understands immediately the problem many black people, years ago, especially black intellectuals and political leaders, had with it. It resolutely records the atrocities African peoples inflicted on each other, long before shackled Africans, traumatized, ill, disoriented, starved, arrived on ships as "black cargo" in the hellish West. Who could face this vision of the violently cruel behavior of the "brethren" and the "sistren" who first captured our ancestors? Who would want to know, via a blow-by-blow account, how African chiefs deliberately set out to capture Africans from neighboring tribes, to provoke wars of conquest in order to capture for the slave trade—men, women, children—who belonged to Africa? And to do this in so hideous a fashion that reading about it two hundred years later brings waves of horror and distress. This is, make no mistake, a harrowing read. (Hurston, *Barracoon*, x)

Hurston acknowledges the paradigm shift she experienced after taking in Cudjo Lewis's life story: "One thing impressed me strongly from this three months of association with Cudjo Lewis. The white people had held my people in slavery here in America. They had bought us, it is true and exploited us. But the inescapable fact that stuck in my craw, was: my people had *sold* me and the white people had bought me. That did away with the folklore I had been brought up on—that the white people had gone to Africa, waved a red handkerchief at the Africans and lured them aboard ship and sailed away." Zora Neale Hurston, *Dust Tracks on a Road: An Autobiography* (New York: HarperCollins, 1996), 165. Deborah Plant quotes this passage in her afterword to *Barracoon* (124–25).

18. Gomez, *Exchanging Our Country Marks*, 199.

19. Gomez, *Exchanging Our Country Marks*, 208.

20. Arlonzia Pettway, in Carey, *Quiltmakers of Gee's Bend*.

21. Arlonzia Pettway, quoted in Zegart and P. Arnett, "My Way," 92.

22. Federal Writers' Project, interview with Josephine Howard, Texas, 1936, *Born in Slavery: Slave Narratives from the Federal Writers' Project, 1936 to 1938*, vol. 16, https://www.loc.gov/item/mesn162.

23. Virginia Van der Veer Hamilton, *Seeing Historic Alabama: Fifteen Guided Tours* (Tuscaloosa: University of Alabama Press, 1982), 143.

24. The Trans-Atlantic Slave Trade Database, Slave Voyages, Voyage ID# 36990, *Clotilda* (1860), https://www.slavevoyages.org/voyages/WxrDIrrn. In 2018 researchers aided by the Smithsonian's National Museum of African American History and Culture found, and a year later positively identified, the wrecked ship in Alabama's Mobile River. Allison Keyes, "The 'Clotilda,' the Last Known Slave Ship to Arrive in the US, Is Found," *Smithsonian Magazine*, May 22, 2019.

25. Sylviane A. Diouf, *Dreams of Africa in Alabama: The Slave Ship "Clotilda" and the Story of the Last Africans Brought to America* (New York: Oxford University Press, 2007), 72. See also Sylviane A. Diouf, "The Last Slave Ship," *National Geographic* (February 2020).

26. Diouf, *Dreams of Africa in Alabama*, 4.

27. Diouf, *Dreams of Africa in Alabama*, 6. Shelly Zegart and Paul Arnett state that Arlonzia Pettway was unaware of the *Clotilda* in 2000–2001, when she was interviewed by William Arnett. They posit that perhaps the surname Miller was derived from Meaher, the ship's owner. See Zegart and P. Arnett, "My Way," 92.

28. Arlonzia Pettway, quoted in Zegart and P. Arnett, "My Way," 92; Arlonzia Pettway, in *The Quiltmakers of Gee's Bend*, dir. Celia Carey, transcript.

29. Arlonzia Pettway, quoted in Zegart and P. Arnett, "My Way," 92–93. Loretta P. Bennett remembers her grandfather Tank describing his mother Sally as being both African American and Native American. See Bennett, "Dinah, Sally, Tank, Mother, and Me," 158.

30. The 1880 census lists Sallie Miller as three years of age (b. ca. 1877) and living in a household with her father, Gasway Miller; mother, Dinah Miller; sister, Minerva (age nine), and brother, Shade (age five). Alabama death records list a birth date of July 10, 1876, and a death date of July 11, 1943, for Sallie Miller (recorded in the Deaths and Burials Index as "Sallie Pettwag").

31. Arlonzia Pettway, quoted in Zegart and P. Arnett, "My Way," 93.

32. Arlonzia Pettway, quoted in Zegart and P. Arnett, "My Way," 93.

33. Another possible piece to this story is that Mark H. Pettway, in his will filed in Wilcox County in July 1860, left his daughter Lucy "a girl named Dinah." This child, of course, may or may not have been Arlonzia Pettway's great-grandmother. See Amei Wallach, "The Living Legacy of Dinah the Slave," in Arnett, Cubbs, and Metcalf, *Gee's Bend*, 144.

Chapter Three | Seeking Sanctuary

1. Mary Lee Bendolph, in *The Quiltmakers of Gee's Bend*, dir. Celia Carey (Birmingham: Alabama Public Television, 2004). For more on links between quilting and spirituality, see Carolyn Mazloomi, *Spirits of the Cloth: Contemporary African-American Quilts* (New York: Clarkson Potter, 1998); Carolyn Mazloomi and Patricia C. Pongracz, *Threads of Faith: Recent Works from the Women of Color Quilters Network* (New York: American Bible Society, 2004); and Bernard L. Herman, "Architectural Definitions," in *Gee's Bend: The Architecture of the Quilt*, ed. Paul Arnett, Joanne Cubbs, and Eugene W. Metcalf Jr. (Atlanta: Tinwood Books, 2006), 206–18.

2. Essie Pettway, in *While I Yet Live*, dir. Maris Curran (New York: Nightshade Films, 2018).

3. Arlonzia Pettway, in *Do Not Go Gently: The Power of Imagination in Aging*, dir. Melissa Godoy (Green Bay, WI: Newist / CESA 7, 2007).

4. Patricia Turner, *Crafted Lives: Stories and Studies of African American Quilters* (Jackson: University Press of Mississippi, 2009). Jeanette Rivers explained: "I don't know what I would have done without quilting when my husband died. I made eight quilts since he passed" (23). See also Elliott Chambers's account of transforming his late wife's clothes into quilts.

5. Ora Knowell, quoted in Turner, *Crafted Lives*, 63.

6. Marion Coleman, quoted in Turner, *Crafted Lives*, 70.

7. Daisy Anderson Moore, quoted in Turner, *Crafted Lives*, 31.

8. Rose Perry Davis, quoted in Maude Southwell Wahlman, *Signs and Symbols: African Images in African American Quilts* (1993; reprint, Atlanta: Tinwood Books, 2001), 15.

9. Pearlie Jackson Posey, quoted in *Signs and Symbols*, 18–19.

10. Roland L. Freeman, *A Communion of the Spirits: African-American Quilters, Preservers, and Their Stories* (Nashville: Rutledge Hill Press, 1996), 106. Betty Tolbert Taylor (1897–1978) was a quilt maker and traditional healer Roland Freeman met in Roxie (Franklin County), Mississippi, in 1975. He

acquired some of her quilts and placed a piece of one of them in his newly deceased grandmother Goldie's hand just before they closed her casket. See Freeman, *Communion of the Spirits*, 58. See also Roland Freeman, *Something to Keep You Warm: The Roland Freeman Collection of Black American Quilts from the Mississippi Heartland* (Jackson: Mississippi Department of Archives and History, 1981).

11. Carolyn Mazloomi, *Quilting African American Women's History: Our Challenges, Creativity, and Champions* (Wilberforce, OH: National Afro-American Museum and Cultural Center, 2008).

12. Marjorie Diggs Freeman, quoted in Mazloomi, *Quilting African American Women's History*, 56.

13. Nettie Young, quoted in Patricia McKissack, *Stitchin' and Pullin': A Gee's Bend Quilt* (New York: Random House, 2008), author's note.

14. Elisabeth Kübler-Ross and David Kessler, *On Grief and Grieving* (New York: Scribner, 2005), 227, 203, 33, 36.

15. Kübler-Ross and Kessler, *On Grief and Grieving*, 10.

16. Kübler-Ross and Kessler, *On Grief and Grieving*, 34.

17. Janet Catherine Berlo, *Quilting Lessons: Notes from the Scrap Bag of a Writer and Quilter* (Lincoln: University of Nebraska Press, 2001), 5. In 1993 Janet Catherine Berlo published a short essay "Loss" in *Piecework* magazine on her resolution to make a mourning quilt in the event her husband died before her as a "survival plan," as a "path" through sorrow and grief. Although written while her husband was alive and well, Berlo's essay prompted women readers to write letters to her regarding their own personal and creative responses to the loss of a partner. Janet Catherine Berlo, "Loss," *Piecework* (July 1993); reprinted in Berlo, *Quilting Lessons*, 11–13.

18. Berlo, *Quilting Lessons*, 2, 3.

19. Berlo, *Quilting Lessons*, 8.

20. Berlo, *Quilting Lessons*, 3.

21. Berlo, *Quilting Lessons*, 5, 8, 4, 5.

22. Nettie Young, in *The Quilts of Gee's Bend*, dir. Matt Arnett and Vanessa Vadim (Atlanta: Tinwood Media, 2006).

23. Loretta Pettway, in M. Arnett and Vadim, *Quilts of Gee's Bend*.

24. Nettie Young, quoted in Linda Matchan, "With These Hands," Boston Globe, May 15, 2005.

25. Mary Lee Bendolph, quoted in Joanne Cubbs, "The Life and Art of Mary Lee Bendolph," in *Mary Lee Bendolph, Gee's Bend Quilts, and Beyond*,

ed. Paul Arnett and Eugene W. Metcalf Jr. (Atlanta: Tinwood Books, 2006), 14. See also Joanne Cubbs, "A History of the Work-Clothes Quilt," in Arnett, Cubbs, and Metcalf, *Gee's Bend*, 73–74.

26. Lucy Mingo, in *The Quilters of Gee's Bend*, recording of library event (Columbia, SC: Richland County Public Library, 2011).

27. Freeman, *Communion of the Spirits*, 106.

28. Arlonzia Pettway, quoted in Zegart and P. Arnett, "My Way," 96.

29. Arlonzia Pettway, quoted in Zegart and P. Arnett, "My Way," 96, 94.

30. Arlonzia Pettway, in M. Arnett and Vadim, *Quilts of Gee's Bend*.

31. Arlonzia Pettway, quoted in Zegart and P. Arnett, "My Way," 94. In the 2007 documentary *Do Not Go Gently*, Arlonzia Pettway explained that her husband, Bizzell Pettway, died of a heart attack while working and that this sudden tragedy left her with five children and five grandchildren to raise.

32. Cubbs, "History of the Work-Clothes Quilt," 73. For the details on this quilt, the author cites an interview with Arlonzia Pettway conducted by Bernard Herman in October 2003. See also Joanne Cubbs, "The Poetry of Castaway Things," in *Creation Story: Gee's Bend Quilts and the Art of Thornton Dial*, ed. Mark Scala (Nashville: Vanderbilt University Press, 2012), 3.

Chapter Four | Lined with Labor

1. Johnnetta Cole, "Interview with Mary Lee Bendolph," 2008, National Visionary Leadership Project, Archive of Folk Culture, American Folklife Center, Library of Congress.

2. Mary Lee Bendolph, quoted in John Beardsley, "Pettway," in John Beardsley, William Arnett, Paul Arnett, Jane Livingston, and Alvia Wardlaw, *Gee's Bend: The Women and Their Quilts* (Atlanta: Tinwood Books, 2002), 254.

3. Bettie Bendolph Seltzer, quoted in Beardsley, "Pettway," in Beardsley, W. Arnett, P. Arnett, Livingston, and Wardlaw, *Gee's Bend*, 222.

4. Wilcox County Heritage Book Committee, *The Heritage of Wilcox County, Alabama* (Clanton, AL: Heritage Publishing Consultants, 2002), 283.

5. Nettie Young, in the documentary *With Fingers of Love: Economic Development and the Civil Rights Movement*, dir. Carolyn Hales (Tuscaloosa: University of Alabama Center for Public Television, 1994). Her account also reveals that multiple systems of farm labor were present in Gee's Bend, including work as wage hands as well as sharecropping and tenant farming. Nettie Young went on to serve as cofounder and president of the Freedom Quilting

Bee, a sewing cooperative founded in 1966 and infused with the ideals of the civil rights movement. For more on this cooperative sewing center based in Alberta, Alabama (about eighteen miles from the Gee's Bend ferry), and issues of social creativity and economic development, see Callahan, *Freedom Quilting Bee*; Calvin Trillin, "US Journal: 'Gees Bend, Ala.,'" *New Yorker*, March 22, 1969; and Nancy Scheper-Hughes, "Anatomy of a Quilt: The Gee's Bend Freedom Quilting Bee," *Southern Cultures* 10:3 (Fall 2004): 88–98.

6. For selling of eggs, see John Temple Graves II, "The Big World at Last Reaches Gee's Bend," *New York Times Magazine*, August 22, 1937. For work on the docks in Mobile, see the documentary *From Fields of Promise*, dir. Bruce Kuerten and John DiJulio (Auburn, AL: Auburn University Television, 1995).

7. Sterling Brown, "Gee's Bend," in *Sterling A. Brown's "A Negro Looks at the South,"* ed. John Edgar Tidwell and Mark A. Sanders (New York: Oxford University Press, 2007), 159.

8. Loretta Pettway, in *The Quiltmakers of Gee's Bend*, dir. Celia Carey (Birmingham: Alabama Public Television, 2004). Loretta Pettway's understanding, "I never had a child life," in Paul Arnett, "Work Clothes," in *The Quilts of Gee's Bend*, 72.

9. Nettie Young, in *The Quilts of Gee's Bend*, dir. Matt Arnett and Vanessa Vadim (Atlanta: Tinwood Media, 2006).

10. J. R. Moehringer, "Crossing Over," *Los Angeles Times*, August 22, 1999.

11. Graves, "Big World at Last Reaches Gee's Bend."

12. Charles S. Johnson, *Statistical Atlas of Southern Counties* (Chapel Hill: University of North Carolina, 1941), 16–17.

13. Onnie Lee Logan, as told to Katherine Clark, *Motherwit: An Alabama Midwife's Story* (New York: Dutton, 1989), 41. Onnie Lee Logan was one of the last practicing lay midwives in Alabama. She practiced from 1931 to 1984, when lay midwifery was banned in the state. Logan's recollections of midwifery span three generations and include the experiences of her mother and paternal grandmother too.

14. Logan, *Motherwit*, 40.

15. Margaret Charles Smith and Linda Janet Holmes, *Listen to Me Good: The Life Story of an Alabama Midwife* (Columbus: Ohio State University Press, 1996), 17. Born in Eutaw, Greene County, Alabama, in 1906, Margaret Charles Smith worked as a traditional midwife within the Black Belt from 1949 to 1981.

16. Logan, *Motherwit*, 41.

17. Loretta Pettway, in M. Arnett and Vadim, *Quilts of Gee's Bend*.

18. Johnnetta Cole, "Interview with Nettie Young," 2008, National Visionary Leadership Project, Archive of Folk Culture, American Folklife Center, Library of Congress, transcript, 12–13.

19. John Beardsley, "River Island," in *Quilts of Gee's Bend*, 26–27.

20. Renwick C. Kennedy, "Roosevelt's Tenants," *Christian Century* 52:19, May 8, 1935, 610.

21. Moehringer, "Crossing Over."

22. Wallach, "Fabric of Their Lives."

23. Arlonzia Pettway, in *Do Not Go Gently: The Power of Imagination in Aging*, dir. Melissa Godoy (Green Bay, WI: Newist / CESA 7, 2007).

24. Arlonzia Pettway, quoted in Shelly Zegart and Paul Arnett, "My Way," in Beardsley, W. Arnett, P. Arnett, Livingston, and Wardlaw, *Quilts of Gee's Bend*, 94.

25. Loretta Pettway, in M. Arnett and Vadim, *Quilts of Gee's Bend*.

26. Loretta Pettway, quoted in Wallach, "Fabric of Their Lives."

27. Mary Lee Bendolph, quoted in Beardsley, "Pettway," in Beardsley, W. Arnett, P. Arnett, Livingston, and Wardlaw, *Gee's Bend*, 254.

28. Joanna Pettway, quoted in Maude Southwell Wahlman and Ella King Torrey, *Ten Afro-American Quilters* (Jackson: University of Mississippi, Center for the Study of Southern Culture, 1983), 13.

29. Lucy T. Pettway, quoted in Barbara Pollack, "Stitches in Time," *House and Garden*, November 2002, 102.

30. Arlonzia Pettway, quoted in Matchan, "With These Hands."

31. Moehringer, "Crossing Over."

32. Alice Walker, "In Search of Our Mothers' Gardens" (1974), In Search of Our Mothers' Gardens: Womanist Prose (New York: Harcourt Brace Jovanovich, 1983), 231–43, 233.

33. Arlonzia Pettway, quoted in Zegart and P. Arnett, "My Way," 93.

34. Arlonzia Pettway, quoted in Zegart and P. Arnett, "My Way," 93.

35. Marion Post Wolcott, 1939, Library of Congress. Prints & Photographs Division, FSA/OWI Collection, reproduction number LC-DIG-fsa-8a40121. There is a related image of Sally Miller Pettway also on file reproduction number LC-DIG-fsa-8a40122.

36. Sally Miller Pettway is identified as the subject of this photograph in Zegart and P. Arnett, "My Way," 93.

37. Logan, *Motherwit*, 49–50. Onnie Lee Logan was a third-generation midwife: both her mother and grandmother were also midwives. Concerning

the meaning and use of the term *granny midwife* in her day and before, Logan explained: "I hear 'granny midwife' all the time. That's what it was. That's what it was from the beginnin. My grandmother and my mother were called that. They'd call her granny. Many years ago they used to say, 'That's yo' granny. That's yo' grannymother. She delivered you. She was the first one to put her hands on you. She's the one that made you cry, got the breath in you.' . . . Catchin babies—that's what they call it. They'd say, 'Where's Tinny goin?' 'She gone to catch so-and-so's baby.' That's what they called it" (50).

38. Logan, *Motherwit*, 50.

39. Logan *Motherwit*, 54–55.

40. Lola Pettway and Arlonzia Pettway, quoted in Matchan, "With These Hands."

41. Alice Walker, "The Black Writer and the Southern Experience" (1970), *In Search of Our Mothers' Gardens*, 17. The payment of midwives is also the subject of Walker's poem "Three Dollars Cash," in *Revolutionary Petunias* (New York: Harcourt Brace Jovanovich, 1973), 6.

42. Nell Hall Williams, quoted in Alvia Wardlaw, "Rehoboth," in Beardsley, W. Arnett, P. Arnett, Livingston, and Wardlaw, *Gee's Bend*, 406.

43. Gladys-Marie Fry, *Stitched from the Soul: Slave Quilts from the Ante-Bellum South* (New York: Dutton Studio Books, 1990), 42–43. For more on quilts and the protection of babies, see Eli Leon, *Accidentally on Purpose: The Aesthetic Management of Irregularities in African Textiles and African-American Quilts* (Davenport, IA: Figge Art Museum, 2006), 16–17.

44. Dykeman and Stokely, *Seeds of Southern Change*, 311.

45. Kennedy, "Life at Gee's Bend," 1073.

46. This crisis continues and spans well beyond Gee's Bend. See Linda Villarosa, "Why America's Black Mothers and Babies Are in a Life-or-Death Crisis," *New York Times Magazine*, April 11, 2018; and "Black Mothers Respond to Our Cover Story on Maternal Mortality," *New York Times Magazine*, April 18, 2018.

47. Scheper-Hughes, "Anatomy of a Quilt," 89.

48. Scheper-Hughes, "Anatomy of a Quilt," 92. Nancy Scheper-Hughes's "two final reports," as she explains, "were used in a class action suit—'Peoples v. the Department of Agriculture'—that reached a federal appeals court in Washington, DC, in the spring of 1968."

49. Scheper-Hughes, "Anatomy of a Quilt," 89–90.

50. Logan, *Motherwit*, 24.

51. Lucinda Pettway Franklin, quoted in Ben Raines, "Suit Claims Oldest Gee's Bend Quilts Stolen," *Associated Press News Service*, June 26, 2007. Anna C. Chave also quotes this passage in her article "Dis/Cover/ing the Quilts of Gee's Bend, Alabama," *Journal of Modern Craft* 1:2 (July 2008): 225–26.

52. Walker, "Black Writer and the Southern Experience," 17.

53. Moehringer, "Crossing Over."

Chapter Five | Shared Care and Prayer

1. Mary Lee Bendolph, quoted in John Beardsley, "Pettway," in John Beardsley, William Arnett, Paul Arnett, Jane Livingston, and Alvia Wardlaw, *Gee's Bend: The Women and Their Quilts* (Atlanta: Tinwood Books, 2002), 254.

2. Georgiana B. Pettway, in *The Quilts of Gee's Bend*, dir. Matt Arnett and Vanessa Vadim (Atlanta: Tinwood Media, 2006).

3. Nettie Young, in M. Arnett and Vadim, *Quilts of Gee's Bend*.

4. Bettie Bendolph Seltzer, quoted in Beardsley, "Pettway," 216.

5. Arlonzia Pettway, quoted in Shelly Zegart and Paul Arnett, "My Way," in John Beardsley, William Arnett, Paul Arnett, Jane Livingston, and Alvia Wardlaw, *Quilts of Gee's Bend* (Atlanta: Tinwood Books, 2002), 94.

6. Essie Pettway, in *While I Yet Live*, dir. Maris Curran (Nightshade Films, 2018).

7. Arlonzia Pettway, in M. Arnett and Vadim, *Quilts of Gee's Bend*.

8. Johnnetta Cole, "Interview with Nettie Young," 2008, National Visionary Leadership Project, Archive of Folk Culture, American Folklife Center, Library of Congress, transcript, 32.

9. Georgiana B. Pettway, in M. Arnett and Vadim, *Quilts of Gee's Bend*.

10. Mary Lee Bendolph, quoted in Patricia Leigh Brown, "From the Bottomlands, Soulful Stitches," New York Times, November 21, 2002.

11. Mary Lee Bendolph, in *Gee's Bend: From Quilt to Print*, dir. Muffie Dunn (New York: Checkerboard Film Foundation, 2007).

12. Johnnetta Cole, "Interview with Lucy Mingo," 2008, National Visionary Leadership Project, Archive of Folk Culture, American Folklife Center, Library of Congress, transcript, 48.

13. Lucy Mingo, in Curran, *While I Yet Live*.

14. Carolyn Mazloomi and Patricia C. Pongracz, *Threads of Faith: Recent Works from the Women of Color Quilters Network* (New York: American Bible Society, 2004), 44.

15. For more on links between space, place, and faith in Gee's Bend: sociologist Olive M. Stone discusses "praying ground" in her article "Cultural Uses of Religious Visions: A Case Study," *Ethnology* 1:3 (July 1962): 330; writer J. R. Moehringer thinks on "praying place" in his feature story "Crossing Over," *Los Angeles Times*, August 22, 1999; and art and architectural historian Bernard Herman considers the notion of "praise spaces" as an aspect of quilt making in Gee's Bend in his essay "Architectural Definitions," in *Gee's Bend: The Architecture of the Quilt*, ed. Paul Arnett, Joanne Cubbs, and Eugene W. Metcalf Jr. (Atlanta: Tinwood Books, 2006), 214.

16. Cole, "Interview with Nettie Young," 31–32.

17. Essie Pettway, in Curran, *While I Yet Live*.

18. Gee's Bend Quilters' Collective, "Artist's Statement," in *The Global Africa Project*, ed. Lowery Stokes Sim and Leslie King-Hammond (New York: Museum of Arts and Design, 2010), 221.

19. Reverend Clinton Pettway Jr., pastor of Ye Shall Know the Truth Baptist Church, in *The Quiltmakers of Gee's Bend*, dir. Celia Carey (Birmingham: Alabama Public Television, 2004).

20. Arlonzia Pettway, in M. Arnett and Vadim, *Quilts of Gee's Bend*. While Arlonzia is sharing the origins of the White Rose, she is also socializing around a working quilting frame with other founding members of the singing group, Leola Pettway, Georgiana B. Pettway, and Creola B. Pettway.

21. Cole, "Interview with Nettie Young," 37.

22. Smith and Holmes, *Listen to Me Good*, 17.

23. Cole, "Interview with Nettie Young," 6, 17–18, 17, 24–26, 3.

24. Nettie Young, in Carey, *Quiltmakers of Gee's Bend*. Art and cultural historian Bridget R. Cooks draws on this passage in her discussion of religiosity in relation to the quilt makers and quilts of Gee's Bend. See Cooks, "Back to the Future: *The Quilts of Gee's Bend, 2002*," in *Exhibiting Blackness: African Americans and the American Art Museum* (Amherst: University of Massachusetts Press, 2011), 153.

25. Nettie Young, in Carey, *Quiltmakers of Gee's Bend*.

26. Cole, "Interview with Nettie Young," 20–21.

27. Gee's Bend Quilters (Mary Ann Pettway, China Pettway, Larine Pettway, and Nancy Pettway), *Boykin, Alabama: Sacred Spirituals of Gee's Bend*, produced and recorded by Dan Torigoe (Dolceola Recordings, 2019). China Pettway's words appear in the liner notes for the CD.

28. China Pettway, in liner notes for *Boykin, Alabama.*

29. My youngest son and I had the wonderful privilege of attending two of their workshops in Nauvoo, Alabama (in the northwestern part of the state)—in 2015 and again in 2018. Mary Ann Pettway and China Pettway are currently offering workshops and retreats in their own neighborhood at the Gee's Bend Quilters' Collective.

30. Gee's Bend Quilters, *Boykin, Alabama.* Mary Ann Pettway and China Pettway are also featured vocalists on Eric Essix's gospel album *This Train: The Gospel Sessions,* produced by Kelvin Wooten, Daniel Beard, and Eric Essix (Essential Recordings, 2016).

31. "Swing Low, Sweet Chariot," traditional African American spiritual, opening chorus and second verse, as sung by Gee's Bend Quilters.

32. Arlonzia Pettway, in Carey, *Quiltmakers of Gee's Bend.*

Conclusion

1. Arlonzia Pettway, quoted in John Beardsley, William Arnett, Paul Arnett, Jane Livingston, and Alvia Wardlaw, *The Quilts of Gee's Bend* (Atlanta: Tinwood Books, 2002), 67.

Coda

1. Martin Luther King Jr. gave a rousing speech in Gee's Bend the month before the historic voting rights march from Selma (in neighboring Dallas County) to Montgomery. For more on King's visit, see Jack Nelson, "Martin Luther King Jr.: From Gee's Bend to Memphis," in *Scoop: The Evolution of a Southern Reporter,* ed. Barbara Matusow (Jackson: University Press of Mississippi, 2013), 139–40. Journalist Jack Nelson recalled King spoke to an audience of about three hundred residents. He also recalled that Gee's Bend at the time was an entirely African American community of "116 families and a population of 700" located within a county (Wilcox) in which African Americans "comprised 75 percent of the population but had no registered voters." See also Cynthia Griggs Fleming, *In the Shadow of Selma: The Continuing Struggle for Civil Rights in the Rural South* (Lanham, MD: Rowman & Littlefield, 2004), xvi, 163. Wilcox County is the focus of Fleming's study of African American struggles and activism in the rural Black Belt during the twentieth century;

Gee's Bend and its residents are a focus of her research. For Fleming's discussion of Gee's Bend and the voting rights campaign, see Fleming, *In the Shadow of Selma*, 137–41.

2. Arizona senator John McCain visited Gee's Bend in April 2008 while on the presidential campaign trail. While being filmed by his camera crew, McCain visited with local quilt makers and purchased three quilts. Elisabeth Bumiller, "On McCain Tour, a Promise to Find 'Forgotten' America," *New York Times*, April 22, 2008.

3. My youngest son and I also twice traveled (in 2015 and 2018) to the Alabama Folk School at Camp McDowell in Nauvoo, Alabama (in the northwestern part of the state), to participate in Gee's Bend Quilting Workshops led by Mary Ann Pettway and her neighbor and fellow singer and quilt maker China Pettway.

4. J. R. Moehringer, "Crossing Over," *Los Angeles Times*, August 22, 1999.

5. Sociologist Olive M. Stone refers to Gee's Bend—the "anonymous Negro folk community in the Gulf States" that was the site of her resident research in 1943—as "River Island." See Stone, "Cultural Uses of Religious Visions: A Case Study," *Ethnology* 1:3 (July 1962): 329. In his essay for the exhibition catalog, John Beardsley extends her use of the term ("River Island," *The Quilts of Gee's Bend*, by John Beardsley, William Arnett, Paul Arnett, Jane Livingston, and Alvia Wardlaw [Atlanta: Tinwood Books, 2002]). In "Crossing Over" Moehringer refers to the community centered around the Boykin Post Office as a "virtual island."

6. Beardsley, "River Island," 21.

7. Fleming, *In the Shadow of Selma*, xix.

8. Sterling Brown set down the experience of his day trip in a short, unpublished travel essay discovered at Howard's Moorland-Springarn Research Center. See Brown, "Gee's Bend," in *Sterling A. Brown's "A Negro Looks at the South,"* ed. John Edgar Tidwell and Mark A. Sanders (New York: Oxford University Press, 2007), 149–59.

9. Nancy Callahan reports that in 1966 Episcopal priest and civil rights worker Francis X. Walter paid $10 each for area quilts before helping to establish the Freedom Quilting Bee in Rehoboth, just up the road from Gee's Bend. In Callahan's mid-1980s interview with civil rights activist and Freedom Quilting Bee manager Estelle Witherspoon, Witherspoon explained: "Just in this area the quilting bee has come from selling quilts for $10. Now we can sell

'em for $400 and $450. An average job is $300." Callahan, *The Freedom Quilting Bee* (1987. reprint, Tuscaloosa: University of Alabama Press, 2005), 14–15, 238.

10. See Roland L. Freeman, *A Communion of the Spirits: African-American Quilters, Preservers, and Their Stories* (Nashville: Rutledge Hill Press, 1996), 338. Freeman's photograph was taken in 1993. William Arnett reportedly purchased the medallion quilt by Annie Mae Young for three thousand dollars. See Ben Raines, "Gee's Bend Quilters: Lawsuit Filed in Federal Court in Selma," *Mobile Press-Register*, June 5, 2007. For a thoughtful, well-researched discussion of this "classic narrative of discovery" as well as issues of authority, taxonomy, power, and resources within the context of the quilts and their stakeholders, see Anna Chave, "Dis/Cover/ing the Quilts of Gee's Bend, Alabama," *Journal of Modern Craft* 1:2 (July 2008): 221–54. Also see Bernard Herman's response to Chave's essay in which the art and cultural historian, and former director of the Souls Grown Deep Foundation Board, shares his views on the contemporaneous legal challenges and controversies surrounding the collecting and dealing of the quilts as well as their possible meanings and consequences. Bernard L. Herman, "The Quilts of Gee's Bend: How Great Art Gets Lost," *Journal of Modern Craft* 2:1 (March 2009): 9–16.

11. Andrew Dietz, in his book *The Last Folk Hero: A True Story of Race and Art, Power and Profit* (Atlanta: Ellis Lane Press, 2006), writes that Mary McCarthy, a former Freedom Quilting Bee manager who had lived in the Bend for seventeen years, starting in the late 1960s, served as a guide for Arnett's frequent trips to Gee's Bend in the late 1990s. Dietz's book includes Mary McCarthy's memory of these collecting trips: "Bill just wanted to see *everybody's* quilts. Whatever house we went to, Bill would look through stacks of quilts and select what he liked best. Then he would think about it a little and give the woman a number—a dollar amount—and the woman's eyes would pop. 'You gonna pay me that for these old raggly quilts?' the women would say. We went to lots and lots of houses, and by the time we left the white van was chock full of quilts, piled up so high and deep they were stuffed between the driver and passenger seats" (251). According to Dietz, Arnett recalled going to "twenty-eight houses" and buying the best of what he saw in his trips to Gee's Bend (252). Amelia Peck, curator of decorative arts and textiles at the Metropolitan Museum of Art, writes that William Arnett came "into contact with more than 150 other quilt makers from the area." See Peck, "Quilt/Art: Deconstructing the Gee's Bend Quilt Phenomenon," in *My Soul Has Grown Deep: Black Art from the*

American South, by Cheryl Finley, Randall Griffey, Amelia Peck, and Darryl Pinckney (New York: Metropolitan Museum of Art, 2018), 63.

12. For the 530 estimate, see Patricia Leigh Brown, "From the Bottomlands, Soulful Stitches," *New York Times*, November 21, 2002. For the 700-plus estimate, see Barbara Pollack, "Stitches in Time," *House and Garden* November 2002, 103.

13. P. L. Brown, "From the Bottomlands."

14. Pollack, "Stitches in Time," 103.

15. Linda Hales, "From Museum to Housewares: Marketing Gee's Bend Quilts," *Washington Post*, February 28, 2004.

16. Matt Schudel, "Bill Arnett, Who Collected and Promoted Black Vernacular Art, Dies at 81," *Washington Post*, August 19, 2020; Richard Sandomir, "Bill Arnett, Collector and Promoter of Little-Known Black Art, Dies at 81," *New York Times*, August 27, 2020.

17. In 2007 three quilt makers—Annie Mae Young, Loretta Pettway, and Lucinda Pettway Franklin—each filed a lawsuit against William Arnett and sons over issues of intellectual property rights, compensation, and/or earnings. The suits were resolved out of court, without a disclosure of the details, in 2008. See Ben Raines, "Gee's Bend Quilters: Lawsuit Filed in Federal Court in Selma," *Mobile Press-Register*, June 5, 2007; Ben Raines, "Gee's Bend: A Fight for Rights," *Mobile Press-Register*, June 15, 2007; Ben Raines, "Gee's Bend: "Quilts Stolen, Claims Woman," *Mobile Press-Register*, June 23, 2007; Michael Huebner, "Gee's Bend Quilts Delivered to Lawyers," *Birmingham News*, June 28, 2007; Shaila Dewan, "Handmade Alabama Quilts Find Fame and Controversy," *New York Times*, July 29, 2007; and Bob Johnson, "Suits Brought by Rural Alabama Quilters Resolved," *Associated Press News Service*, August 25, 2008. Also see Paige Williams, "Composition in Black and White," *New Yorker*, August 5, 2013; and Alexandra Marvar, "Can You Copyright a Quilt?" *Nation*, October 29, 2018. On issues of commodification, see Linda Hales, "From Museum to Housewares: Marketing Gee's Bend Quilts," *Washington Post*, February 28, 2004; Linda Matchan, "The Blurred Line between Purity and Profit," *Boston Globe*, May 15, 2005; and Victoria F. Phillips, "Symposium: Commodification, Intellectual Property and the Quilters of Gee's Bend," *Journal of Gender, Social Policy and the Law* 15:2 (2007): 359–77. For concerns about financial compensation, see Patricia A. Turner, "One More River to Cross," *Crafted Lives: Stories and Studies of African American Quilters* (Jackson: University Press of Mississippi,

2009), 190–201. See also Bridget R. Cooks, "Back to the Future: *The Quilts of Gee's Bend, 2002*," in *Exhibiting Blackness: African Americans and the American Art Museum* (Amherst: University of Massachusetts Press, 2011), 135–54; and Bridget R. Cooks, "The Gee's Bend Effect," *Textile: Journal of Cloth and Culture* 12:3 (November 2014): 351.

18. For a window into this confusion, see Dietz, *Last Folk Hero*, 301–10.

19. Brown, "From the Bottomlands."

20. This tension is on full display in a late 2003–early 2004 *Artforum* exchange between Thelma Golden, then deputy director for exhibitions and programs at the Studio Museum in Harlem, and Rennie Young Miller, then head of the Gee's Bend Quilters' Collective. In her curt review, Golden summed up her experience of the Whitney show—"love the quilts / hate the exhibition"—and raised the issue of compensation: "I just wish the quilters were making a little more money for all their brilliance!" Thelma Golden, "The Quilts of Gee's Bend," *Artforum International* 42:4 (December 2003): 126. In her published response "on behalf of the fifty-four quilters of Gee's Bend, Alabama," Miller affirmed the exhibition and its aftermath, writing: "The 'Quilts of Gee's Bend' exhibition project has transformed our community. It has brought hope and renewal to dozens of African-American women artists here. We have been treated with dignity and respect for the first time in our lives. Thanks to the exhibition, we now have a stake in our future as artists. Earlier this year, the women quilters of Gee's Bend—every able-bodied quilter in the exhibition—founded the Gee's Bend Quilters' Collective. We own the Collective, which establishes prices, creates inventories, and handles sales, marketing, and accounting. Individual quilters receive half the proceeds from the sale of their quilts, and above that, we pay dividends to all our members. Things are off to a good start." Rennie Young Miller, "To the Editor," *Artforum International* 42:7 (March 2004): 22, 30. Not long after her rebuttal was published, however, Miller "resigned as director of the quilt makers' collective due, indeed, to financial concerns," alleging "the collective that the Arnetts had helped to establish 'didn't have any bylaws, no incorporation, so there weren't any rules' and that 'they would never tell us where the money was or how to get access to it.'" See Chave, "Dis/Cover/ing the Quilts of Gee's Bend," 237. Here Chave draws on the reporting of Ben Raines ("Gee's Bend: A Fight for Rights"). As reported by Raines, three years after the *Artforum* exchange, looking back on the period, Miller said: "It was a bright time for us. We had

never been exposed like that. I thought we were going to go someplace, but undoubtedly the lady that wrote that article seen something that we didn't see at that time. Some of the quilters still don't see it, but I do."

21. Nettie Young, in *The Quiltmakers of Gee's Bend*, dir. Celia Carey (Birmingham: Alabama Public Television, 2004). See also Tinnie Pettway's 2005 poem "Our Quilt Value," *The Gee's Bend Experience* (Birmingham: Banner Press, 2008), 19–20. Her poem speaks to the change in perception of the quilts by their makers and how their exhibition enabled quilt makers from Gee's Bend to travel and experience warm receptions by the many admirers of their work.

22. Arlonzia Pettway, quoted in Matchan, "With These Hands," *Boston Globe*, May 15, 2005. The final stanza of Arlonzia Pettway's 2005 praise poem "The Path" also pays tribute to the Arnett family. The last lines read: "They took us to the house of joy, the house of peace, and the house of love. / And we are very happy for them." "The Quilts of Gee's Bend," *Boston Globe*, May 15, 2005, https://archive.boston.com/ae/theater_arts/articles/2005/05/13/Arlonzia _Pettways_poem.

23. Mary Lee Bendolph, in Josephine Reed, "Interview with Mary Lee Bendolph and Lucy Mingo," September 30, 2015, National Endowment for the Arts.

24. Arlonzia Pettway, in Jeffrey Brown, "The Quilts of Gee's Bend," *PBS NewsHour*, July 1, 2003. Journalist Lisa Gray reports on a meeting around 1998 in which Arlonzia Pettway showed William Arnett "a whole closet full of quilts" ("Made in Gee's Bend," *Houston Chronicle*, June 11, 2006).

25. See Dietz, *Last Folk Hero*, 264. Matt Arnett, cofounder of Tinwood Media and co-organizer of Gee's Bend Quilt Projects, also shares this story of an exchange between Arlonzia Pettway and a woman visiting the exhibition who, upon seeing Missouri Pettway's quilt made in mourning, directly asks Arlonzia Pettway about its acquisition in the documentary *Why Quilts Matter: History, Art, & Politics,* executive produced and hosted by Shelly Zegart (Louisville: Kentucky Quilt Project, 2011), episode 2: "Quilts Bring History Alive." See also episode 5: "Gee's Bend: 'The Most Famous Quilts in America?'"

26. Randy Kennedy, "For Met Museum, a Major Gift of Works by African-American Artists from the South," *New York Times*, November 24, 2014. See also Paige Williams, "The Met Embraces Neglected Southern Artists," *New Yorker*, December 4, 2014. The acquisition of fifty-seven works by thirty African American artists from the Souls Grown Deep Foundation's William

S. Arnett Collection by the Metropolitan Museum of Art includes Annie Mae Young's 1976 work clothes quilt centered by a strip medallion featured in Roland Freeman's 1993 photograph of its maker and her great-granddaughter (accession number 2014.548.57). Providing a sense of the scope of the foundation's holdings at the time, Cheryl Finley, in her introduction to the book published in 2018 in conjunction with the Met's acquisition and related exhibition, notes: "The Souls Grown Deep Foundation holds approximately twelve hundred works by one hundred sixty-five artists donated by William S. Arnett in 2010 from his collections dating back to the 1970s." Cheryl Finley, "Troubling the Waters," in *My Soul Has Grown Deep: Black Art from the American South*, by Cheryl Finley, Randall Griffey, Amelia Peck, and Darryl Pinckney (New York: Metropolitan Museum of Art, 2018), 99.

27. In April 2022 the Souls Grown Deep Foundation announced the first international acquisitions of works from its collection, reporting it had already placed "more than 500 works in more than 30 museums across the US." See Francesca Aton, "Tate Modern and Other International Institutions Acquire Artworks from Souls Grown Deep Collection for the First Time," *ARTnews*, April 19, 2022, https://www.artnews.com/art-news/news/souls-grown-deep-collection-first-international-acquisitions-1234625740.

28. National Gallery of Art, Department of Communications, press release, Acquisition Announcement, December 28, 2020, https://www.nga.gov/press/2020/soulsgrowndeep.html. The acquisition is comprised of work by twenty-one artists. It includes nine quilts from Gee's Bend artists (Missouri Pettway [2], Mary Lee Bendolph, Irene Williams, Mary L. Bennett, Flora Moore, Lucy P. Pettway, Sue Willie Seltzer, and Sally Mae Pettway Mixon) as well as works by other southern-based artists, including Nellie Mae Rowe, Thornton Dial, and Lonnie Holley. Two quilts by Missouri Pettway are part of the acquisition: her 1942 quilt (accession number 2020.28.15); and a 1971 quilt she called "Path through the Woods" (accession number 2020.28.16). See also Zachary Small, "National Gallery of Art Acquires 40 Works by Black Southern Artists," *New York Times*, December 30, 2020.

29. The provenance, or history of ownership, accompanying Missouri Pettway's 1942 quilt at the National Gallery of Art states: "The artist [1902–81], Boykin, Alabama; by inheritance 1981 to her son, Early Pettway, Boykin; purchased 1997 by William S. Arnett [1939–2020], Atlanta; gift 2002 to Tinwood Alliance, Atlanta; transfer 2010 to Souls Grown Deep Foundation, Atlanta; acquired 2020 by NGA through a gift/purchase agreement." I was surprised

to see Early Pettway, one of Arlonzia Pettway's younger brothers, listed as the inheritor of their mother's quilt as well as 1902 given as the year of birth for Missouri Pettway, which is inconsistent with the December 3, 1900, birth date incised on her headstone in the cemetery behind Pleasant Grove Missionary Baptist Church.

BIBLIOGRAPHY

Arnett, Matt, and Vanessa Vadim, dirs. *The Quilts of Gee's Bend*. Atlanta: Tinwood Media, 2006.

Arnett, Paul, Joanne Cubbs, and Eugene W. Metcalf Jr., eds. *Gee's Bend: The Architecture of the Quilt*. Atlanta: Tinwood Books, 2006.

Arnett, William, and Paul Arnett, eds. *Souls Grown Deep: African American Vernacular Art of the South*. Vol. 2. Atlanta: Tinwood Books, 2001.

Aton, Francesca. "Tate Modern and Other International Institutions Acquire Artworks from Souls Grown Deep Collection for the First Time." *ARTnews*, April 19, 2022, https://www.artnews.com/art-news/news/souls-grown-deep-collection-first-international-acquisitions-1234625740.

Beardsley, John, William Arnett, Paul Arnett, Jane Livingston, and Alvia Wardlaw. *Gee's Bend: The Women and Their Quilts*. Rev. ed. Atlanta: Tinwood Books, 2003.

———. *The Quilts of Gee's Bend*. Atlanta: Tinwood Books, 2002.

Bennett, Loretta P. "Dinah, Sally, Tank, Mother, and Me." In *Gee's Bend: The Architecture of the Quilt*, edited by Paul Arnett, Joanne Cubbs, and Eugene W. Metcalf Jr., 156–71. Atlanta: Tinwood Books, 2006.

Berlo, Janet Catherine. *Quilting Lessons: Notes from the Scrap Bag of a Writer and Quilter*. Lincoln: University of Nebraska Press, 2001.

Blitz, John H. *Moundville*. Tuscaloosa: University of Alabama Press, 2008.

Brown, Jeffrey. "The Quilts of Gee's Bend." *PBS NewsHour*, July 1, 2003.

Brown, Patricia Leigh. "From the Bottomlands, Soulful Stitches." *New York Times*, November 21, 2002.

Bumiller, Elisabeth. "On McCain Tour, a Promise to Find 'Forgotten' America." *New York Times*, April 22, 2008.

Callahan, Nancy. *The Freedom Quilting Bee*. 1987. Reprint, Tuscaloosa: University of Alabama Press, 2005.

Carey, Celia, dir. *The Quiltmakers of Gee's Bend*. Birmingham: Alabama Public Television, 2004.

Chave, Anna C. "Dis/Cover/ing the Quilts of Gee's Bend, Alabama." *Journal of Modern Craft* 1:2 (July 2008): 221–54.

Clark, Blue. *Indian Tribes of Oklahoma: A Guide*. 2nd ed. Norman: University of Oklahoma Press, 2020.

Cole, Johnnetta. "Interview with Lucy Mingo." 2008. National Visionary Leadership Project, Archive of Folk Culture, American Folklife Center, Library of Congress.

———. "Interview with Mary Lee Bendolph." 2008. National Visionary Leadership Project, Archive of Folk Culture, American Folklife Center, Library of Congress.

———. "Interview with Nettie Young." 2008. National Visionary Leadership Project, Archive of Folk Culture, American Folklife Center, Library of Congress.

Cooks, Bridget R. "Back to the Future: *The Quilts of Gee's Bend, 2002.*" In *Exhibiting Blackness: African Americans and the American Art Museum*, 135–54. Amherst: University of Massachusetts Press, 2011.

———. "The Gee's Bend Effect." *Textile: Journal of Cloth and Culture* 12:3 (November 2014): 346–65.

Cubbs, Joanne. "A History of the Work-Clothes Quilt." In *Gee's Bend: The Architecture of the Quilt*, edited by Paul Arnett, Joanne Cubbs, and Eugene W. Metcalf Jr., 66–89. Atlanta: Tinwood Books, 2006.

———. "The Life and Art of Mary Lee Bendolph." In *Mary Lee Bendolph, Gee's Bend Quilts, and Beyond*, edited by Paul Arnett and Eugene W. Metcalf Jr., 8–33. Atlanta: Tinwood Books, 2006.

———. "The Poetry of Castaway Things." In *Creation Story: Gee's Bend Quilts and the Art of Thornton Dial*, edited by Mark Scala, 1–9. Nashville: Vanderbilt University Press, 2012.

Curran, Maris, dir. *While I Yet Live*. New York: Nightshade Films, 2018.

Dewan, Shaila. "Handmade Alabama Quilts Find Fame and Controversy." *New York Times*, July 29, 2007.

Dietz, Andrew. *The Last Folk Hero: A True Story of Race and Art, Power and Profit*. Atlanta: Ellis Lane Press, 2006.

Dietz, Ulysses Grant. "From under the Bedcovers: A Culture Curator's

Perspective." In *Unconventional & Unexpected: American Quilts Below the Radar, 1950–2000*, edited by Roderick Kiracofe, 130–43. New York: Stewart, Tabori, & Chang, 2014.

Diouf, Sylviane A. "Africatown." *Encyclopedia of Alabama*. Updated July 21, 2021. http://encyclopediaofalabama.org/article/h-1402.

———. "Cudjo Lewis." *Encyclopedia of Alabama*. Updated October 20, 2009. http://encyclopediaofalabama.org/article/h-1403.

———. *Dreams of Africa in Alabama: The Slave Ship "Clotilda" and the Story of the Last Africans Brought to America*. New York: Oxford University Press, 2007.

———. "The Last Slave Ship." *National Geographic* (February 2020).

Dunn, Muffie, dir. *Gee's Bend: From Quilt to Print*. New York: Checkerboard Film Foundation, 2007.

Dykeman, Wilma, and James Stokely. *Seeds of Southern Change: The Life of Will Alexander*. Chicago: University of Chicago Press, 1962.

Equal Justice Initiative. *Slavery in America: The Montgomery Slave Trade*. Montgomery, AL: Equal Justice Initiative, 2018.

Essix, Eric. *This Train: The Gospel Sessions*. Produced by Kelvin Wooten, Daniel Beard, and Eric Essix. Essential Recordings, 2016.

Featherstonhaugh, George W. *Excursion through the Slave States*. New York: Harper & Brothers, 1844.

Federal Writers' Project. Library of Congress. *Born in Slavery: Slave Narratives from the Federal Writers' Project, 1936 to 1938*. https://www.loc.gov /collections/slave-narratives-from-the-federal-writers-project-1936-to -1938/about-this-collection.

Finley, Cheryl, Randall Griffey, Amelia Peck, and Darryl Pinckney. *My Soul Has Grown Deep: Black Art from the American South*. New York: Metropolitan Museum of Art, 2018.

Fleming, Cynthia Griggs. *In the Shadow of Selma: The Continuing Struggle for Civil Rights in the Rural South*. Lanham, MD: Rowman & Littlefield, 2004.

Freeman, Roland L. *A Communion of the Spirits: African-American Quilters, Preservers, and Their Stories*. Nashville: Rutledge Hill Press, 1996.

———. *Something to Keep You Warm: The Roland Freeman Collection of Black American Quilts from the Mississippi Heartland*. Jackson: Department of Archives and History, Mississippi State Historical Museum, 1981.

Fry, Gladys-Marie. *Stitched from the Soul: Slave Quilts from the Ante-Bellum South*. New York: Dutton Studio Books, 1990.

Gee's Bend Quilters (Mary Ann Pettway, China Pettway, Larine Pettway, and Nancy Pettway). *Boykin, Alabama: Sacred Spirituals of Gee's Bend*. Produced and recorded by Dan Torigoe. Dolceola Recordings, 2019.

Gee's Bend Quilters' Collective. "Artist's Statement." In *The Global Africa Project*, edited by Lowery Stokes Sims and Leslie King-Hammond, 220–21. New York: Museum of Arts and Design, 2010.

Godoy, Melissa, dir. *Do Not Go Gently: The Power of Imagination in Aging*. Green Bay, WI: Newist / CESA 7, 2007.

Golden, Thelma. "The Quilts of Gee's Bend." *Artforum International* 42:4 (December 2003): 126.

Gomez, Michael A. *Exchanging Our Country Marks: The Transformation of African Identities in the Colonial and Antebellum South*. Chapel Hill: University of North Carolina Press, 1998.

Graves, John Temple, II. "The Big World at Last Reaches Gee's Bend." *New York Times Magazine*, August 22, 1937.

Gray, Lisa. "Made in Gee's Bend." *Houston Chronicle*, June 11, 2006.

Hales, Carolyn, dir. *With Fingers of Love: Economic Development and the Civil Rights Movement*. Tuscaloosa: University of Alabama Center for Public Television, 1994.

Hales, Linda. "From Museum to Housewares: Marketing Gee's Bend Quilts." *Washington Post*, February 28, 2004.

Hamilton, Virginia Van der Veer. *Seeing Historic Alabama: Fifteen Guided Tours*. Tuscaloosa: University of Alabama Press, 1982.

Herman, Bernard L. "Architectural Definitions." In *Gee's Bend: The Architecture of the Quilt*, edited by Paul Arnett, Joanne Cubbs, and Eugene W. Metcalf Jr., 206–18. Atlanta: Tinwood Books, 2006.

———. "The Quilts of Gee's Bend: How Great Art Gets Lost." *Journal of Modern Craft* 2:1 (March 2009): 9–16.

Hudson, Angela Pulley. *Creek Paths and Federal Roads: Indians, Settlers, and Slaves and the Making of the American South*. Chapel Hill: University of North Carolina Press, 2010.

Huebner, Michael. "Gee's Bend Quilts Delivered to Lawyers." *Birmingham News*, June 28, 2007.

Hurston, Zora Neale. *Barracoon: The Story of the Last "Black Cargo."* Edited

by Deborah G. Plant. With a foreword by Alice Walker. New York: Amistad, 2018.

———. *Dust Tracks on a Road: An Autobiography.* 1942. Reprint, New York: HarperCollins, 1996.

Jackson, Harvey H., III. *Rivers of History: Life on the Coosa, Tallapoosa, Cahaba, and Alabama.* Tuscaloosa: University of Alabama Press, 1995.

Johnson, Bob. "Suits Brought by Rural Alabama Quilters Resolved." *Associated Press News Service,* August 25, 2008.

Johnson, Charles S. *Statistical Atlas of Southern Counties.* Chapel Hill: University of North Carolina Press, 1941.

Kennedy, Randy. "For Met Museum, a Major Gift of Works by African-American Artists from the South." *New York Times,* November 24, 2014.

Kennedy, Renwick C. "Life at Gee's Bend." *Christian Century* 54:35, September 1, 1937, 1072–75.

———. "Life Goes On at Gee's Bend." *Christian Century* 55:50, December 14, 1938, 1546–47.

———. "Rehabilitation: Alabama Version." *Christian Century* 51:46, November 14, 1934, 1455–57.

———. "Roosevelt's Tenants." *Christian Century* 52:19, May 8, 1935, 608–10.

Keyes, Allison. "The 'Clotilda,' the Last Known Slave Ship to Arrive in the US, Is Found." *Smithsonian Magazine,* May 22, 2019.

Kimmelman, Michael. "Jazzy Geometry, Cool Quilters." *New York Times,* November 29, 2002.

Kübler-Ross, Elisabeth, and David Kessler. *On Grief and Grieving.* New York: Scribner, 2005.

Kuerten, Bruce, and John DiJulio, dirs. *From Fields of Promise.* Auburn, AL: Auburn University Television, 1995.

Lankford, George E., F. Kent Reilly III, and James F. Garber, eds. *Visualizing the Sacred: Cosmic Visions, Regionalism, and the Art of the Mississippian World.* Austin: University of Texas Press, 2011.

Leon, Eli. *Accidently on Purpose: The Aesthetic Management of Irregularities in African Textiles and African-American Quilts.* Davenport, IA: Figge Art Museum, 2006.

———. *Models in the Mind: African Prototypes in American Patchwork.* Winston-Salem, NC: Diggs Gallery, 1992.

Logan, Onnie Lee, as told to Katherine Clark. *Motherwit: An Alabama Midwife's Story*. New York: Dutton, 1989.

Marvar, Alexandra. "Can You Copyright a Quilt?" *Nation*, October 29, 2018.

Matchan, Linda. "The Blurred Line between Purity and Profit." *Boston Globe*, May 15, 2005. http://archive.boston.com/ae/theater_arts/articles /2005/05/15/the_blurred_line_between_purity_and_profit.

———. "With These Hands." *Boston Globe*, May 15, 2005. http://archive .boston.com/news/globe/living/articles/2005/05/15/with_these_hands ?pg=full.

Mazloomi, Carolyn. *Quilting African American Women's History: Our Challenges, Creativity, and Champions*. Wilberforce, OH: National Afro-American Museum and Cultural Center, 2008.

———. *Spirits of the Cloth: Contemporary African-American Quilts*. New York: Clarkson Potter, 1998.

Mazloomi, Carolyn, and Patricia C. Pongracz. *Threads of Faith: Recent Works from the Women of Color Quilters Network*. New York: American Bible Society, 2004.

McKissack, Patricia. *Stitchin' and Pullin': A Gee's Bend Quilt*. New York: Random House, 2008.

Miles, Tiya. *All That She Carried: The Journey of Ashley's Sack, a Black Family Keepsake*. New York: Random House, 2021.

Miller, Rennie Young. "To the Editor." *Artforum International* 42:7 (March 2004): 22, 30.

Moehringer, J. R. "Crossing Over." *Los Angeles Times*, August 22, 1999.

Nelson, Jack. "Martin Luther King Jr.: From Gee's Bend to Memphis." In *Scoop: The Evolution of a Southern Reporter*, edited by Barbara Matusow, 138–45. Jackson: University Press of Mississippi, 2013.

Peck, Amelia. "Quilt/Art: Deconstructing the Gee's Bend Quilt Phenomenon." In *My Soul Has Grown Deep: Black Art from the American South*, by Cheryl Finley, Randall Griffey, Amelia Peck, and Darryl Pinckney, 53–91. New York: Metropolitan Museum of Art, 2018.

Pettway, Tinnie. *The Gee's Bend Experience*. Birmingham: Banner Press, 2008.

Phillips, Victoria F. "Symposium: Commodification, Intellectual Property and the Quilters of Gee's Bend." *Journal of Gender, Social Policy & the Law* 15:2 (2007): 359–77.

Pollack, Barbara. "Stitches in Time." *House and Garden* (November 2002): 98, 102–3.

Raines, Ben. "Gee's Bend: A Fight for Rights." *Mobile (AL) Press-Register*, June 15, 2007.

———. "Gee's Bend Quilters: Lawsuit Filed in Federal Court in Selma." *Mobile (AL) Press-Register*, June 5, 2007.

———. "Gee's Bend: Quilts Stolen, Claims Woman." *Mobile (AL) Press-Register*, June 23, 2007.

———. "Suit Claims Oldest Gee's Bend Quilts Stolen." *Associated Press News Service*, June 26, 2007.

Reed, Josephine. "Interview with Mary Lee Bendolph and Lucy Mingo." Conducted on September 30, 2015. National Endowment for the Arts (NEA). https://www.arts.gov/honors/heritage/mary-lee-bendolph-lucy -mingo-and-loretta-pettway.

Reilly, F. Kent, III. "Thoughts on the Preservation of Traditional Culture: An Interview with Joyce and Turner Bear." In *Hero, Hawk, and Open Hand: American Indian Art of the Ancient Midwest and South*, edited by Richard F. Townsend, 183–89. Chicago: Art Institute of Chicago, 2004.

Richland County Public Library (SC). *The Quilters of Gee's Bend*. DVD. Columbia, SC: Richland County Public Library, 2011.

Sandomir, Richard. "Bill Arnett, Collector and Promoter of Little-Known Black Art, Dies at 81." *New York Times*, August 27, 2020.

Saunt, Claudio. *Unworthy Republic: The Dispossession of Native Americans and the Road to Indian Territory*. New York: Norton, 2020.

Scheper-Hughes, Nancy. "Anatomy of a Quilt: The Gee's Bend Freedom Quilting Bee." *Southern Cultures* 10:3 (Fall 2004): 88–98.

Schudel, Matt. "Bill Arnett, Who Collected and Promoted Black Vernacular Art, Dies at 81." *Washington Post*, August 19, 2020.

Small, Zachary. "National Gallery of Art Acquires 40 Works by Black Southern Artists." *New York Times*, December 30, 2020.

Smith, Margaret Charles, and Linda Janet Holmes. *Listen to Me Good: The Life Story of an Alabama Midwife*. Columbus: Ohio State University Press, 1996.

Southerland, Henry deLeon, Jr., and Jerry Elijah Brown. *The Federal Road through Georgia, the Creek Nation, and Alabama, 1806–1836*. Tuscaloosa: University of Alabama Press, 1989.

Steponaitis, Vincas P., and C. Margaret Scarry, eds. *Rethinking Moundville and Its Hinterland*. Gainesville: University Press of Florida, 2016.

Steponaitis, Vincas P., and Vernon J. Knight Jr. "Moundville Art in

Historical and Social Context." In *Hero, Hawk, and Open Hand: American Indian Art of the Ancient Midwest and South*, edited by Richard F. Townsend, 167–81. Chicago: Art Institute of Chicago, 2004.

Stone, Olive M. "Chronology of Gee's Bend Economy." Unpublished paper. Gee's Bend Project Papers and Photographs, Department of Archives and Manuscripts, Birmingham Public Library.

———. "Cultural Uses of Religious Visions: A Case Study." *Ethnology* 1:3 (July 1962): 329–48.

Tidwell, John Edgar, and Mark A. Sanders, eds. *Sterling A. Brown's "A Negro Looks at the South."* New York: Oxford University Press, 2007.

Trillin, Calvin. "US Journal: Gees Bend, Ala." *New Yorker*, March 22, 1969.

Turner, Patricia A. *Crafted Lives: Stories and Studies of African American Quilters.* Jackson: University Press of Mississippi, 2009.

Villarosa, Linda. "Why America's Black Mothers and Babies Are in a Life-or-Death Crisis." *New York Times Magazine*, April 11, 2018.

Wahlman, Maude Southwell. *Signs and Symbols: African Images in African American Quilts.* 1993. Reprint, Atlanta: Tinwood Books, 2001.

Wahlman, Maude Southwell, and Ella King Torrey. *Ten Afro-American Quilters.* Jackson: University of Mississippi, Center for the Study of Southern Culture, 1983.

Walker, Alice. *In Search of Our Mothers' Gardens: Womanist Prose.* New York: Harcourt Brace Jovanovich, 1983.

———. "Three Dollars Cash." *Revolutionary Petunias.* New York: Harcourt Brace Jovanovich, 1973.

Wallach, Amei. "Fabric of Their Lives." *Smithsonian Magazine* (October 2006). https://www.smithsonianmag.com/arts-culture/fabric-of-their-lives-132757004.

———. "The Living Legacy of Dinah the Slave." In *Gee's Bend: The Architecture of the Quilt*, edited by Paul Arnett, Joanne Cubbs, and Eugene W. Metcalf Jr., 142–55. Atlanta: Tinwood Books, 2006.

Wilcox County Heritage Book Committee. *The Heritage of Wilcox County, Alabama.* Clanton, AL: Heritage Publishing Consultants, 2002.

Williams, Paige. "Composition in Black and White." *New Yorker*, August 5, 2013.

———. "The Met Embraces Neglected Southern Artists." *New Yorker*, December 4, 2014.

Windham, Kathryn Tucker. "Interview with Clint Pettway." September

25, 1980. Gee's Bend Project Papers and Photographs, Department of Archives and Manuscripts, Birmingham Public Library.

———. "They Call It Gee's Bend." Unpublished narrative history of Gee's Bend. Gee's Bend Project Papers and Photographs, Department of Archives and Manuscripts, Birmingham Public Library.

———. *Twice Blessed*. Montgomery: Black Belt Press, 1996.

Zegart, Shelly, exec. prod. *Why Quilts Matter: History, Art, & Politics*. Nine-part documentary series. Louisville: Kentucky Quilt Project, 2011.

Zegart, Shelly, and Paul Arnett. "My Way." In *The Quilts of Gee's Bend*, by John Beardsley, William Arnett, Paul Arnett, Jane Livingston, and Alvia Wardlaw, 78–97. Atlanta: Tinwood Books, 2002.

INDEX

✕

Page numbers in *italics* refer to illustrations